IMAGES
of America

CAMPS OF
GENEVA LAKE

GENEVA LAKE

SHORELINE	20.2 miles
MAXIMUM DEPTH	140 feet
BOAT POPULATION	1,400

KEY:
1. Camp Collie, 1873
2. Eleanor Camp, 1912
3. Wesley Woods, 1955
4. Fourth Church Camp, 1915
5. YMCA Camp, 1886
6. Vralia Heights, 1898
7. Olivet Camp, 1909
8. Holiday Home, 1887
9. Camp Aurora, 1934
10. Timber Trails Camp, 1970
11. Camp Offield, 1947
12. Camp Northwestern, 1909
13. Lake Geneva Youth Camp, 1950
14. St. Anne's School Camp, 1939
15. Covenant Harbor, 1947
16. Cisco Beach Camp, 1926
17. Immanuel Women's Association, 1926
18. Camp Willabay, 1946

Local artist, sailor, and industrial designer Frederick S. "Ted" Brennan created this map of Geneva Lake around 1988. (Courtesy of Carolyn Hope Smeltzer and Martha Cucco.)

IMAGES
of America

CAMPS OF GENEVA LAKE

Carolyn Hope Smeltzer and Jill Westberg

ARCADIA
PUBLISHING

Published by Arcadia Publishing
Charleston, South Carolina

Library of Congress Control Number: 2015947235

For all general information, please contact Arcadia Publishing:
Telephone 843-853-2070
Fax 843-853-0044
E-mail sales@arcadiapublishing.com
For customer service and orders:
Toll-Free 1-888-313-2665

Visit us on the Internet at www.arcadiapublishing.com

Carolyn dedicates this book to Bob Kelly, her husband and friend. Over 20 years ago, Bob introduced her to Geneva Lake living, which is like "one great big camp." Together, they take advantage of the natural beauty and resources of Geneva Lake, walking the shore path, boating, enjoying the water, golfing, and relaxing. Thank you, Bob, for giving me my first camp experience, which will last forever.

Jill dedicates this book to her grandfather O.E. Johnson, who in 1908 was the first in her family to discover the wonders of Geneva Lake.

Both Carolyn and Jill dedicate this book to the founders, supporters, leaders, and volunteers of the camps around the lake. They also dedicate this book to the campers. Preserving the history and culture of this lake ensures that many children and adults will continue to enjoy camp experiences just as those who attended the camps in the past.

CONTENTS

ACKNOWLEDGMENTS

A special thank-you goes to all who contributed to the preservation and history of the Geneva Lake camps, making the camp experience from the past come alive: Barbara Lokhorst, Carolyn Smith Slocum, Jeff Smith, and Peg Williams of Conference Point Center; William Bentsen, David Cox, Lisbeth and Tom Cox, Liz Cox, William Duncan, Carolyn Gramley, Betsy Hamlin, Richard Hamlin, Peter King, Tom McReynolds, Christy Gross Muse, Janis Plisis, Connie Gross Schmidt, Marilyn Smith Slocum, and Dianna Woss of George Williams College; Brad Cripe, Susan Grey, and Brian Herron of Holiday Home; Nancy Brown, Ford Colley, Tim Elsner, Valerie and Patrick Hanafee, Joan Elsner Miller, and Ethelyn Wolf of Norman B. Barr; Deb Dornbusch, Mary D. King, Elizabeth Probasco Kutchai, and Joy Peterkin Rasin of Eleanor Camp; Grace Melvin Hanny, Bruce Melvin, Mark Lindahl, Nancy Newcomb, and Carol Melvin Raabe of Camp Augustana; Al Bjorkman, Peter Heintzelman, Jane and Robert Klockars, and John Lokhorst of Covenant Harbor; Lisa Hanson Brellenthin, Bob Hanson, Brian Ogne, Wendell Oman, and Dave Yost of Camp Willabay; Paula Heick, Laurie Meisner, Lori Heick Murray, William Pollard, and Wendy Soderquist-Togami of Lake Geneva Youth Camp; Chris Brookes of Camp Northwestern; Joe Johnson and Joy Hulting of Camp Aurora; Robert Aspinall, Allan Buttons, Bruce Gates, and Nancy Lehman of Camp Offield.

We appreciate those who contributed to more than one camp: Joyce Falk Aspinall, Deborah Dumelle Kristmann, Joan Onder, Christian Snedeker, Jane Westberg, and John Westberg.

A special recognition goes to the may institutions that preserved the history of the camps and contributed to this book: Barrett Memorial Library; Covenant Archives and Historical Library of North Park University (CAHL); Camp Willabay Heritage Files; Covenant Harbor; Glacier's Edge Council of Boy Scout of America; First Presbyterian Church of Aurora, Illinois; Fourth Presbyterian Church in Chicago; Conference Point Center; Geneva Lake Museum; George Williams College of Aurora University; Holiday Home Camp; Lake Geneva Public Library; Lake Geneva Youth Camp; St. John's Northwestern Military Academy (SJNMA); Wesley Woods Retreat Center; and Williams Bay Historical Society.

ABOUT THE AUTHORS

Carolyn Hope Smeltzer, a nurse, serves on Advocate Christ Medical Center Governing Council and on mission journeys to developing nations. This is her fifth book; all combine images with research and storytelling to highlight nurses' lives and preserve the history of Geneva Lake. Golfing, kayaking, swimming, walking the path, playing bridge, writing, and practicing yoga and tai chi make her lake life an "adult camping experience."

Jill Westberg has published books in the field of faith and health, but this is her first book about history. She feels extremely fortunate to have had the opportunity to tromp through all of the camps and talk with so many remarkable people whose lives have made such a difference to others.

INTRODUCTION

Long ago, people built homes to protect their families from the elements of nature but at the same time longed for their children to experience the wilderness, where purity, natural beauty, quietness, and simplicity abounded. As families became city dwellers, summer camps gained in popularity. Camps educated the whole child, fostering physical health, social development, and spiritual enrichment in a natural environment.

Frederick William and Abigail Gunn are considered the founders of America's organized camps. They were headmasters of a private Connecticut school. In the summer of 1861, they organized a 30-mile march with 30 boys and a dozen girls. Their destination was Long Island Sound. During the two-week period, the children boated, fished, and sailed. This was the birth of the summer camp. Camp equipment and dress have changed through the years; however, the basic premise of the camps has not changed.

In 1905, Dr. Winthrop Tisdale Talbot described camp culture: "In cultivating general morality and kindly behavior the camps help chiefly through their usefulness in making boys strong vitally, in improving their power of digestion, in increasing their lung capacity, in letting the sunshine pour upon every portion of their bared bodies."

Camps held a very important place in Geneva Lake's cultural heritage and history. Beginning with Camp Collie in 1873, the camps hosted a broad range of people, both economically and ethnically. Many of the camps were begun by Christian groups who felt closer to God when they were in nature. In some cases, their founders were recent immigrants from rural areas in the old country.

Camps on Geneva Lake provided a respite from polluted and congested city life. Think of Chicago in the 1800s: black smoke billowing from tall chimneys, garbage thrown into the Chicago River, the stench of the stockyards, and children toiling long hours in poorly ventilated factories. Geneva Lake was a refuge. Children from low-income homes attended some of the camps for free. Working-class families could take the train up for the day or the week and go to "their" camp to swim and picnic.

Camps offered the disadvantaged an escape from the world they knew, if only temporarily. Holiday Home Camp focused on children with health problems who could benefit from fresh air. Olivet Camp hosted women and children from their settlement house in Chicago. Eleanor Camp served professional women who otherwise might not have been able to vacation. Other camps hosted groups of children with disabilities and chronic illnesses.

Building the early camps on Geneva Lake required a bit of ingenuity, since most roads were nothing more than dirt tracks. Often, construction materials for the sites were transported over water. Boats generally carried the items in the summer. Once the lake froze, horse-drawn wagons hauled supplies across the ice.

Geneva Lake was the perfect place for camps in terms of beauty, health, and accessibility. What could be prettier than a large, deep, spring-fed lake nestled among high bluffs and woods? The air was clean, and the water pure enough to drink. Once the railroad came to Lake Geneva (1871) and later to Williams Bay (1888), the camps were easily accessible. Train tickets from Chicago to Williams Bay cost only $2.83 in 1927.

From the train depots, campers lugged their baggage to public steam yachts waiting to transport them to camp, sometimes for as little as 25¢. Between 1899 and 1922, campers coming from southwest of Geneva Lake had another option for transportation. They could take a train to Harvard, Illinois, and transfer to the electric trolley, which ended on a pier in Fontana.

People had to take a similar route to get food and other supplies to camp. At the train station in Williams Bay, a porter unloaded the goods and carted them to the dock just across the road. The goods were then loaded onto the boat. Once the boat docked at a camp, the goods were

unloaded by camp employees and put into horse-drawn wagons. These deliveries were not without incident. In 1916, at the YMCA Camp, the gangplank broke and 500 pounds of fish and two boatmen fell overboard.

Some of the camps were fleeting. Others remained but changed names and/or ownership. As the price of lake property soared, owners and board members saw the benefits of selling their camps. One instance where this was averted happened in 1970 at George Williams College (formerly Y Camp). Deeply in debt, some board members felt it necessary to sell the Lake Geneva campus. Pres. Richard Hamlin rounded up key students and faculty to convince the board otherwise. At the lake, the night before the actual meeting, students gathered around a campfire with the board members. They told stories of their personal experiences at the lake's campus—why that camp mattered. The next morning, the motion to sell failed.

The Geneva Lake camps offered a sharp contrast to the grand estates along its shores. This book, *Camps of Geneva Lake*, explores the creation, mission, history, and unique characteristics of each camp. It highlights the value of the camps—not only to the attendees, but also to the community.

Sacredness is a common thread that is woven through all the camps. This sentiment is beautifully articulated on a plaque at George Williams College. A gift from the Unitarian Universalists, it commemorates the 62 years they held conferences at College Camp. The statement on the plaque reads, "The miracles of this sacred space will forever dance in the hearts and minds of those whose lives it has touched."

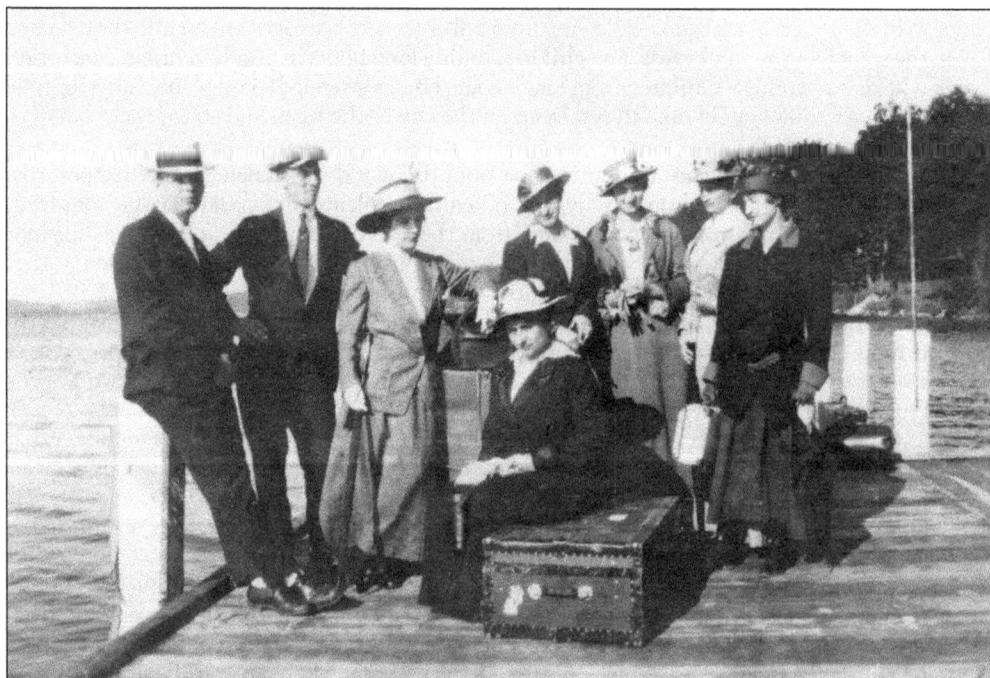

People arrived at and left the camps via the public yachts. This image from 1912 includes O.E. Johnson (far left) and his wife, Marie (sitting on the trunk), waiting for the steamer to pick them up after a week's vacation at the YMCA Camp. (Courtesy of the Westberg family.)

One

PLACE WITH A VIEW
CAMP COLLIE, CONFERENCE POINT, SUNDAY SCHOOL ASSOCIATION, AND CONFERENCE POINT CENTER

Conference Point has one of the most dramatic views of Geneva Lake. Perhaps that is what drew Rev. Joseph Collie to the point when he was looking for property in 1873. Reverend Collie, the pastor at the nearby Congregational church in Delavan, bought 10 acres high up on the point that juts out over Williams Bay. His intention was for it to be a retreat center for other ministers and their families—primarily people he knew.

Enough groups requested to use his camp that in 1884 Reverend Collie opened it to others, gearing it toward adult retreats (usually religious groups) and families. Camp Collie, as it became known, was the first formal camp on Geneva Lake—meaning it offered more than a spot to pitch a tent or rent a cabin. The camp was considered a place of "plain living and high thinking." Reverend Collie advertised that he "had rooms and boats to rent, board by the day or week, single meals, milk, ice, excellent water, a laundry, stable for horses, cookstoves, and wood."

After Reverend Collie died in 1904, his two sons attempted to convert Camp Collie into a resort but failed. They sold the property to E.H. Nicols, who formed a new corporation—the Lake Geneva Sunday School Association. Nicols changed the name to Conference Point Camp.

The International Training School for Sunday School Leaders purchased Conference Point in 1913. In that year, camps were held for older youths (aged 18–25) being trained for leadership roles. For many years, the camp was filled to capacity with Protestant youth and adult conferences.

After its formation in 1950, the National Council of Churches took charge of Conference Point, and it remained with the council until 1989. Soon after, it was acquired by the Lake Geneva Foundation, which renamed it Conference Point Center. The foundation expanded the camp from 50 groups annually to 230. Significant improvements were made. A full-size gymnasium was constructed and additional recreational activities were added along with major improvements of the facilities. The camp's 21 acres included three-fourths of a mile of shoreline.

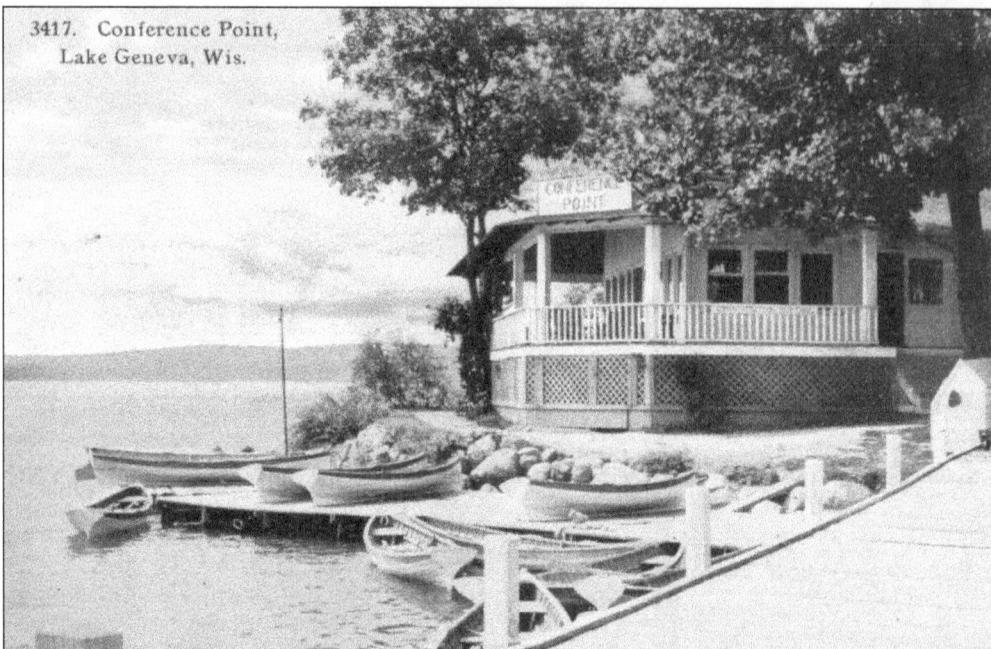

3417. Conference Point,
Lake Geneva, Wis.

Originally, the administration building and camp store were at lake level. There, guests registered and shopped before climbing the steps to their accommodations. When those buildings burned, the site was left empty. It then became a gathering place for campfires. (Courtesy of Joyce Falk Aspinall.)

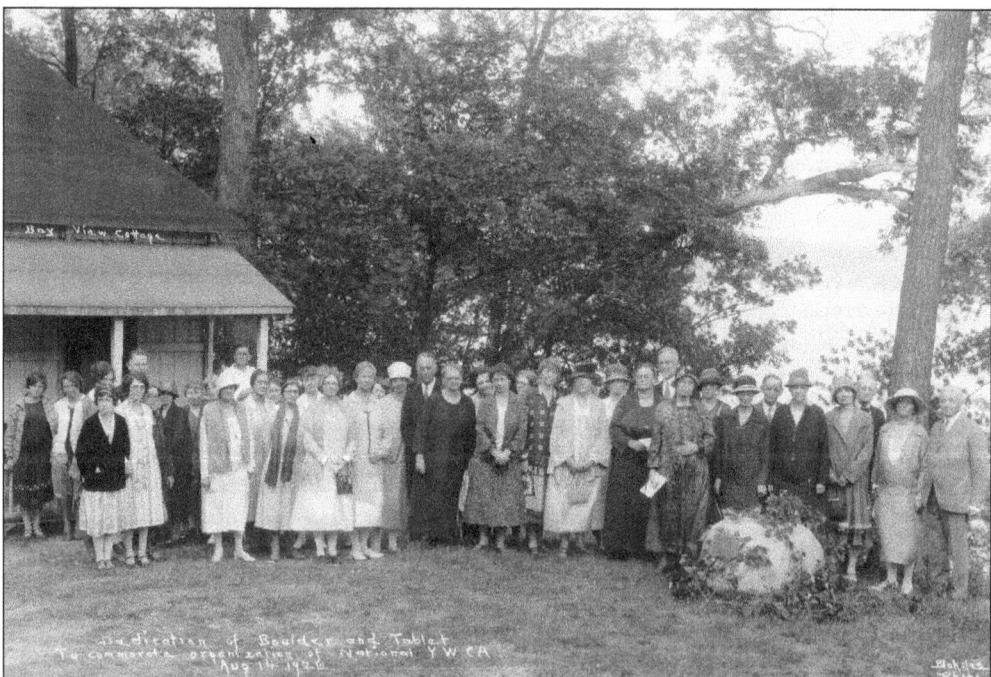

The YMCA camp, now George Williams College, got its start at Camp Collie in 1884. Two years later, the spouses and daughters of those men formed the National Young Women's Christian Association on the same grounds. (Courtesy of the Lake Geneva Foundation.)

10

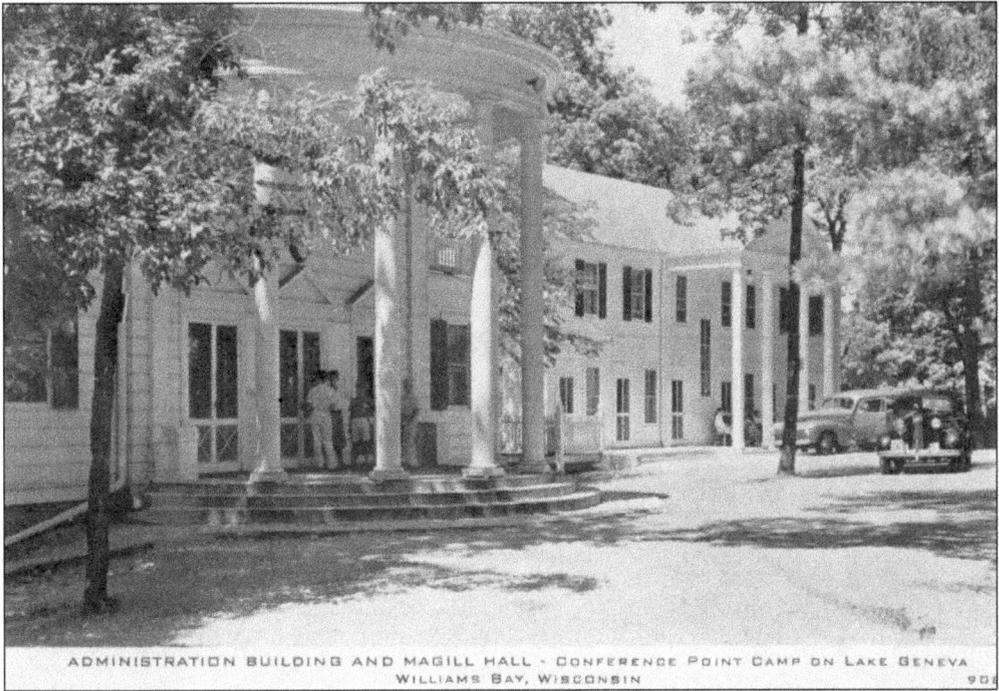

ADMINISTRATION BUILDING AND MAGILL HALL - CONFERENCE POINT CAMP ON LAKE GENEVA
WILLIAMS BAY, WISCONSIN 90

The new office (above) was constructed atop the hill, with a snack bar on the lower level. The dining hall (below) was a gift of J.L. Kraft, a frequent guest at the camp. Some of the equipment came from other sites. For instance, the ovens in the kitchen were taken from Oak Park High School. (Both, courtesy of Marilyn Smith Slocum.)

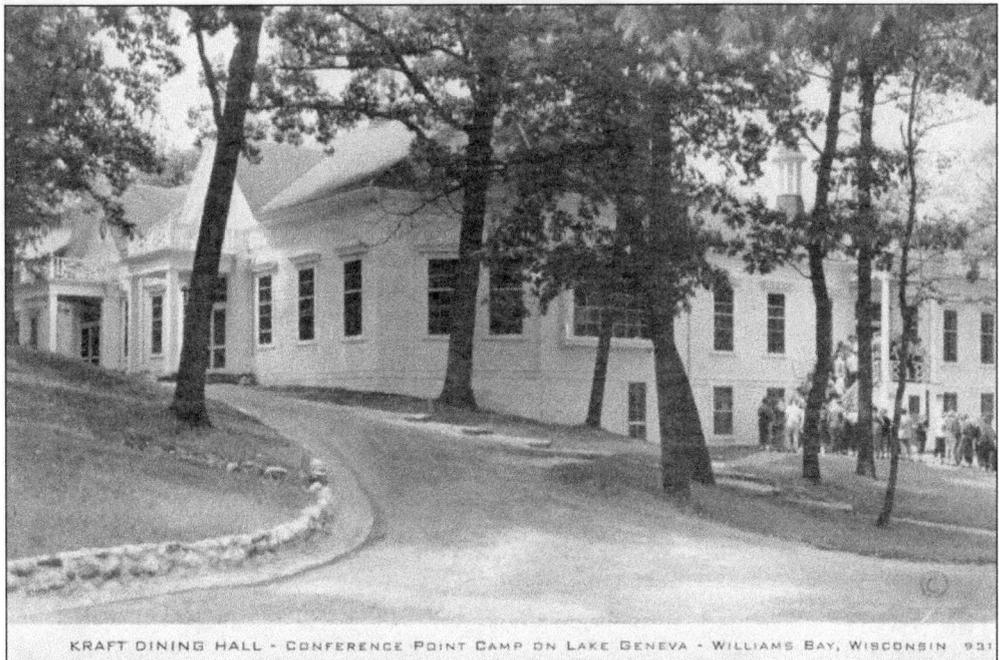

KRAFT DINING HALL - CONFERENCE POINT CAMP ON LAKE GENEVA - WILLIAMS BAY, WISCONSIN 931

11

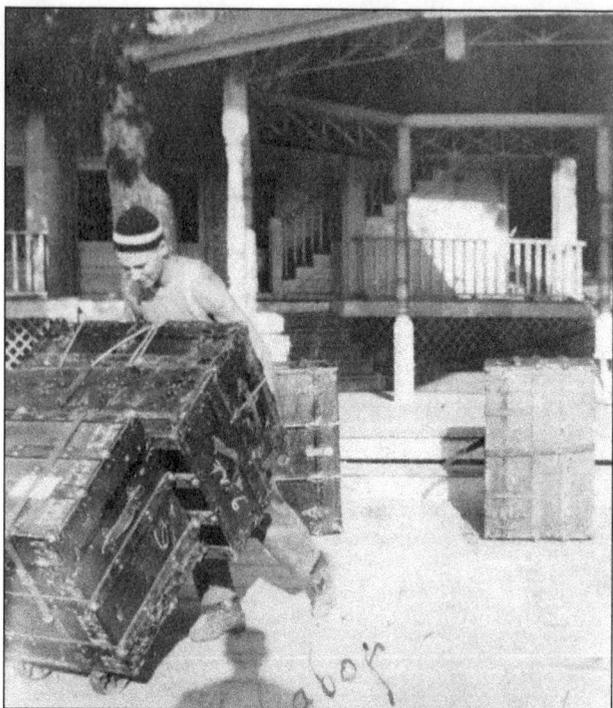

In 1914, Hiram C. Smith (pictured) and his mother worked at Conference Point. She was the bookkeeper and he performed a variety of jobs. For one of his jobs, he hauled the guests' steamer trunks off the boat and loaded them into the wagon. A horse pulled the wagon along a pier road, then up to the top of the property to deliver the luggage. (Courtesy of Peg Williams.)

Large gatherings at Conference Point met in a tent. Nearby was the kitchen and dining hall with an icehouse attached. Staff harvested the ice from the lake with the help of horses. After hauling the 200-pound blocks of ice up the hill, they hoisted the blocks into the icehouse, stacked them, and insulated them with straw and/or sawdust. (Courtesy of Peg Williams.)

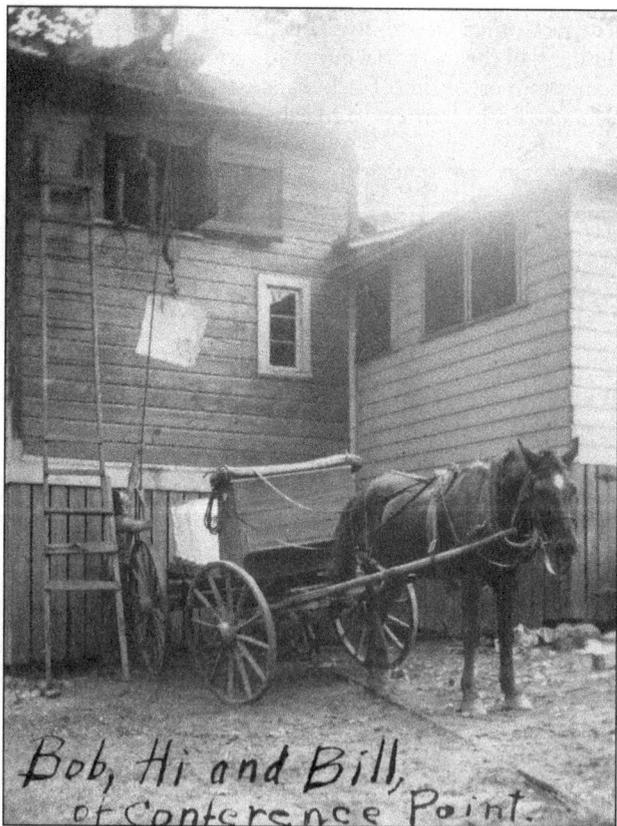

Bob, Hi and Bill, of Conference Point.

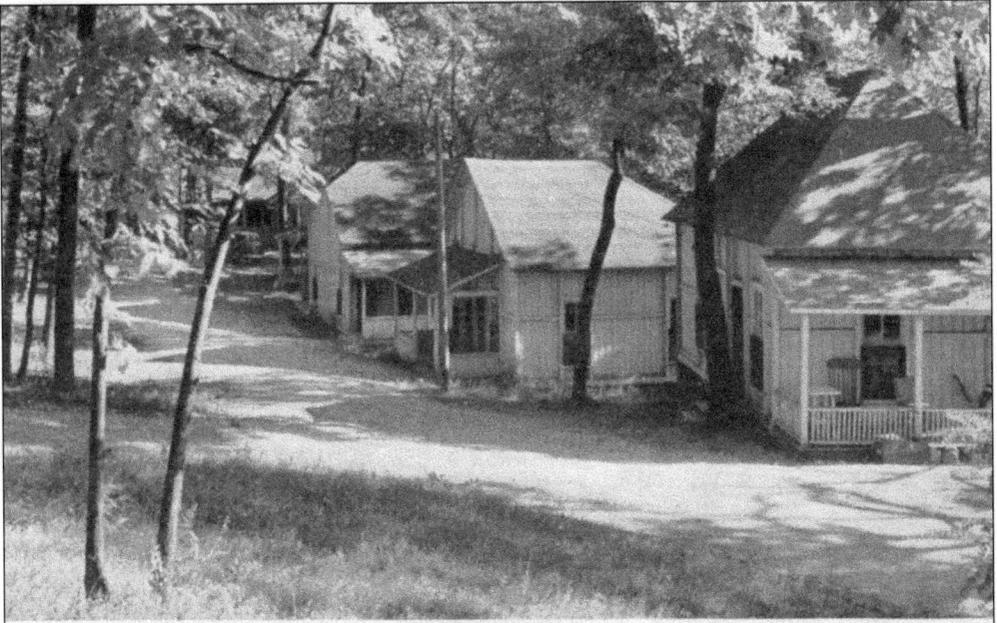

Guests slept in platform tents until simple cottages were constructed. Camps like Conference Point, which catered to educational programs, retreats, and families. But by the 1960s, people wanted more deluxe accommodations equipped with heating and air-conditioning—and of course, private baths. Air travel also became more affordable during the 1960s, allowing people to travel farther. (Courtesy of Jeff Smith.)

The laundry building was nothing more than a shed. In the laundry were deep tubs for washing clothes by hand. People rubbed their clothes with bars of strong soap against a scrub board, after which they hand rinsed everything twice. Next, they hand cranked a wringer to further rinse out the soap and water. After drying the clothes on a line, ironing was a must. (Courtesy of Peg Williams.)

13

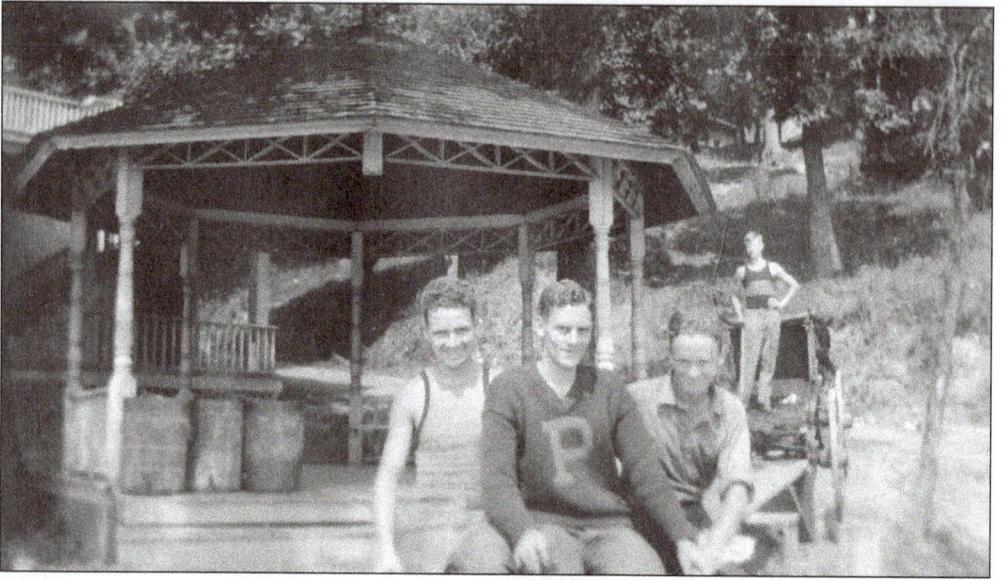

This gazebo was part of the W.J. Chalmer's estate, Dronley. After the Chalmers' daughter drowned in the lake, they sold Dronley to the camp because the memories were too painful. Dronley included the house, several outbuildings, and a small farm. For decades, the underground portion of the old fence posts popped up through the road in the springtime, reminding the staff of the past. (Courtesy of Peg Williams.)

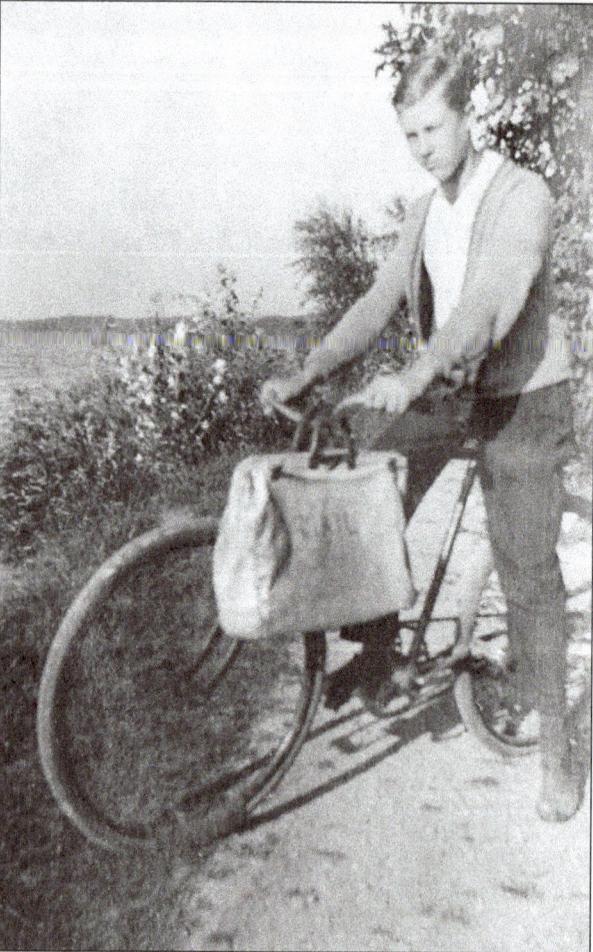

Mail came to Conference Point via boat or the post office box in town. The young man pictured here is carrying the mailbag on his way into Williams Bay to pick up the camp's mail. (Courtesy of Peg Williams.)

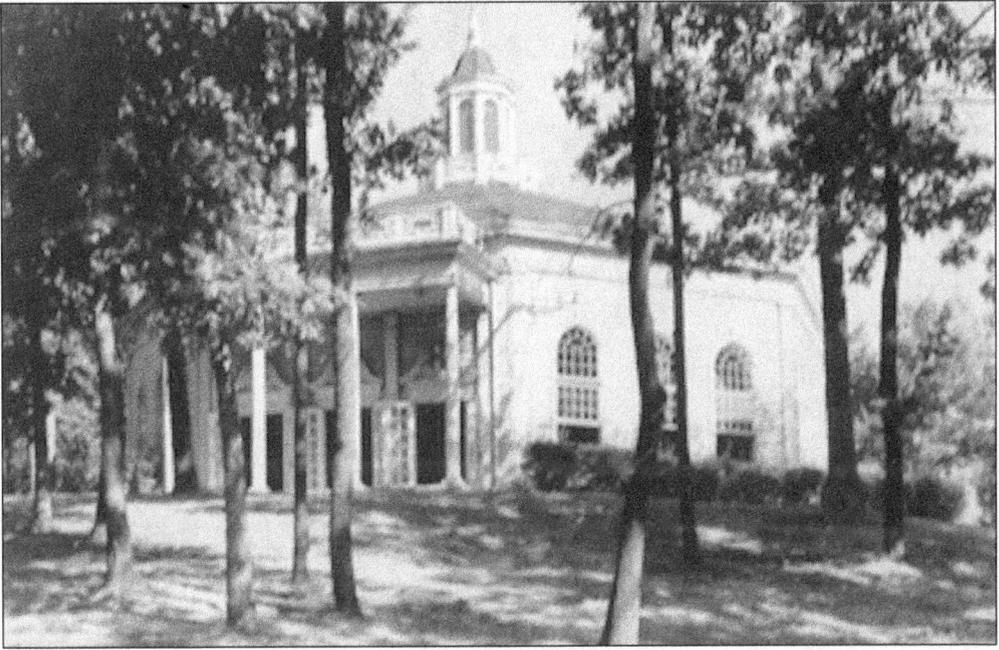

Nichols Chapel, built in 1925, was the center of the camp both physically and spiritually. People from the camp and around the lake area attended this octagonal chapel for Sunday services. S.B. Chapin, a board member and philanthropist, had flowers from his gardens delivered each week for the altar. (Above, courtesy of Marilyn Smith Slocum; below, courtesy of Joyce Falk Aspinall.)

Around 1915, Meg Smith came to Conference Point with five other teachers to escape the flu virus in Kansas. She worked as a waitress but had enough free time to enjoy the outdoors and fall in love with Hiram Smith. He proposed to her on Plymouth Rock. Subsequently, four generations descending from their union were able to pose on the rock. (Left, courtesy of Peg Williams; below, courtesy of the Westberg family.)

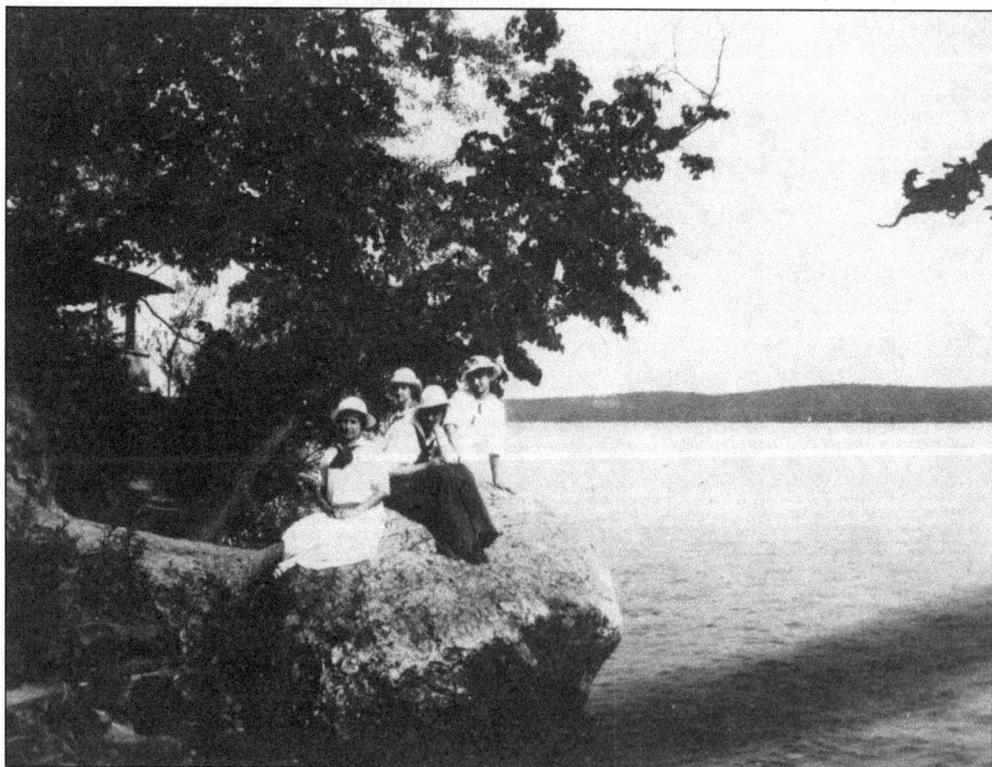

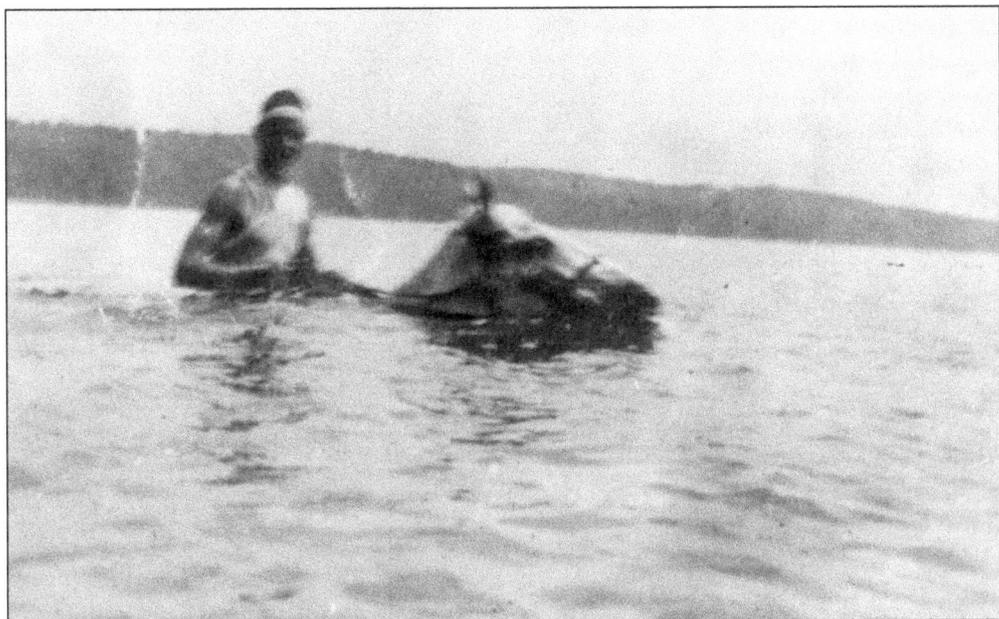

Salaries for employees at camp were minimal, but part of their compensation was free room and board. Most of the staff were college students—many were preachers' kids. It remained so until the 1970s, when more local teenagers were hired. The highest-valued benefit for the workers, including the horses, was their time off in the lake. As these photographs illustrate, they were creative in how they spent that time. Watching Hiram Smith dive off the *Aurora* must have been as much of a thrill for the passengers as it was for him. (Both, courtesy of Peg Williams.)

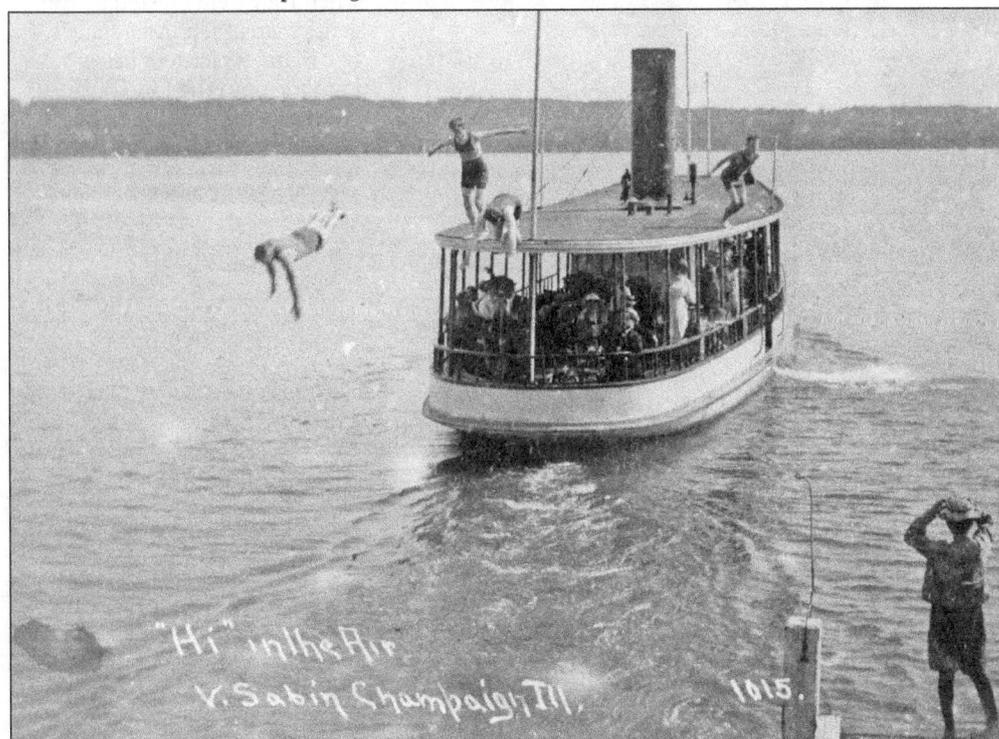

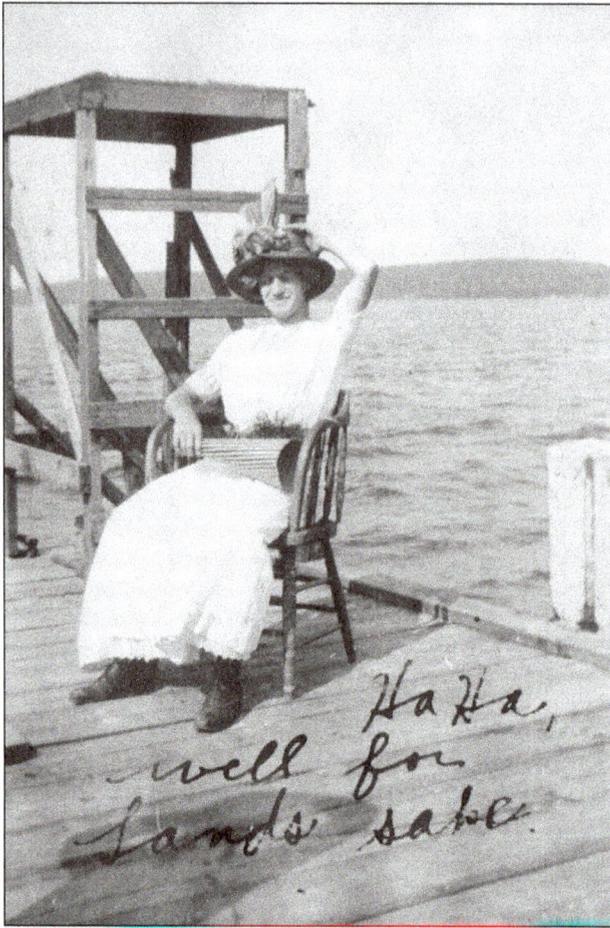

Ha Ha, well for Lands sake.

Camps were known for their antics, and Conference Point was no exception. Just imagine the surprise of the guests in 1914 when they were greeted by this gentleman at left. Meg Smith (far right) is pictured below hanging onto the log. (Both, courtesy of Peg Williams.)

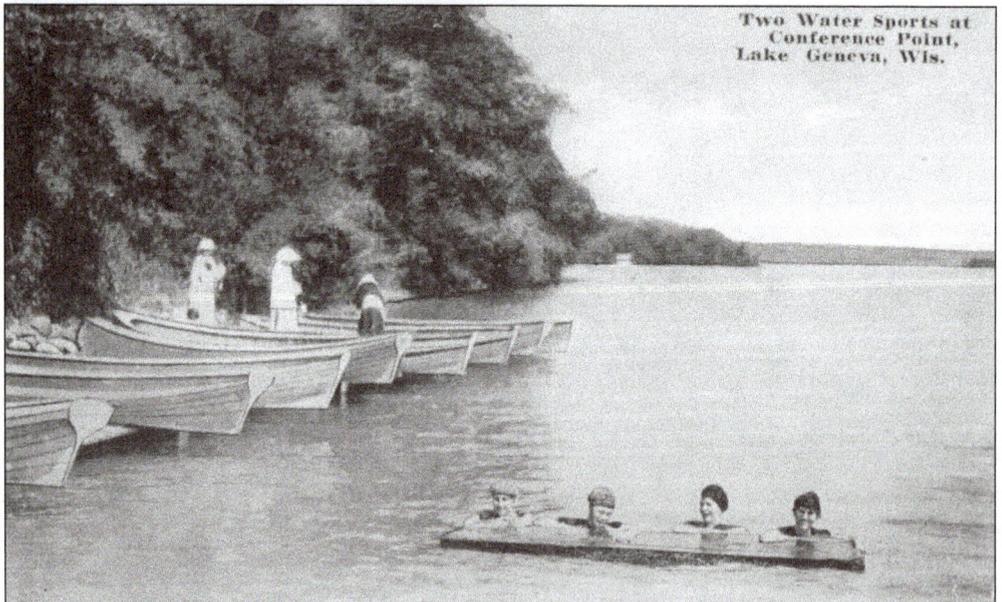

Two Water Sports at Conference Point, Lake Geneva, Wis.

Conference Point widened the lakeshore path so that there was adequate room for a horse pulling a wagon full of steamer trunks. Women were not supposed to be part of the baggage, but rules were broken. The *Harvard* was one of several public yachts that took campers into town for a night out or a little shopping. A round-trip ticket in 1939 from Conference Point to the town of Lake Geneva cost $1. (Courtesy of Peg Williams.)

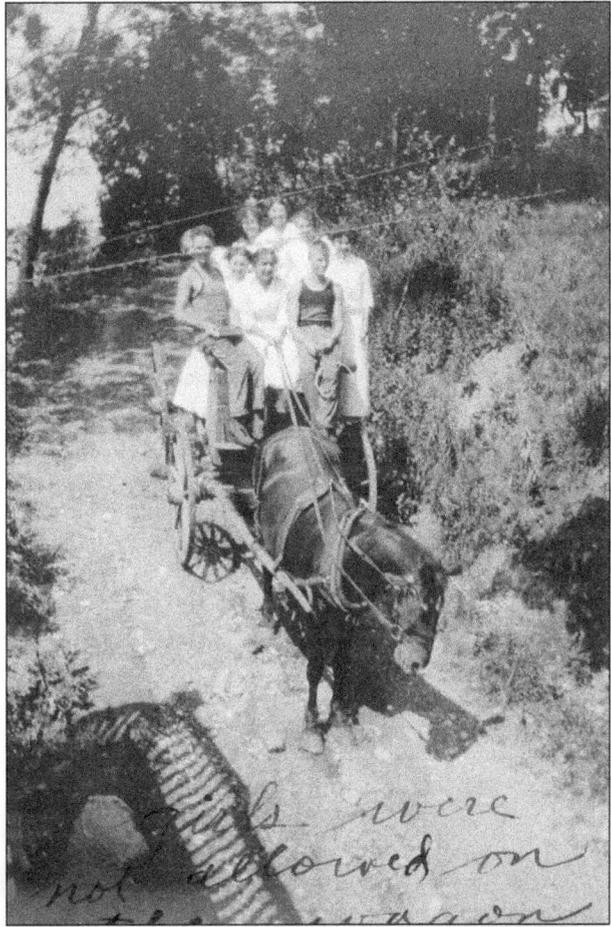

Activities on the pier might be similar to today, but the swimming attire was dramatically different then. Learning to swim had to be exhausting, especially for women in long, heavy woolen suits. Even though swimming suits were modest, when walking to and from their tents or cottages, swimmers were expected to cover up. (Courtesy of Peg Williams.)

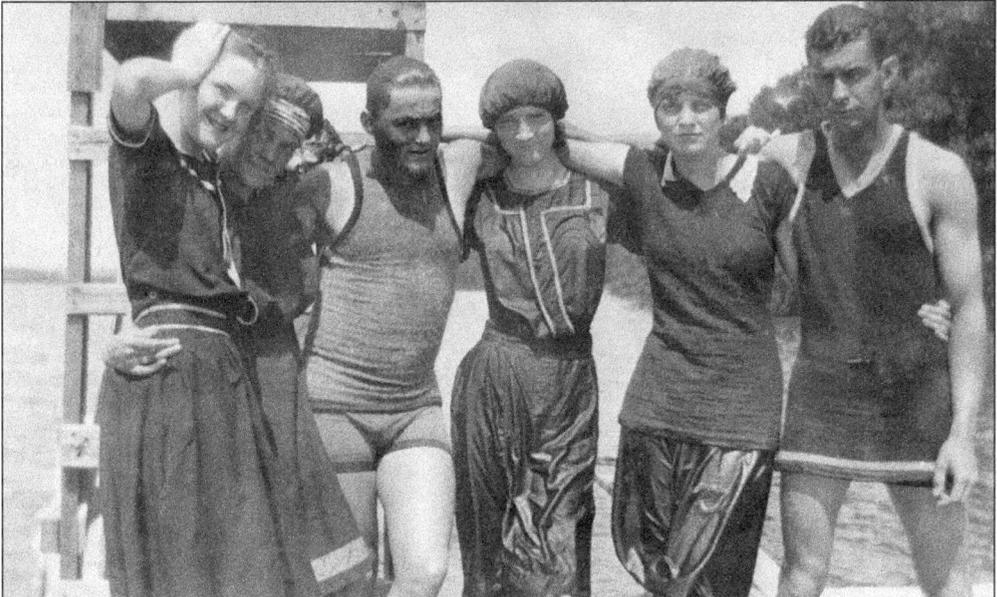

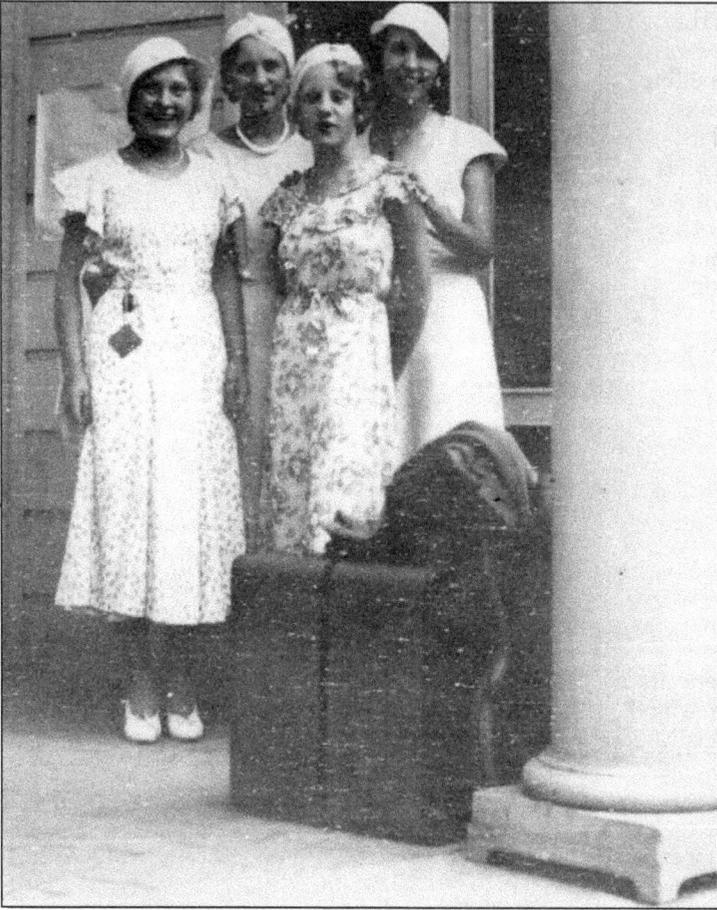

Bernice Erickson Falk (right) and friends are packed and ready to leave Conference Point after attending the High School Institute with the Epworth League from her Methodist church. In 1933, Bernice returned to the camp for the 25th anniversary of the institute. In 1957, she returned again, this time as a newspaper journalist with her young daughter Joyce in tow. Still enamored by Conference Point, she sent Joyce to Conference Point when she was old enough. Pictured below is a postcard Bernice sent from camp. (Both, courtesy of Joyce Falk Aspinall.)

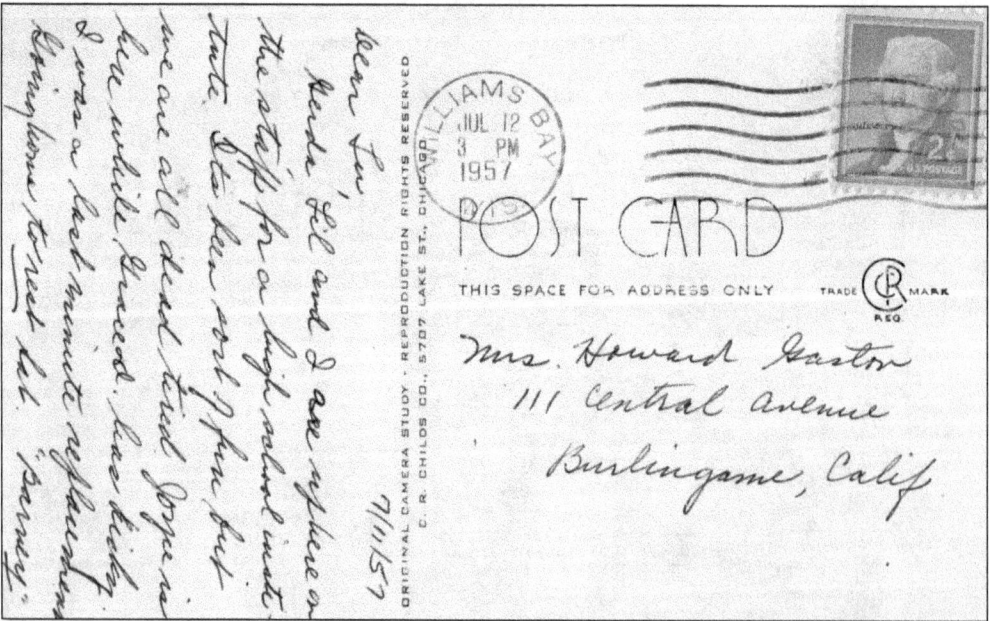

Two

Body, Mind, and Spirit
Western Secretarial Institute, YMCA Camp, College Camp, and George Williams College

George Williams College (GWC) has been known by many names—most reflecting a changing purpose and not a change of ownership. GWC began as a summer camp and institute for training the YMCA executive directors, then called secretaries. This camp was the brainchild of Robert Weidensall, the first paid employee of the national YMCA. In 1884, he convinced the leaders of the YMCA that providing education for the executive directors had merit. In addition to training, the camp served as a place where directors could exchange ideas and methods.

William E. Lewis, I.E. Brown, and Robert Weidensall are considered the three founders of what was initially named the Western Secretarial Institute. The first session of the institute was held August 4–18, 1884, at Camp Collie, now Conference Point. Including secretaries and their families, 57 people attended this session.

In February 1886, the institute bought four acres west of Camp Collie for $3,000. This site was chosen, in part, because of the spring running into the lake, ensuring clear drinking water.

The third session of the institute was held near Camp Collie in 1886, which was also the year earmarked to prepare and dedicate its new campground. For what was dubbed a "Clearing Bee," every man at the session was handed an axe. They then hiked the shore path from Camp Collie to the new campground, clearing much of the land. On the evening of August 12, they celebrated with a dedicatory campfire and prayer meeting on the hill above the spring, where 19 men signed their names on a piece of birch bark, commemorating this significant event.

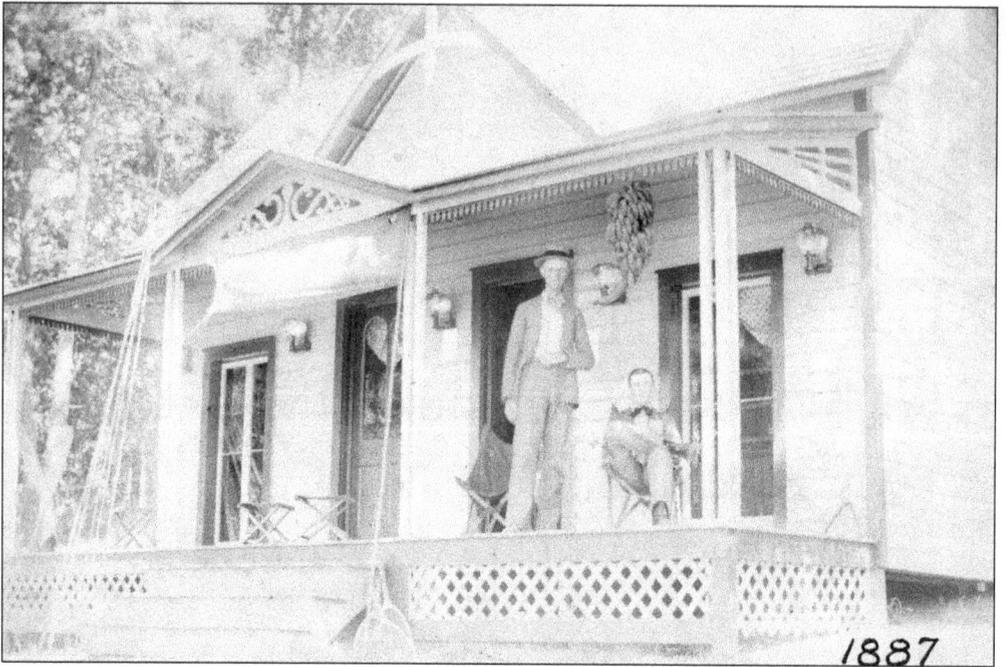

By the summer of 1887, the new camp was ready for visitors. A cottage with a porch across the front housed the administration office. Soon after, a second cottage was added for receiving people at the campground. (Courtesy of GWC Archives.)

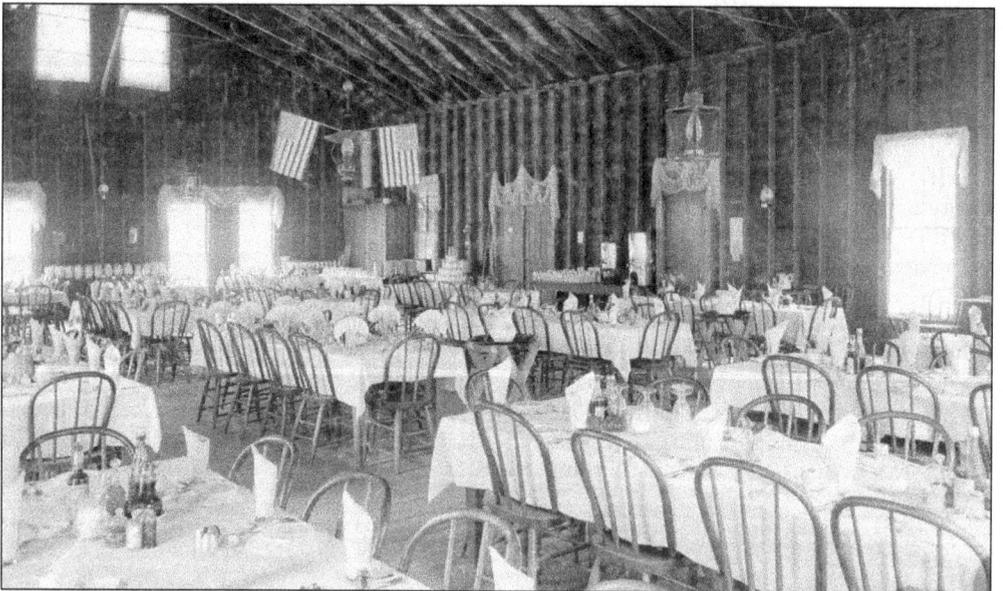

The camp had a lean-to kitchen with a dining room that seated 200 people. In the first year, guests sat on planks resting on logs. The icehouse stood behind the kitchen. (Courtesy of GWC Archives.)

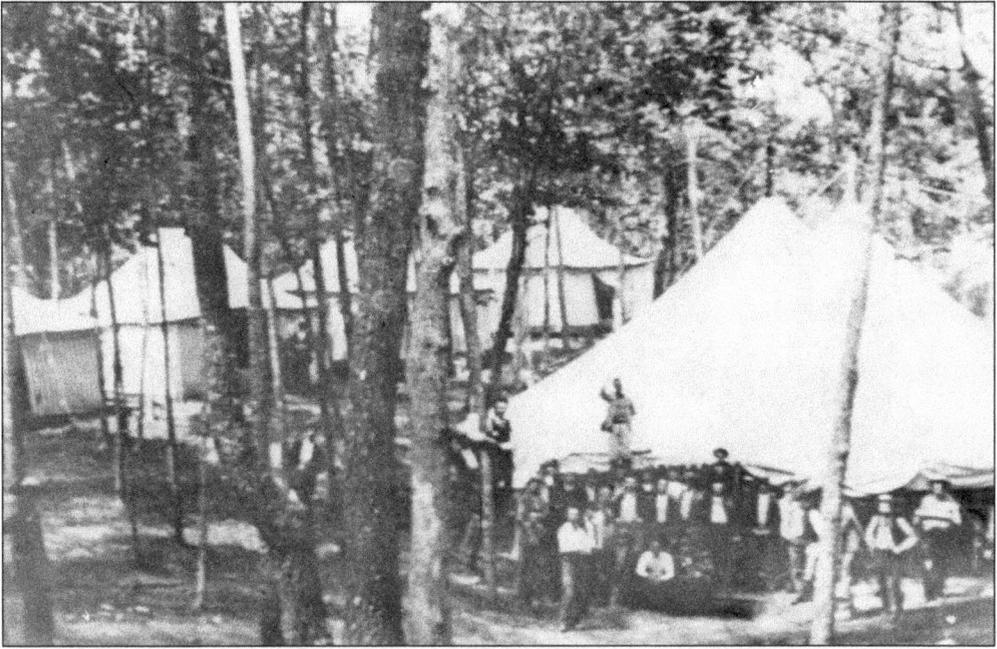

A huge tent, dubbed the tabernacle, served as the only sheltered classroom. Other classes were held outside with students seated on wooden folding chairs. As the lake grew more popular, students were often distracted by the "infernal noise" of motorboats. Once during a worship service, a student listened while dangling his fishing line in the water. He felt a tug on his line and pulled out an eight-pound bass. The men at the worship service burst into laughter. Another setting was clearly needed for outdoor worship services, this time away from water and distractions. (Both, courtesy of GWC Archives.)

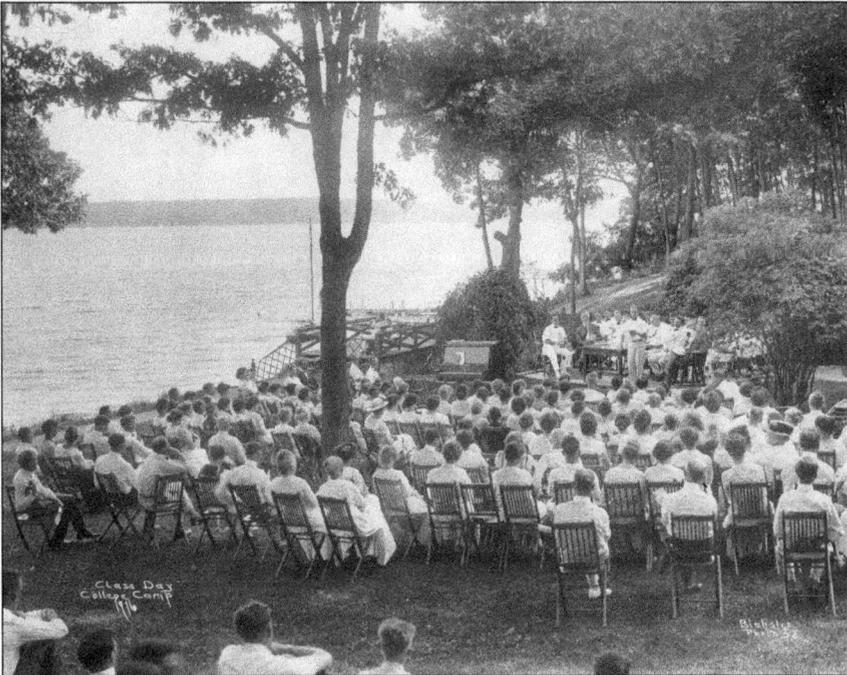

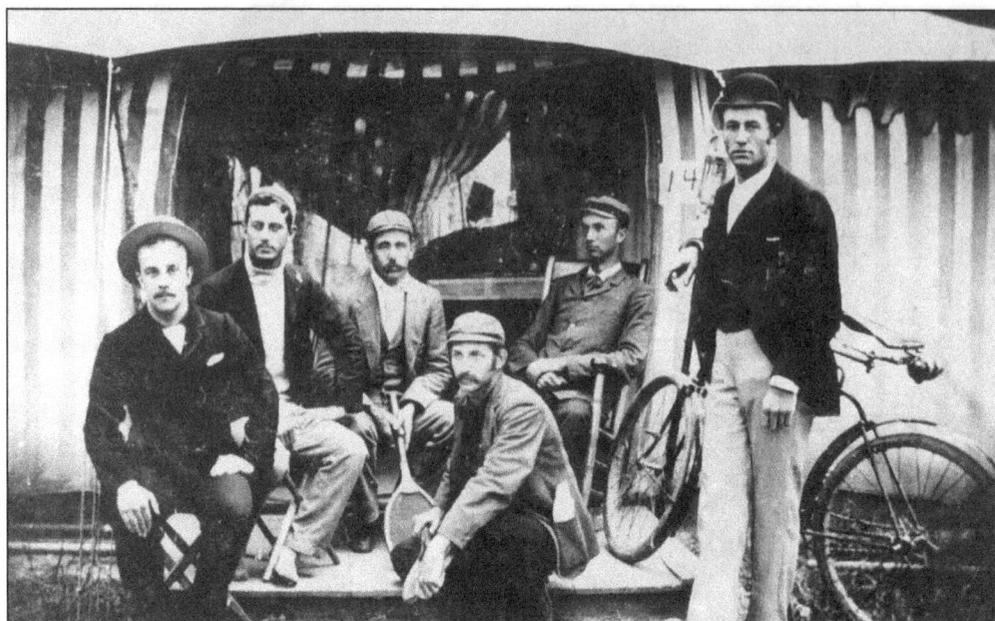

Accommodations went from 20 striped platform tents the first season to 75 tents and five cottages by 1907. Each tent had four bedrooms and a sitting area. Snoring and rustling of sheets could be heard as people in other rooms tossed and turned. Christy Muse remembers that if it rained, the person on the top bunk had to roll to one side to avoid raindrops seeping through the canvas. She and her sisters argued over who would have to sleep on the top bunk. A few tents remained in the early 1960s for the guests who preferred tents to cottages. These photographs compare tenting life in 1892 and 1960. (Above, courtesy of GWC Archives; below, courtesy of the Gross family.)

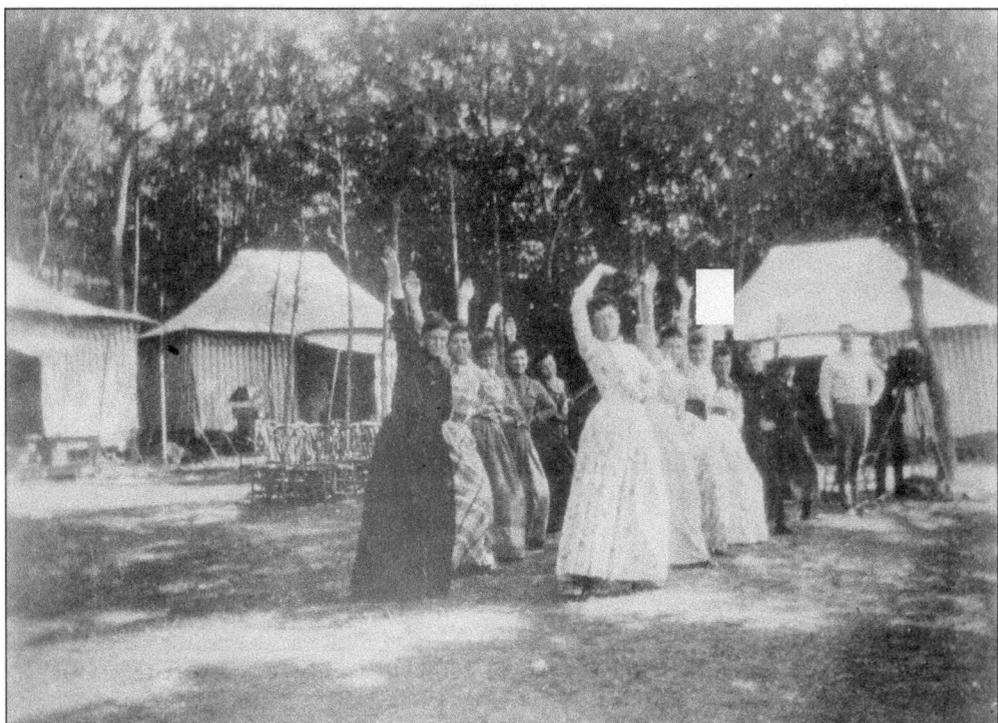

During the first year, the camp lacked athletic equipment. Since it was a YMCA camp, there was a strong emphasis on keeping fit. The instructors improvised exercises without equipment, or they had students make their own. The women's gymnastics class pictured here is from 1890. For a "wand class," the men fashioned wands from tree branches. In 1898, when a new dining room was built, the original dining room became a gym. (Both, courtesy of GWC Archives.)

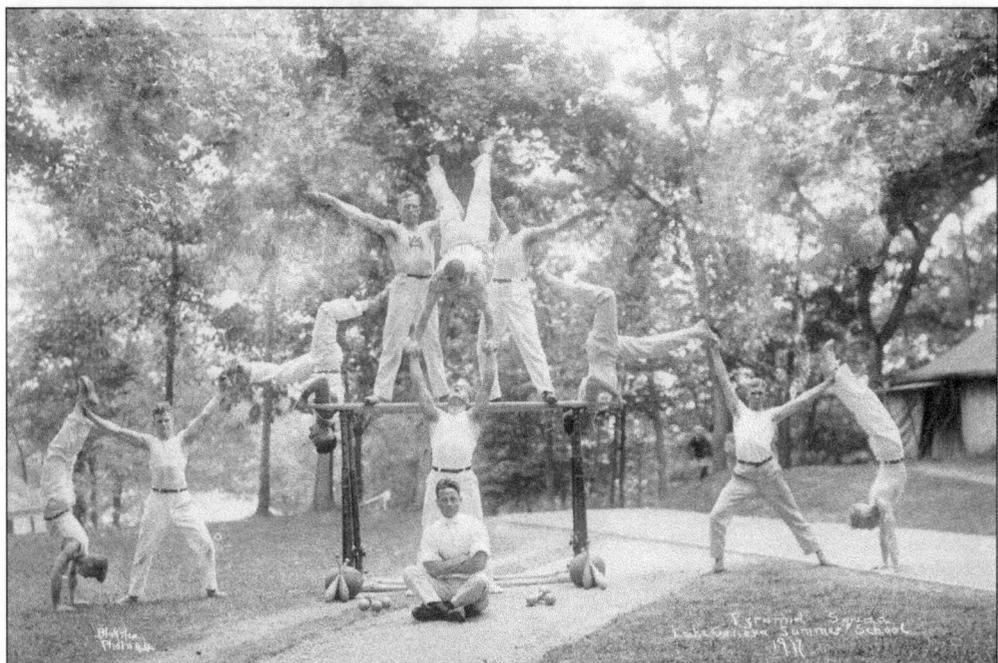

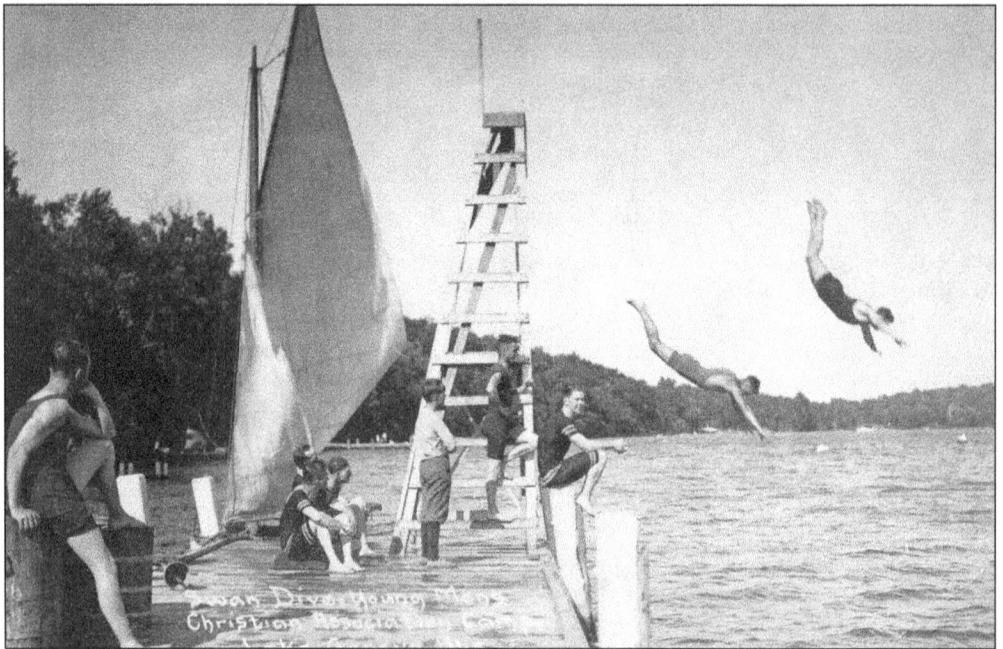

In addition to the more serious work of academic and athletic classes, there was free time. Campers took out the rowboats, swam, and sailed. On land, they hiked and played badminton, tennis, and baseball. They also picnicked. Room and board cost $1 a day in 1889. O.E. Johnson (foreground) is pictured below playing tennis in 1912. (Above, courtesy of GWC Archives; below, courtesy of the Westberg family.)

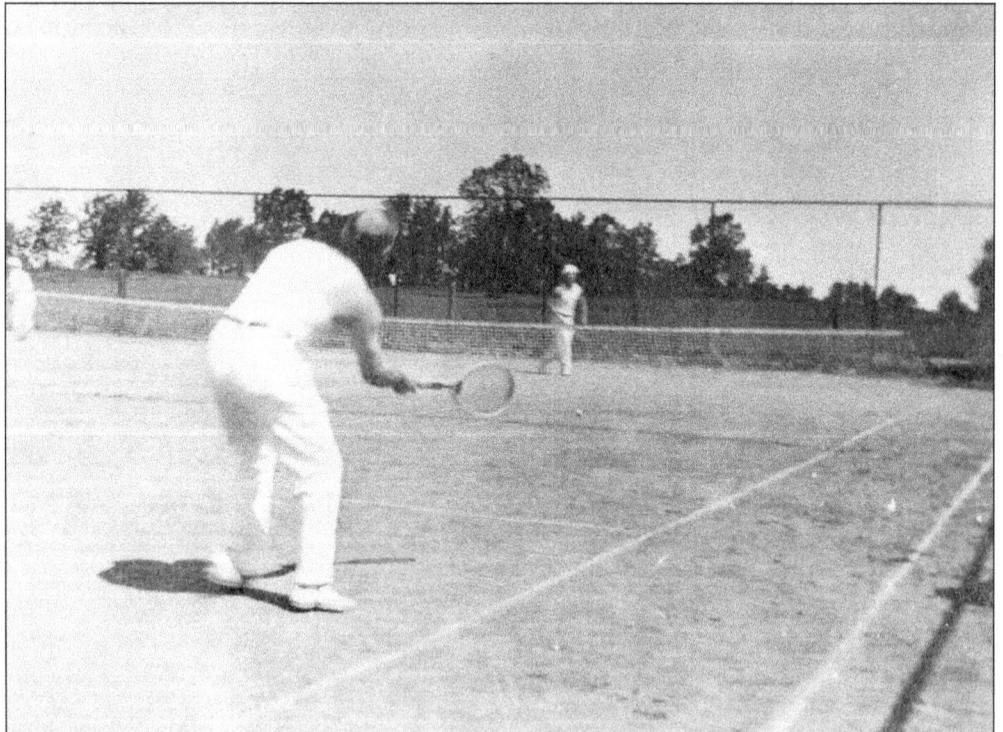

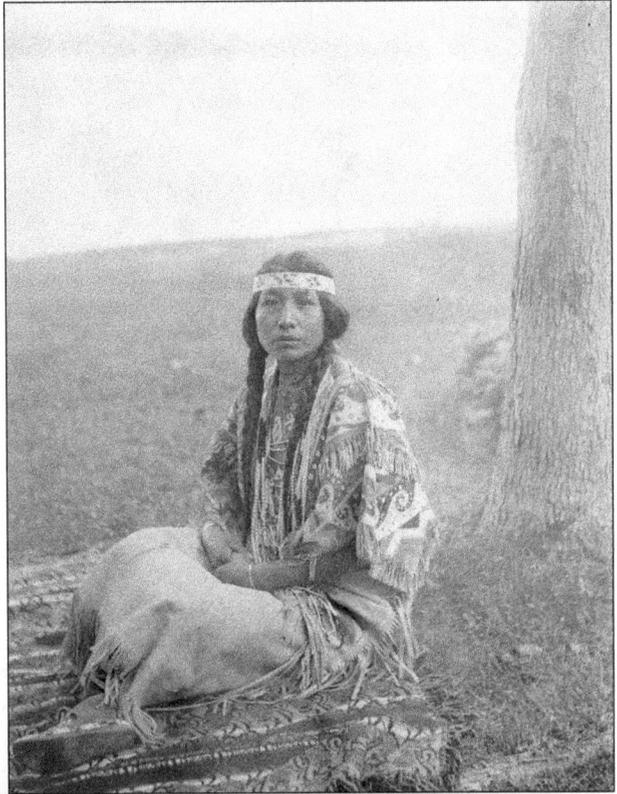

The camp welcomed all people. In 1890, a Sioux woman, Susie Bearchief, attended the YWCA conference. George Washington Carver was a student at the Y Camp during the summer of 1893. Not all of the campers were comfortable with including nonwhites. When asked about this, R.C. Bell responded, "They came with the narrow nationalism and race-prejudice; they went away with new ideals of genuine brotherhood." The year 1890 was known as a period of expansion. In addition to the changes on Geneva Lake, a year-round school was established in Chicago for training YMCA directors. This eventually led to a fully accredited liberal arts college. (Both, courtesy of GWC Archives.)

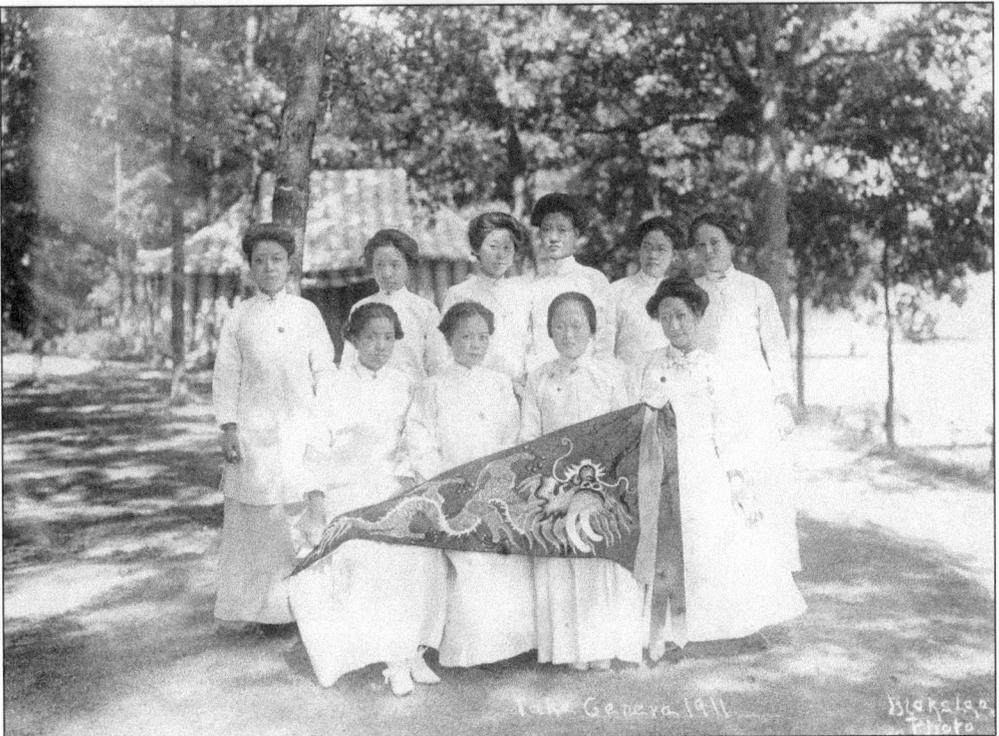

In 1890, a small octagonal springhouse was built. Inside it hung a tin ladle for drinking. "One had to step down upon a concrete slab, take a tin ladle, and reach for the water in the spring basin." In 1912, the springhouse was replaced with a five-cup bubbler because state law forbade drinking from a common cup. (Above; courtesy of GWC Archives; below, courtesy of Tom McReynolds.)

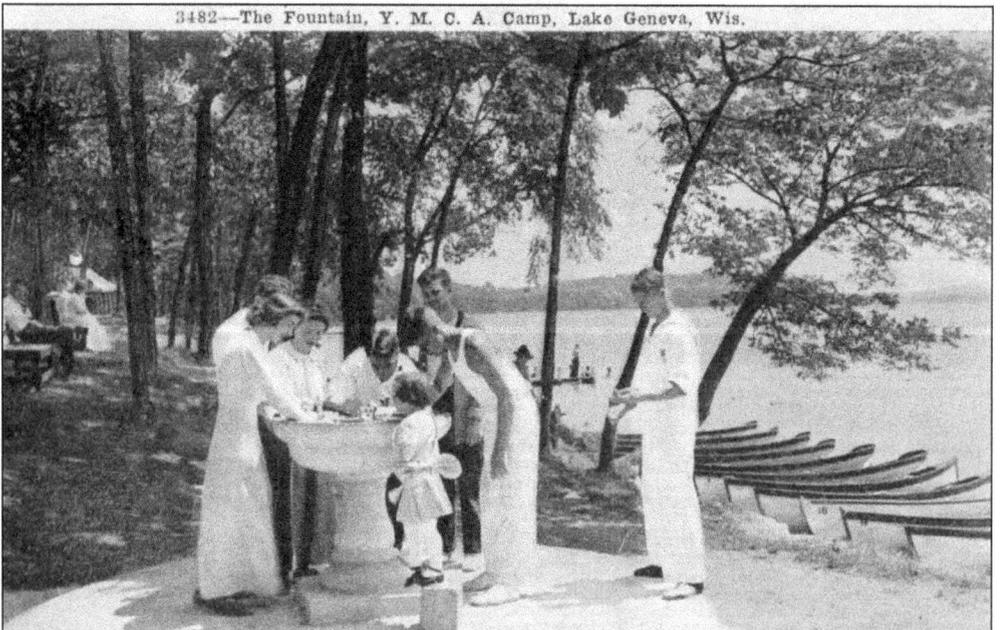

3482—The Fountain, Y. M. C. A. Camp, Lake Geneva, Wis.

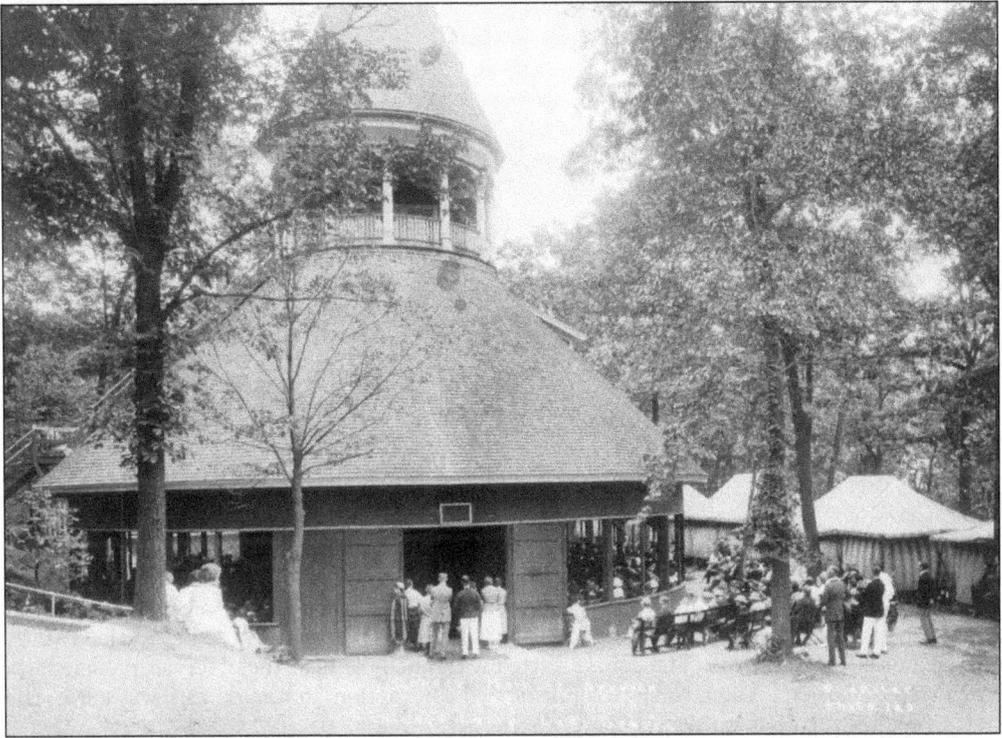

Lewis Auditorium was erected in 1890, replacing the large meeting tent. In the cupola that rose above the trees was a small room. This was reached from the outside by climbing a ladder fixed to the roof. The room's window provided a spectacular view of the lake. Another ladder inside the cupola went to the 250-pound bell and the flagpole. The building's unique design became a symbol of the Lake Geneva campus, appearing on everything from promotional literature to place mats. (Courtesy of GWC Archives.)

In those early years, recreation came to a standstill on Sundays, when the worship service, which featured many nationally renowned ministers, was highlighted instead. Guests from around the lake came by steam yachts (and later by cars) to attend the services. People from nearby camps and homes walked the shore path to attend. After the service, an elegant Sunday dinner was served, often with musical entertainment. (Courtesy of GWC Archives.)

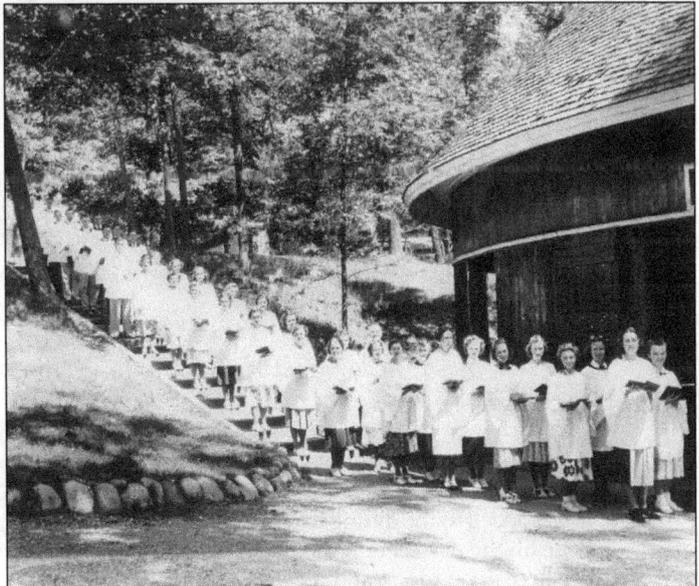

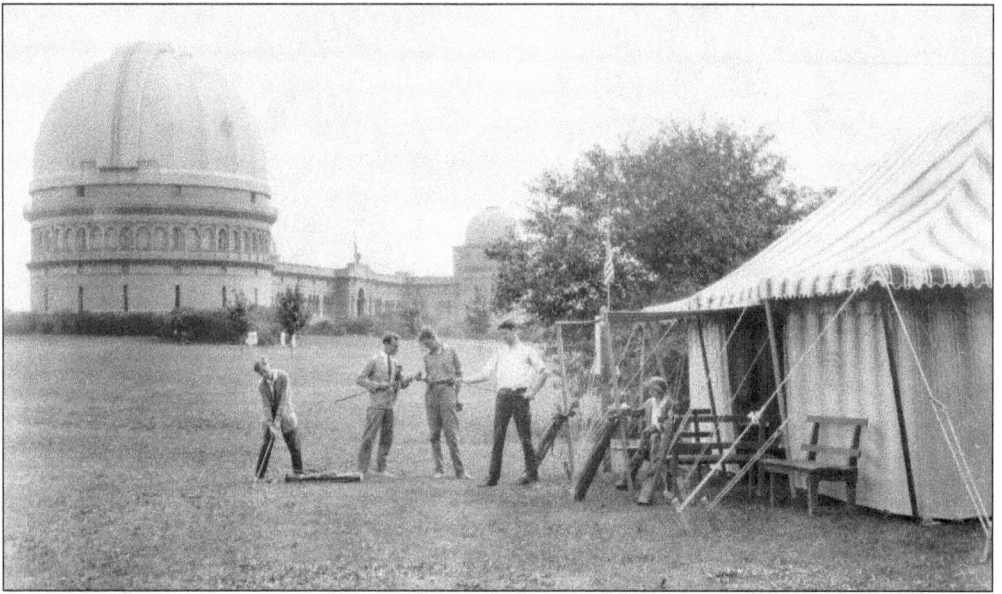

In 1890, college president John W. Hansel envisioned a golf course on the property. Dr. Edwin Brant Frost, director of Yerkes Observatory, shared his enthusiasm. And so began the YMCA Kish-Wau-Ke-Tok Golf Club. The course started with one hole near the observatory—merely a tiny pit in the ground. Later, "a more sophisticated contraption," a tomato can, was put in the hole to catch the ball. (Courtesy of GWC Archives.)

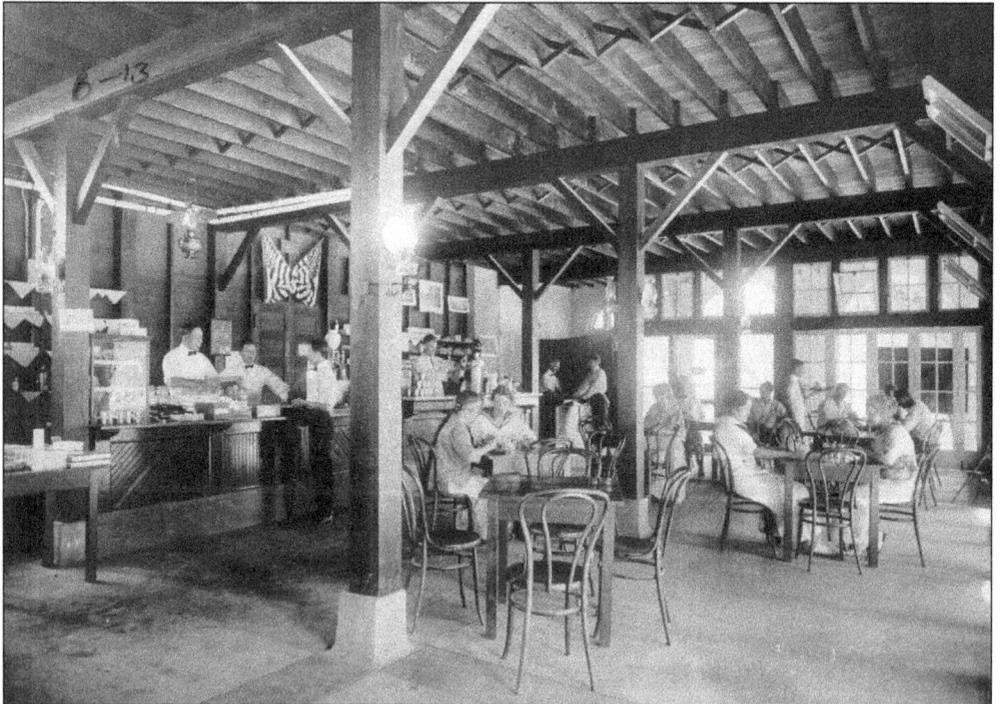

A new room was added to the dining hall in 1912. With that addition, 600 people could be seated at one meal. Beneath the new section was a refectory (College Inn), physician's office, photographer's office, barbershop, linen room, and a grocery room. (Courtesy of GWC Archives.)

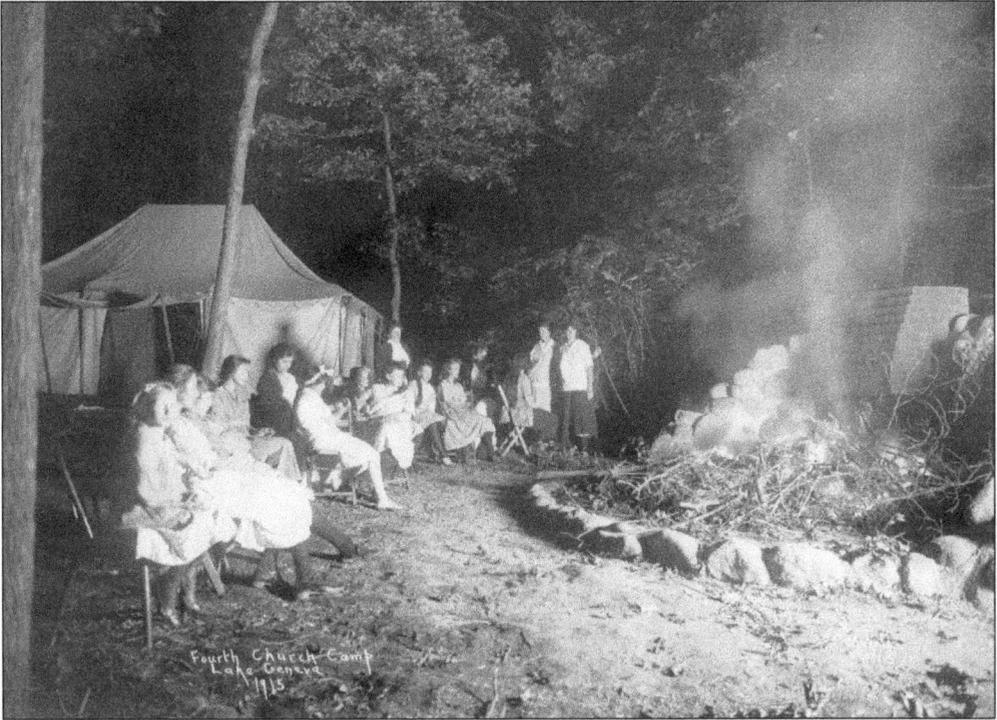

Fourth Presbyterian Church in Chicago had a camp called Fourth Church Camp, which was east of College Camp on the other side of Yerkes's lakefront property. Opened in 1915, it had 350 feet of lakefront and six buildings, including a dining room. The women's dormitory was named Eagle's Nest after the golden eagle that hung opposite the big stone fireplace. Across the ravine was a tent city; each tent was named for a person in the church. Guests pitched their own tents behind the cottages. In 1921, College Camp purchased Fourth Church Camp and dubbed it East Camp. Yerkes allowed College Camp to make a lighted path and stairway through its woods, which stood between Main and East Camp. (Above, courtesy of GWC Archives; below, courtesy of Fourth Presbyterian Church.)

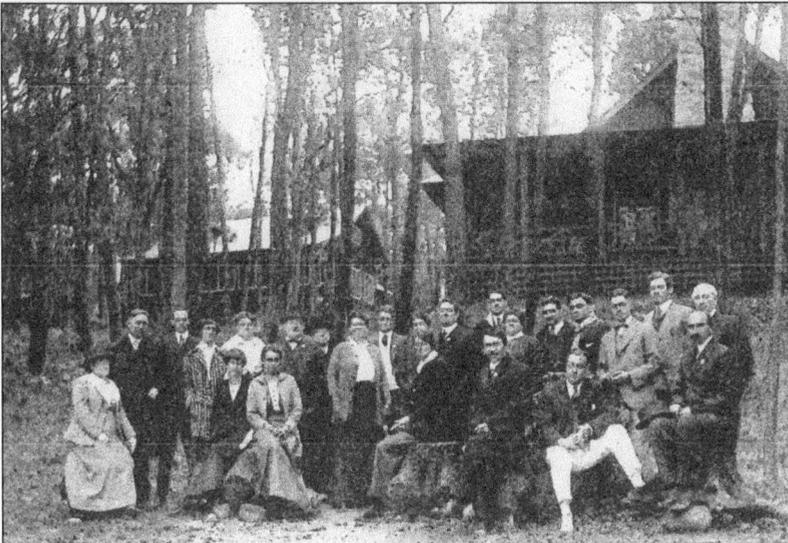

The Women's Building was dedicated in 1926, creating a space for reading and contemplation. But the name was off-putting for men. They used it as an excuse to skip Bible study and play golf instead. As a result, the building was renamed Mabel Cratty, for the first general secretary of the YWCA. A rededication ceremony took place in 1937, featuring reflections written and read by Margaret Mead. (Courtesy of GWC Archives.)

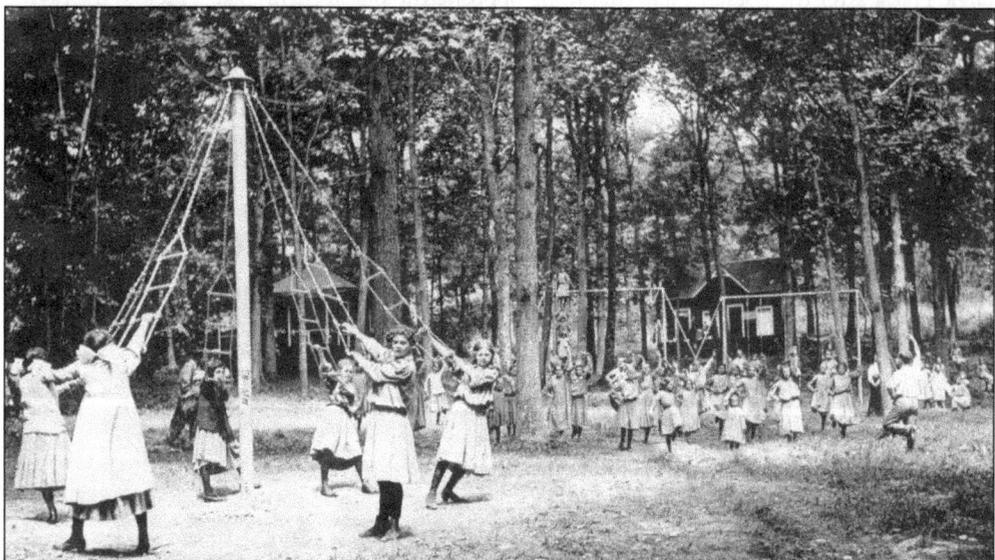

College Camp focused on families. The Ingalls Children's Building housed programs for young children. Older children tried their skill with archery, worm hunting, and campouts. Adults played golf or participated in the discussion groups. In the afternoons, the lakefront teemed with swimming and boating—when the sun was not quite as hot, tennis and hiking. College Camp was an ideal setting for children to roam free, day and night. (Courtesy of GWC Archives.)

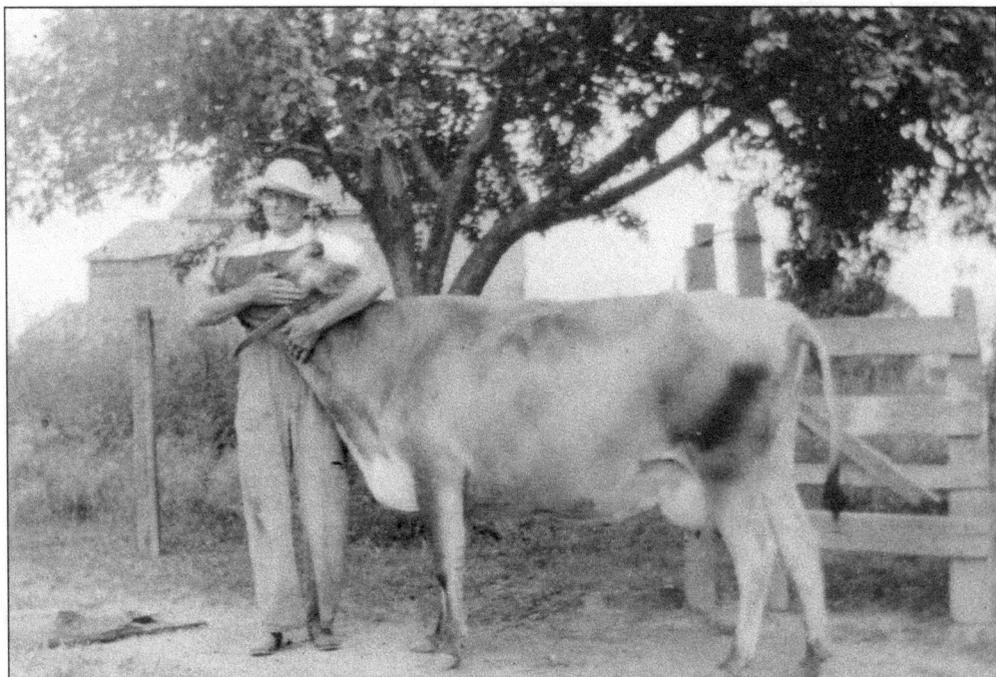

Peter King recalls his great-grandparents' cow, which attended camp every summer. Jay Lyon (pictured) was the camp's attorney. In lieu of payment, the family spent the summer in a tent at East Camp. Naturally, they brought Bess, their milk cow, with them. After school let out, Will Lyon, Peter's grandfather, walked the family cow from Elkhorn down Highway 67 to College Camp. (Courtesy of Doug Lyon.)

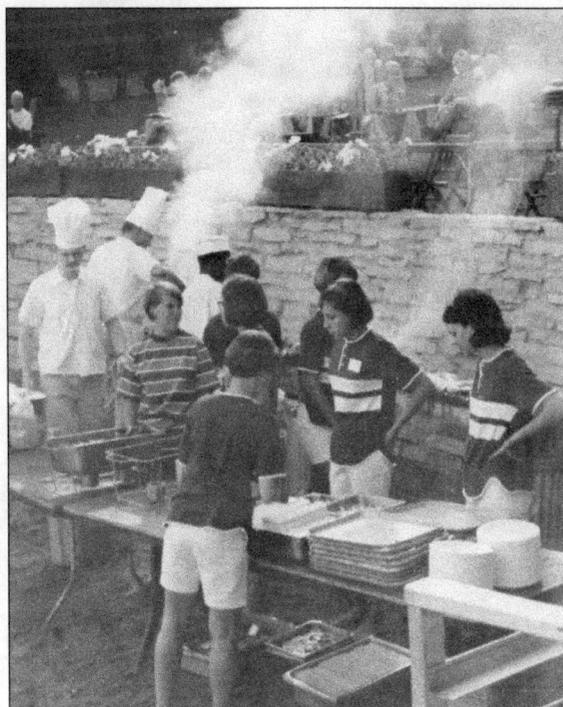

College Camp flourished because of its dedicated staff. Many considered the campus to be sacred, or hallowed ground. They cared for the camp as though it was such, giving of themselves beyond expectations. They watched out for each other as though family. They celebrated marriages and births together. They helped raise each other's children. And during the sad times, they gave strength and support to one another. (Courtesy of GWC Archives.)

Carolyn Gramley worked at the camp from 1961 until 1985. She claims the camp was held together with chewing gum and thumbtacks. Before summer employees arrived, Gramley ran the golf course in addition to her duties as camp director. She managed the camp between flipping hamburgers and registering people for golf. (Courtesy of GWC Archives.)

The employees fixed whatever was thrown their way. When new structures were built, employees installed the plumbing and the wiring rather than hiring outside contractors. When some guests cooled their illicit wine in the toilets, resulting in labels soaking off, the maintenance men routed out the plumbing. Pictured is the year-round maintenance staff. Janis Plisis is front and center. (Courtesy of GWC Archives.)

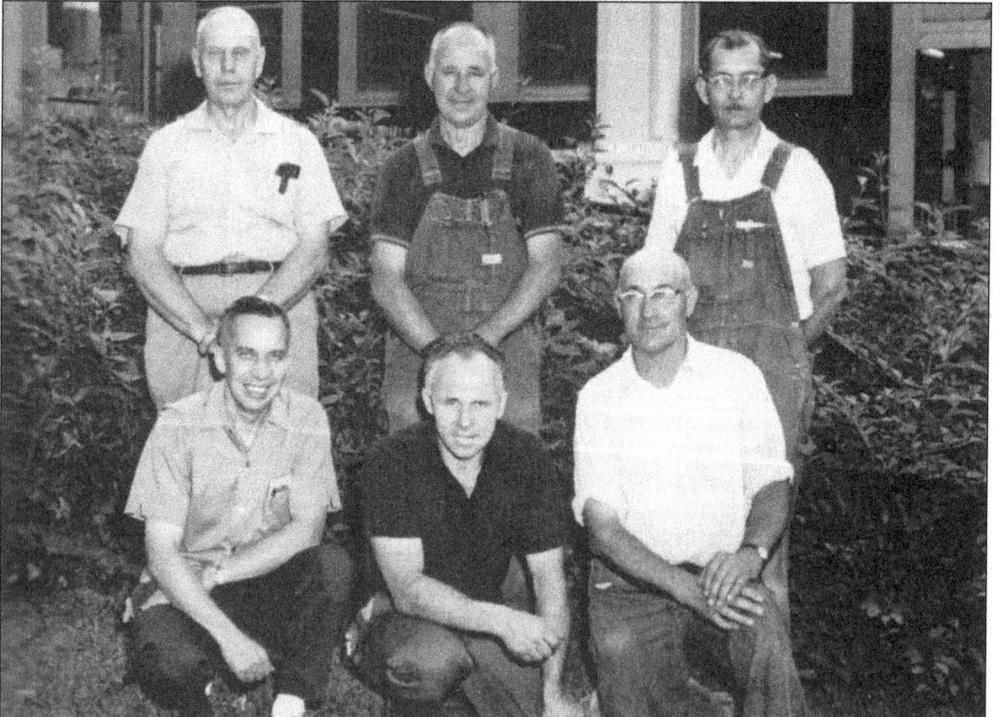

Energetic college students from around the world maintained College Camp during their summer breaks. Once they finished preparing food, cleaning tents, or making lanyards with children, they were free to enjoy the pleasures of the lake. Someone described it as a camp for the staff. Al Palfi and Jim Philan, employees from 1947 and 1948, described it as an "immersion in community." It was "romantic, intellectually stimulating, religious, and friendly." Susan Settlage (left) and Nancy Monsees are pictured in 1968. (Courtesy of Peter King.)

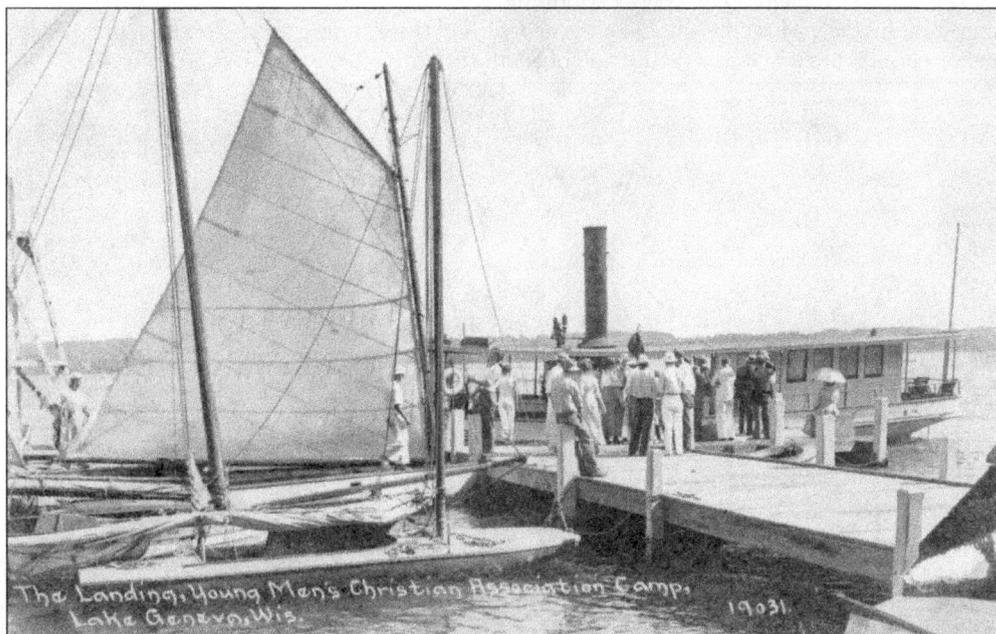

College Camp had its own yacht club. Founded in 1892, its mission was "to promote interest in sailing for both guests and employees." By 1928, there were five sailboats—*Martha Jane, It, Spray, Masquerader,* and *Whitecap.* Races were held every Friday afternoon. Some employees, like Bill Bentsen, raced with the Lake Geneva Yacht Club. He crewed for Harry "Buddy" Melges in the 1972 Olympics, when they won the gold medal. (Courtesy of GWC Archives.)

Musical entertainment for the public was a highlight of College Camp. It began with a talent show in the early 20th century. By 1933, there was a Sunday evening musicale with professional classical musicians. A choir was formed using the college employees. Sunday noon dinners became more elegant with small vocal groups performing. Starting in the late 1950s, College Camp offered musicals. In 1951, Music by the Lake opened with classical music and internationally known performers. Pictured here is a production of *South Pacific*. (Courtesy of GWC Archives.)

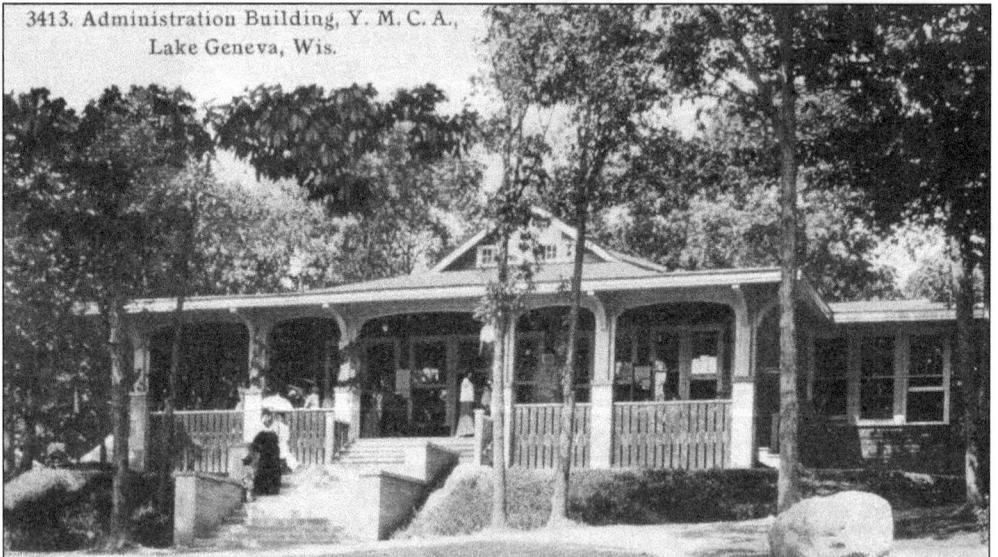

3413. Administration Building, Y. M. C. A., Lake Geneva, Wis.

Since the 1950s, George Williams College has hosted conferences, families, outdoor education, camps for people with disabilities, and academic classes. Today, as a campus of Aurora University, GWC offers service-related degrees and programs, as well as a conference center. Music by the Lake and a speaker series featuring leaders in arts and ideas are still part of the campus. (Courtesy of Joyce Falk Aspinall.)

Three

OPPORTUNITY FOR
CLEAN AIR
HOLIDAY HOME CAMP

Not many camps are dreamed up while boating on a steam yacht. Holiday Home Camp was, or so the story goes. Emma Ayer summered on Geneva Lake, and one warm afternoon in 1887, she and her friends were discussing how lucky they were to be away from the city of Chicago in the summer. Most of these women were connected with Chicago's settlement houses (in particular Hull House), and they clearly understood that the lives of people in the city were often grim. In a day when Chicago was highly polluted and children worked in factories and sweatshops to help eke out a living for their families, these women dreamed of a respite on Geneva Lake for children from economically disadvantaged communities.

Word spread. Many of the women who summered on the shores of Geneva Lake, along with their husbands, joined the Lake Geneva Fresh Air Association to establish Holiday Home Camp. People agreed that a camp where children could escape the noisy and dirty city streets for two weeks could improve their lives. By autumn, they had raised $8,000 to purchase property on the north shore of the lake, including 275 feet of lake frontage. Holiday Home opened on July 5, 1888.

All campers attended free of charge. Supporting Holiday Home became a community effort. Produce was donated from the farms and estates. Parties and games for the children were held at other camps, estates, and housing associations. The doctors from the YMCA Camp helped out in emergencies. Astronomers from Yerkes lectured. Children from around the lake collected their pennies or raised money by selling flowers so they could contribute to Holiday Home. Musicians volunteered to perform for the children.

Camping at Holiday Home taught values and skills necessary for a healthful and successful life. For children who were not well, the clean, outdoor environment aided in recuperation. (Courtesy of Holiday Home Camp.)

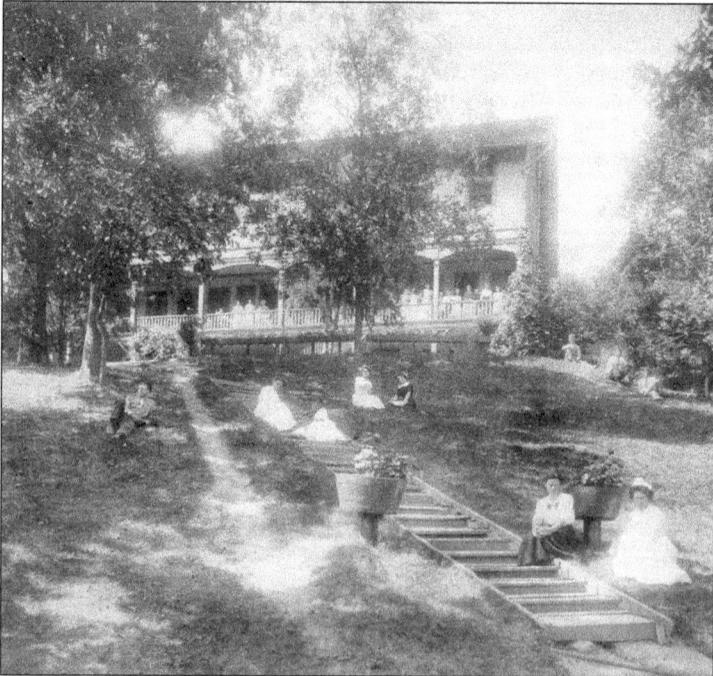

The House on the Hill, now named Founders' Hall, was ready in time for the first season. It housed the dining room and the dorms. Although there was room for 75 campers, there were only 50 children in each session of the first year due to lack of enough cots and bedding. (Courtesy of Holiday Home Camp.)

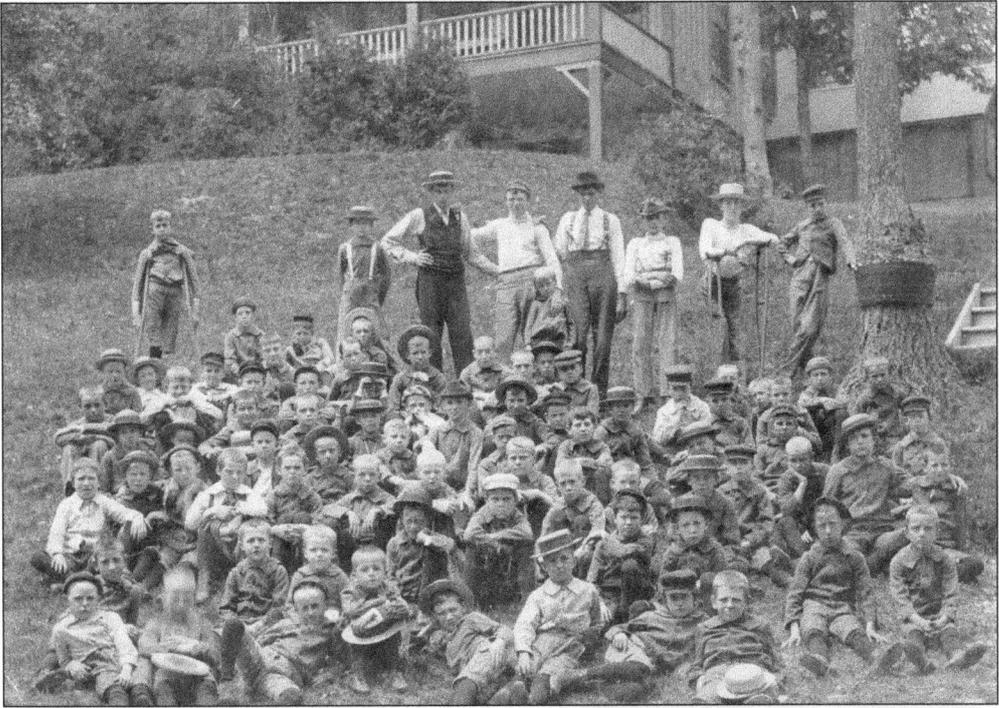

When children came to camp, they bathed first, after which the staff picked lice out of their hair. Children were given clothes to wear at camp. Their own clothes were laundered and mended while they were attending camp. (Courtesy of Holiday Home Camp.)

During the first summer, three two-week sessions were held—one for boys, one for girls, and one for mothers with young children. In 1889, a session for young women was added. By 1902, the camp season lasted 16 weeks. Many of the early campers were immigrants struggling to assimilate. Tuition for the camp as well as fare for train and boat travel was provided. Some children brought money for their semiweekly trips into town. (Courtesy of Bill Herron.)

Preference to attend camp was given to "delicate children." Even by 1947, preference was still being given to children with "health deficiencies or emotional strains resulting from family tensions." Welfare agencies, hospitals, and churches selected who would benefit the most from a camp experience. Some of the children were not well enough to participate in all of the activities, but by being in the fresh air and enjoying a nutritious diet, their health improved. (Both, courtesy of Bill Herron.)

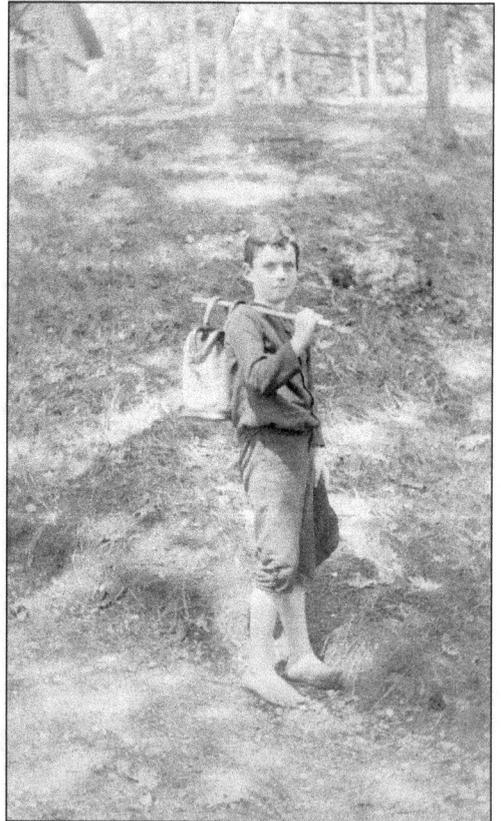

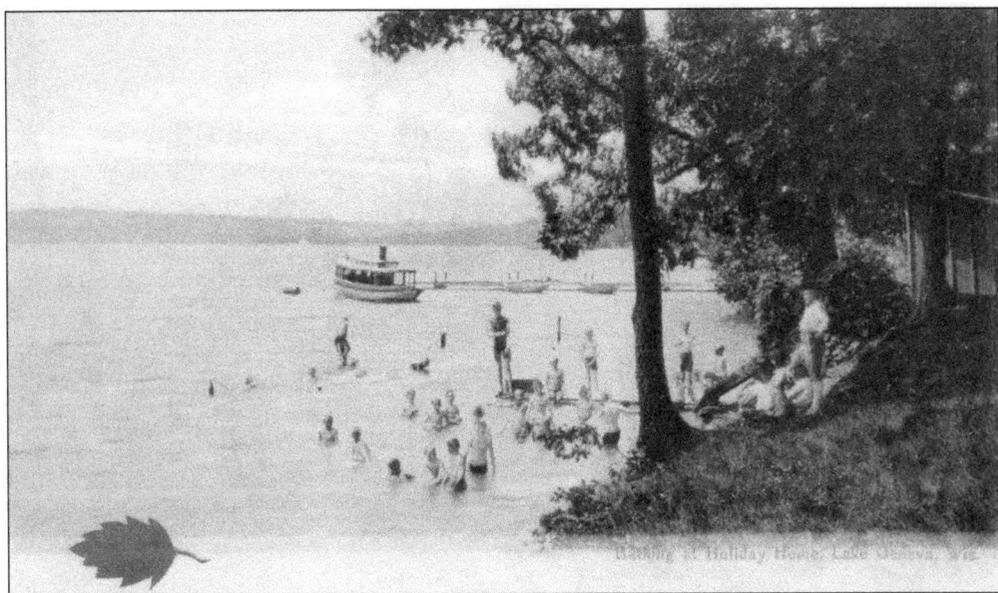

There were so many activities at Holiday Home. Typically, campers began their day with the morning chapel service. On Sundays, they attended the worship service at the YMCA Camp. Throughout their camp stay, they swam, participated in physical drills, and played games. (Courtesy of Deborah Dumelle Kristmann.)

Children sang around campfires and hiked through the woods. There were outings on steam yachts and rowing parties to Kaye's Park. Campers looked forward to trips to the fisheries on the south shore and hayrack rides to Delavan Lake. One evening each session, the campers performed in a stunt show. (Courtesy of Holiday Home Camp.)

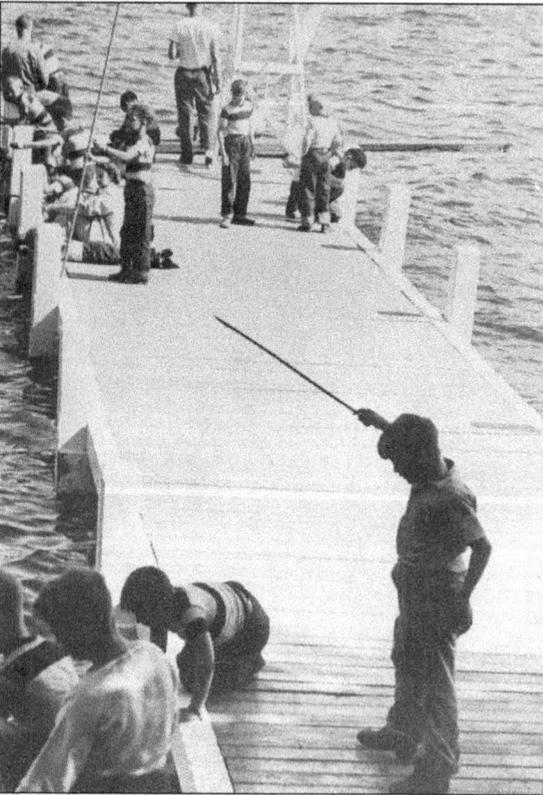

As with every camp on the lake, crafts and fishing were popular pastimes. While the campers were experiencing these activities as fun, the staff knew they were helping the campers grow healthier. Holiday Home allowed the children see that there was more to life then what they had experienced in the city. As the years went by, and physical health became less of a concern, Holiday Home focused more on giving children the skills to change their lives and the inspiration needed to persevere and achieve. (Both, courtesy of Holiday Home Camp.)

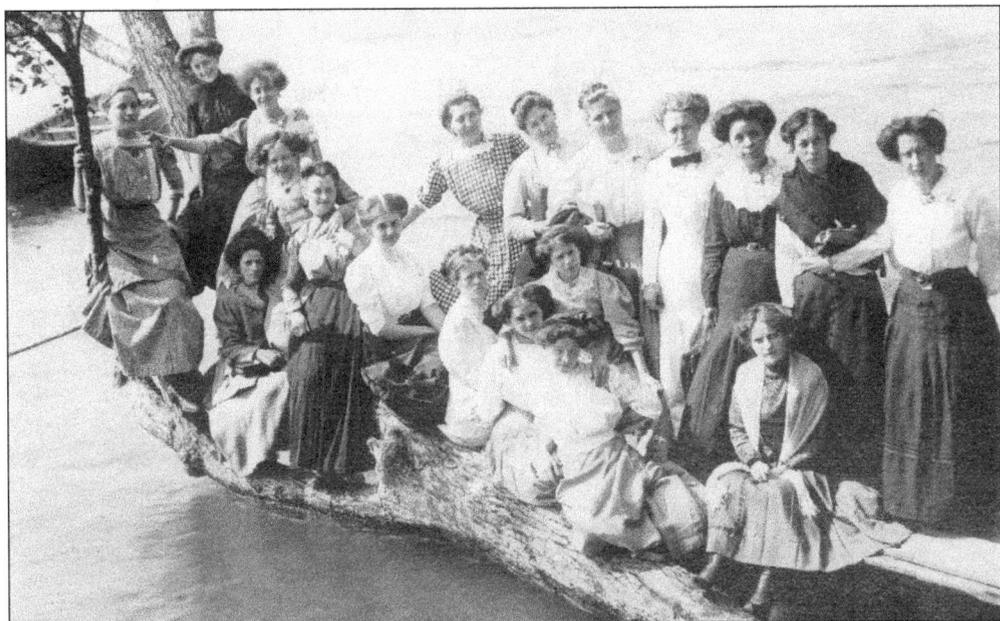

In 1904, more funds were needed to support the camp. An extravagant fundraiser was held called Mid-Summer Fair. Because of its popularity and success, it became an annual event. It might be likened to an upscale county fair. Produce from the estates was sold. Two bunches of grapes were bought for $205. There was music, vaudeville acts, a Japanese teahouse, and sideshows. In 1912, Horticultural Hall was built in Lake Geneva and became the location for the major fundraisers. (Both, courtesy of Holiday Home Camp.)

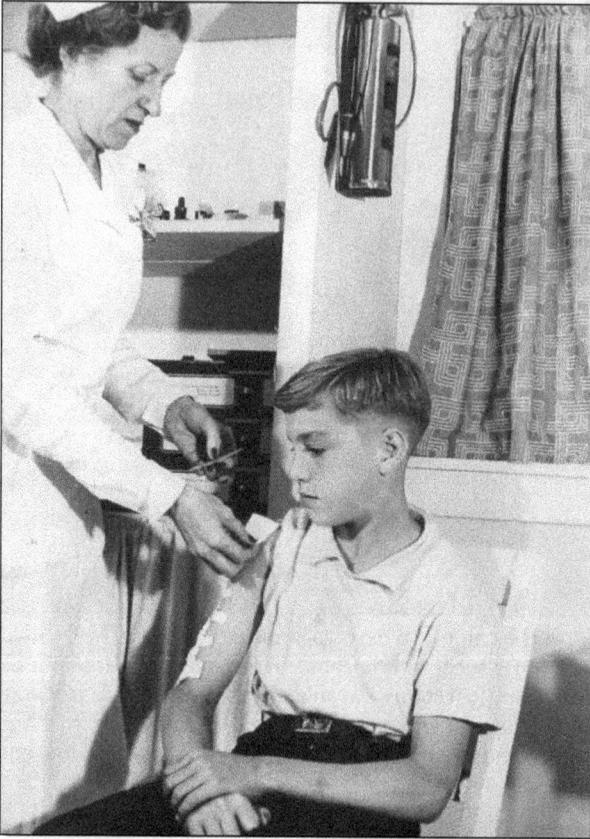

Holiday Home's mission was to instill values of self-sufficiency and hard work. With the campers' health and nutritional needs attended to, the children were more likely to grow up to become productive citizens. In 1956, Holiday Home began administering the Salk vaccine for polio. Children attending Holiday Home received their first shot in the city and the booster at camp. (Courtesy of Holiday Home Camp.)

Holiday Home celebrated the Fourth of July with the YMCA Camp. The staff from both camps made floats by lashing small boats together. Floats included a pirate ship and a boat covered in wildflowers. Prizes were awarded. (Courtesy of GWC Archives.)

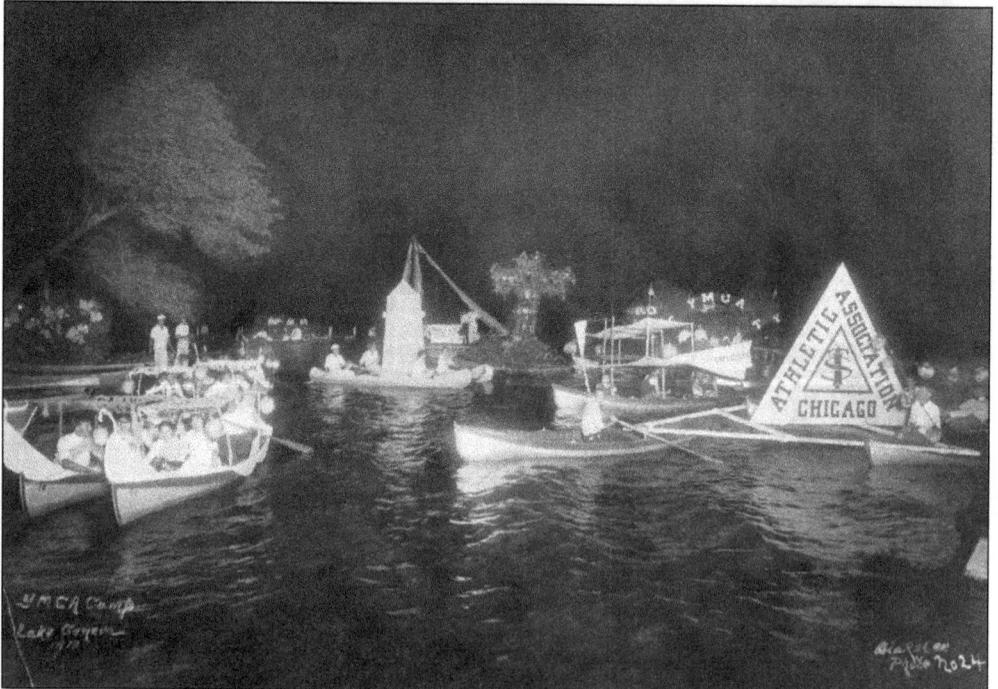

Yes, people really did bathe in the lake. At right, Anna Erhardt was the camp's cook. She is pictured here with her robe and towel getting ready for her bath. Pictured below is her granddaughter Susan Gray. Bathing in the lake was a common practice, even for people of means. (Both, courtesy of Susan Gray.)

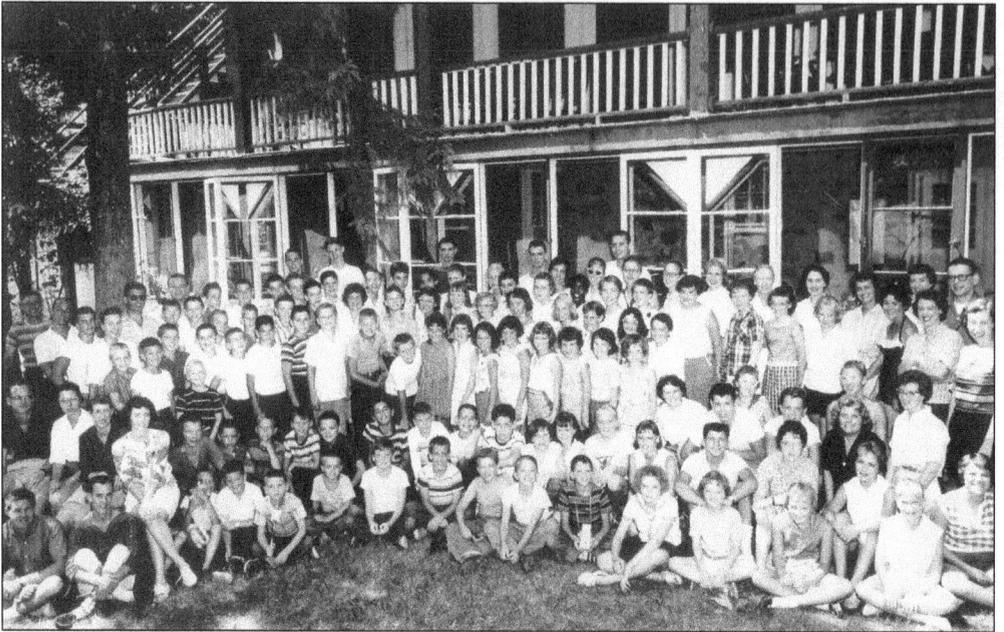

From 1948 to 1982, Holiday Home rented its facility to the American Diabetes Association (ADA) for the month of June. Because of the income from ADA, Holiday Home was able to renovate several buildings and add a few more. The rental fees also covered the cost of Holiday Home's general camp sessions. Holiday Home Camp still targets economically disadvantaged youth. According to its mission statement, Holiday Home helps them "develop the life skills necessary to become self-reliant, productive members of their families, schools, and communities." Support for the camp facilities and campers continues to come from the community, through fundraisers and volunteer activities. Just like in the past, campers' tuition is waived. (Both, courtesy of Holiday Home Camp.)

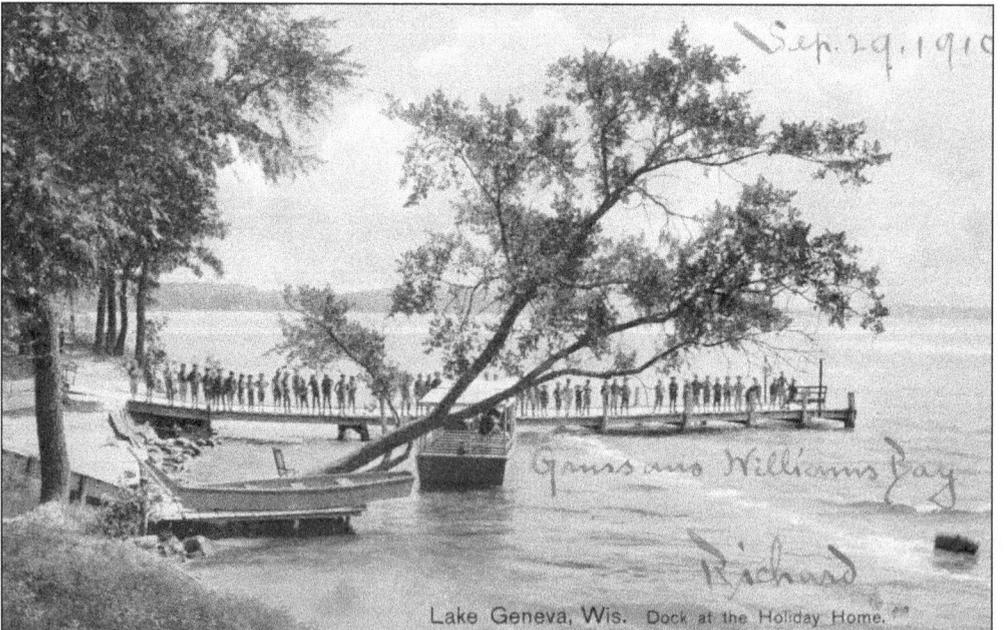

Lake Geneva, Wis. Dock at the Holiday Home.

Four

FOR THE KIDS
VRALIA HEIGHTS, OLIVET INSTITUTE CAMP, AND NORMAN B. BARR CAMP

"Camp is my refuge." "The people at camp are my extended family." "It's Camp Magic." "It's continuity." "It's stability in an unstable world." These are a few of the ways the cottagers, who have been coming to this camp for generations, sum up Norman B. Barr Camp (NBBC).

Norman B. Barr, a Presbyterian minister, was a speaker at the YMCA Camp in 1907. Walking along the shore path, he discovered that Vralia Heights was for sale. He recognized it as an ideal summer respite for the Olivet Institute, a settlement house in the area of Chicago known as "Little Hell." On Geneva Lake, the residents of Little Hell, particularly the women and children, could get a much-needed break from their lives with nourishing meals and plenty of clean air.

Vralia Heights Metaphysical School, also known as Vralia Camp, began in 1898. It was owned by Alice B. Stockham, the fifth woman in the United States to graduate from medical school. Vralia Heights was a summer school of nature study and philosophy. Its classes covered everything from Beethoven to metaphysics, sex, and botany. Dr. Stockham wrote a very popular book, *Tokology*, about the science of obstetrics. In 1899, it was on its 45th printing. Leo Tolstoy found it important enough to have it translated into Russian. But after distributing a brochure called *The Wedding Night*, Dr. Stockham was dragged into court. The costs she incurred from the legal battle and the banning of her books necessitated the sale of Vralia Heights.

In 1909, the ownership of Vralia Heights transferred to what Reverend Barr named the Olivet Institute Camp. The camp was financed by members of Olivet Memorial Church. People rented tents and later cottages. Other visitors stayed in the modest hotel close to the shore. All profits went to fund the campers.

The camp was so popular that reservations were necessary. Sometimes guests ended up sleeping on the porch wrapped in blankets. Consequently, the program for campers was well funded. Maintenance work and improvements around camp were accomplished by a crew of volunteers.

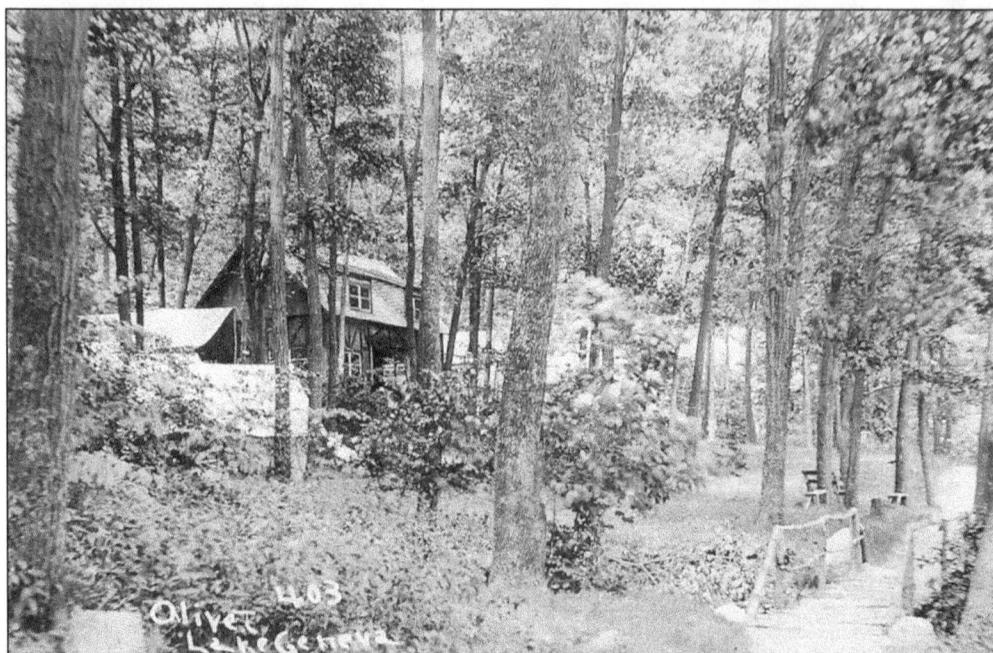

This photograph from about 1909 is the earliest known image of Olivet Camp, so it is likely this is what Vralia Heights looked like. When Dr. Stockham had to sell Vralia Heights, some of her neighbors were relieved, even though a camp for children was moving in. They were scandalized she had allowed her female guests to swim without their stockings. (Courtesy of NBBC Archives.)

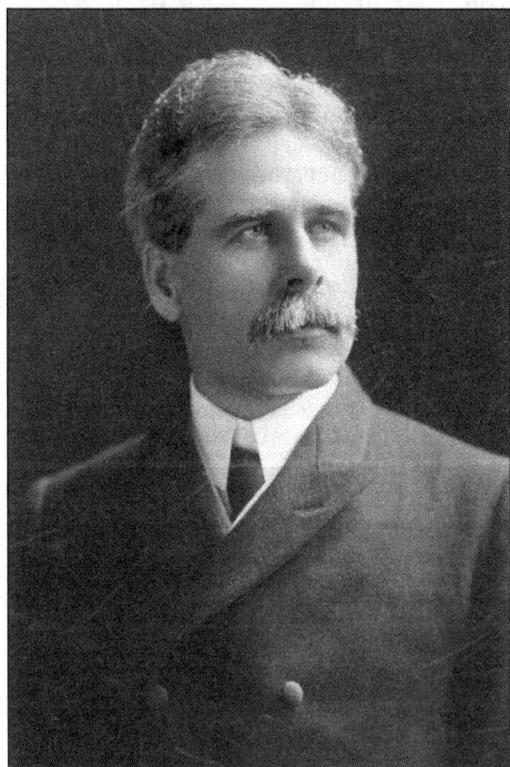

Reverend Barr, known by some as Dr. Barr, was a social reformer. He expanded the Olivet Institute in Chicago to a 120-room facility so that it could serve the community more comprehensively. Olivet had the largest gym in the city. Sewing, cooking, and music lessons were taught. Medical and dental services were offered. The building even contained a branch of the Chicago Public Library. (Courtesy of Ethelyn Wolf.)

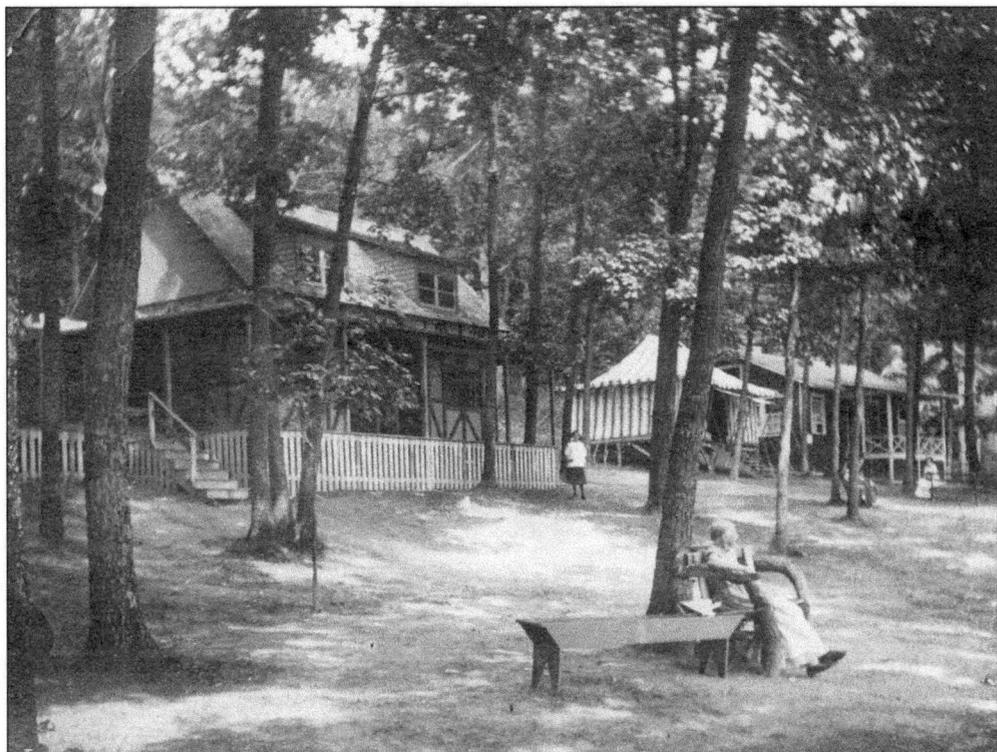

In the first few years, Olivet Camp had six cottages, 35 platform tents, a dining hall, and kitchen. For the first season, Holiday Home Camp let Olivet use its springwater. Perishable food was stored underground. Soon, cottages were built, and eventually they had iceboxes, relying on local ice companies to deliver 50-pound blocks of ice. Vendors selling milk and vegetables also came to the camp. (Courtesy of NBBC Archives.)

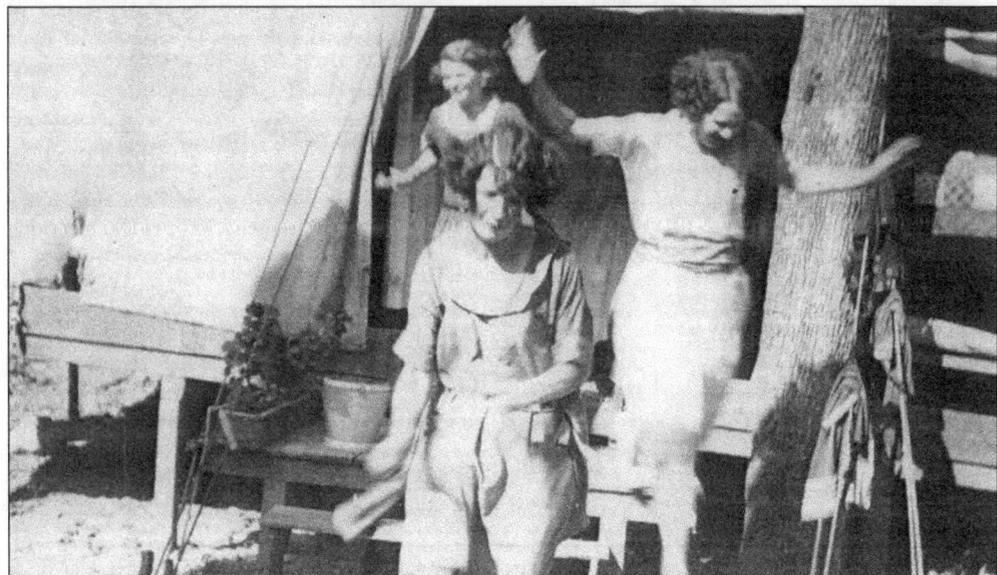

During that first summer, everyone slept in tents. Later, cottages were added and tents dismantled. Families rented cottages by the week or for the entire summer. (Courtesy of NBBC Archives.)

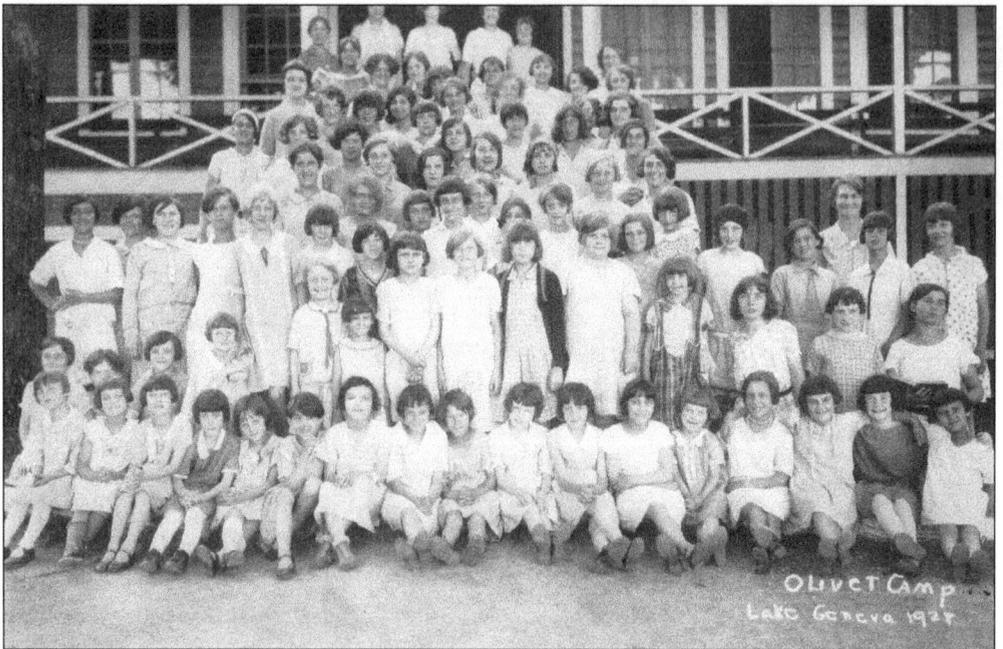

In the 1920s, Olivet Camp primarily served the neighborhood of the Olivet Institute. Most of the campers were from Olivet Institute Church and St. Michael's Catholic Church, also in Chicago. Later, it expanded to include campers from other areas of Chicago where there was a need. (Courtesy of Ethelyn Wolf.)

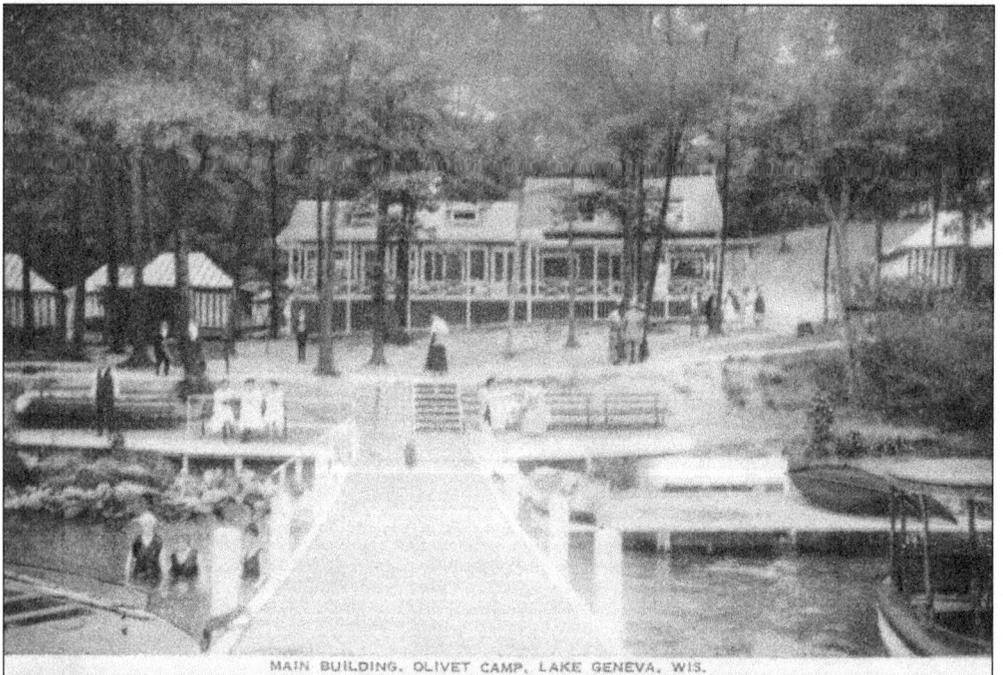

Until Bowman Chapel was added onto the main building, people attended worship at the YMCA Camp. From the beginning, though, Olivet Camp offered its own Sunday school. The camp gave swimming, cooking, and sewing lessons. (Courtesy of NBBC Archives.)

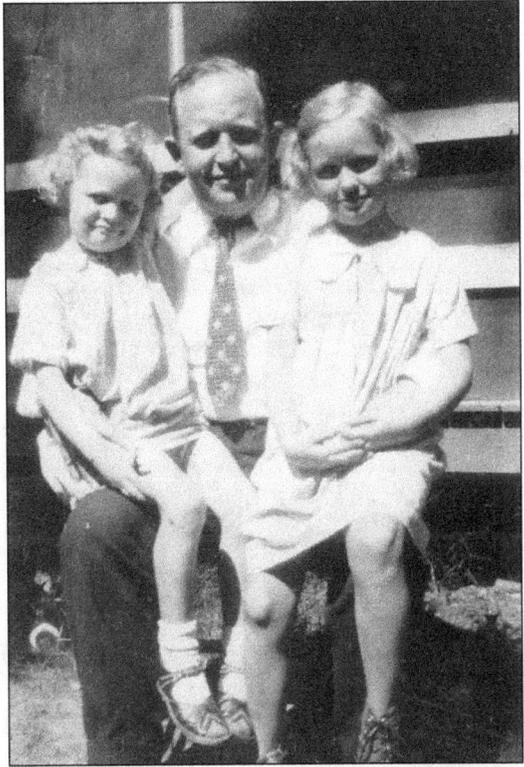

Ethelyn Wolf was a camper and a cottager from the time she was nine months old. She is pictured here sitting on the left knee of her father, Lee, along with her sister Martha Lee. Pictured below are, from left to right, Ethelyn, Marian (with life preserver), Jackie McVittie, and Lillian "Gollaty," around 1929. (Both, courtesy of Ethelyn Wolf.)

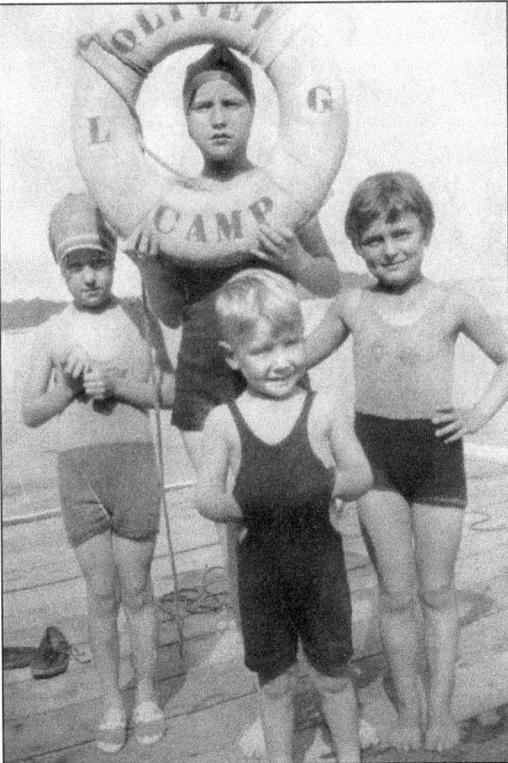

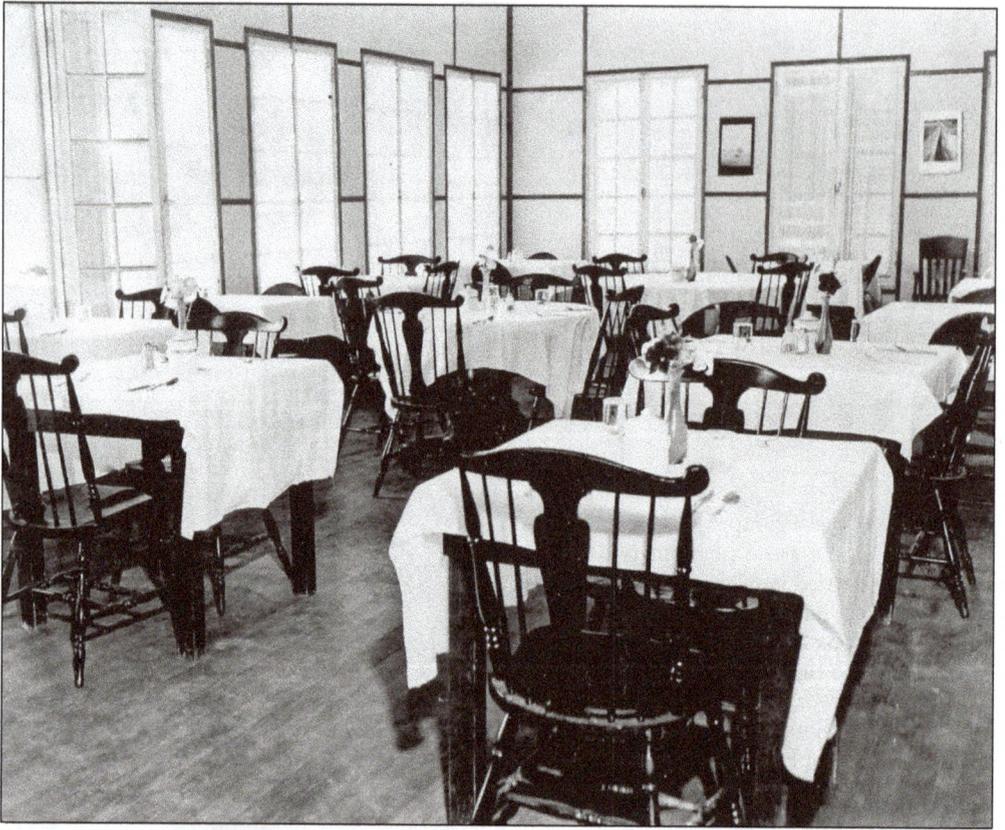

Camp life centered around the lake and the dining hall. Until the 1940s, when kerosene stoves were installed in the cottages, everyone ate together, even if it meant three table settings for each meal. (Courtesy of Ethelyn Wolf.)

Today, there is electricity and running water in each of the cottages, but most still use a common bathhouse. Imagine having Internet but no bathroom. Pictured here in the 1940s are Lee Wolf and Rachel Armstrong Robinson. (Courtesy of Ethelyn Wolf.)

The cottages were a step up from the tents but not exactly luxurious. In the days before hot water, most people bathed and washed their hair in the lake instead of using the common bathhouse. (Right, courtesy of NBBC Archives; below, courtesy of Ethelyn Wolf.)

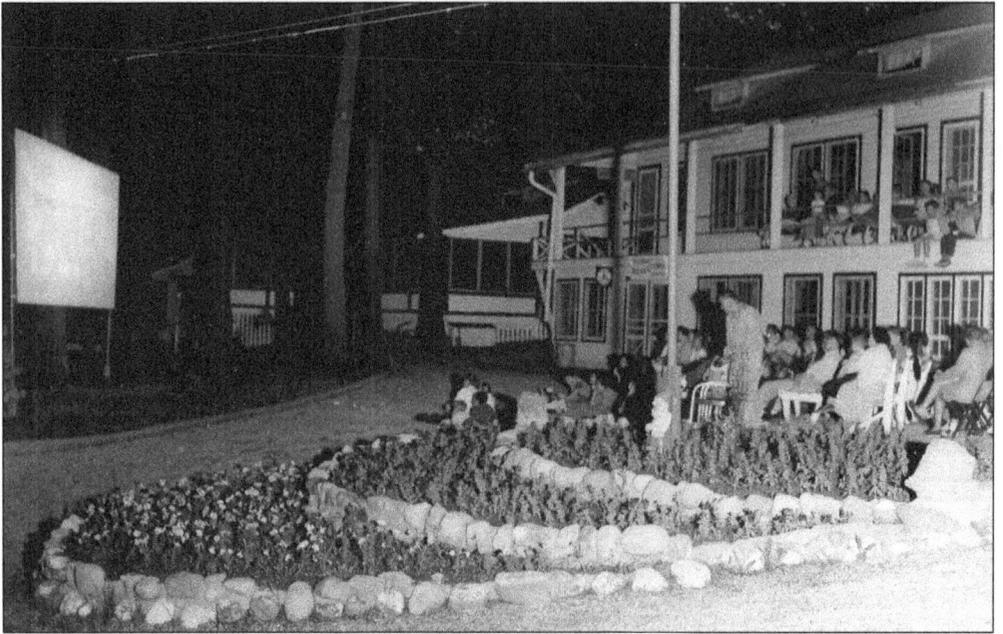

Twice a week, movies were shown at the lakefront. The movie on Monday nights was educational; on Saturdays, it was a popular feature film. A big wooden screen was nailed to the tree at the lakefront. Everyone was welcome; people invited friends or others they happened to meet at the lake. People from other camps or homes wandered over to watch the movie and have ice cream in the refectory. (Both, courtesy of NBBC Archives.)

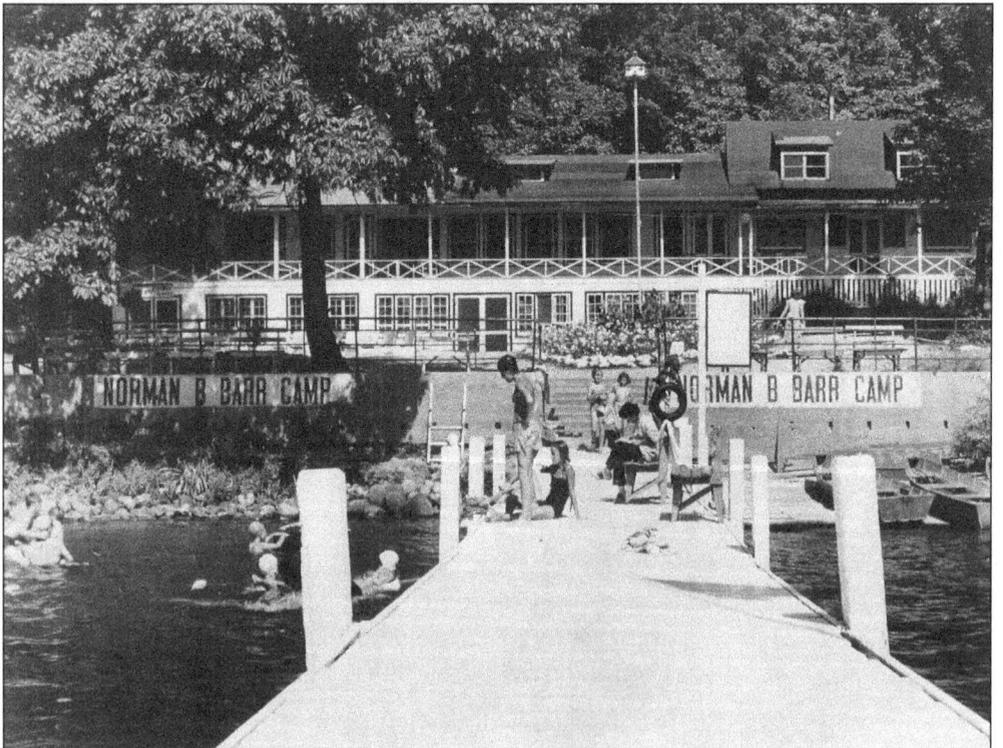

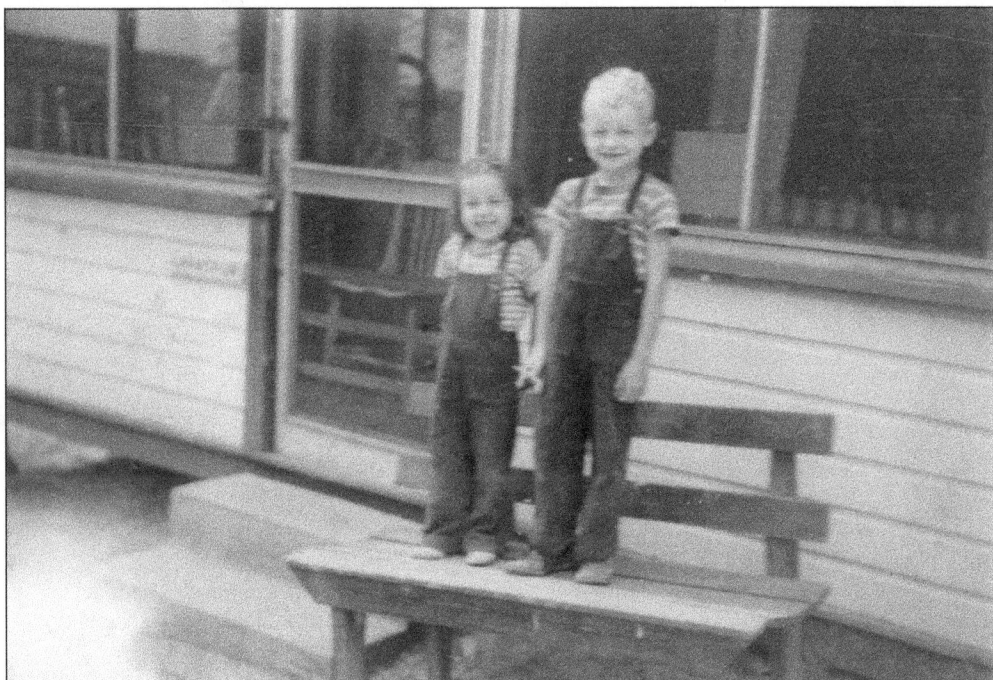

The Elsner family spent summers in Larkspur cottage. They liked it so much that they became full-time residents of Williams Bay. Ed Elsner, an artist and photographer, commuted into Chicago on the North Western train. Pictured here are Joan Elsner Miller and her brother Eddie. (Courtesy of Joan Elsner Miller.)

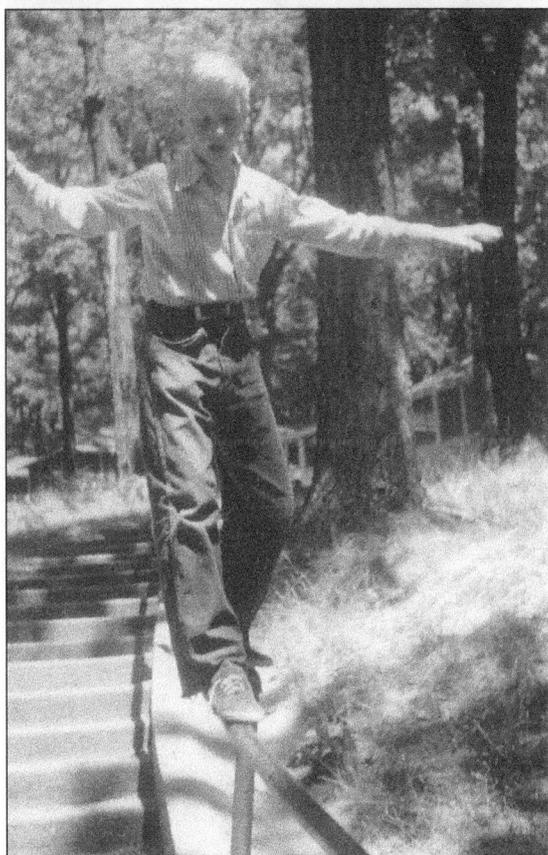

Today, kids at Barr Camp have a basketball court, playground, and a game room, but they still love to count the stairs—there are 89. Eddie Elsner could balance on the railing as he walked down to the lake. (Courtesy of Joan Elsner Miller.)

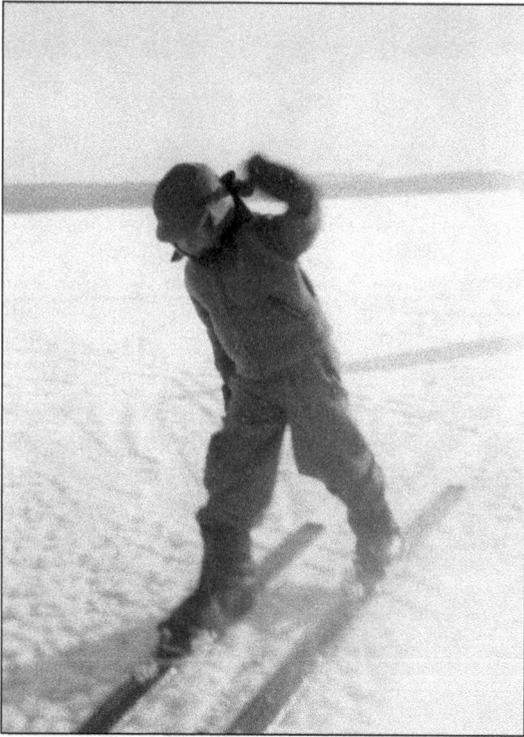

During the winter, the Elsners skied on the frozen lake; and in the fall, they hunted in the woods. As much time as possible was spent in the lake over the summer. Edmund Elsner II and Edmund Elsner III, father and son, are pictured below. (Both, courtesy of Joan Elsner Miller and Tim Elsner.)

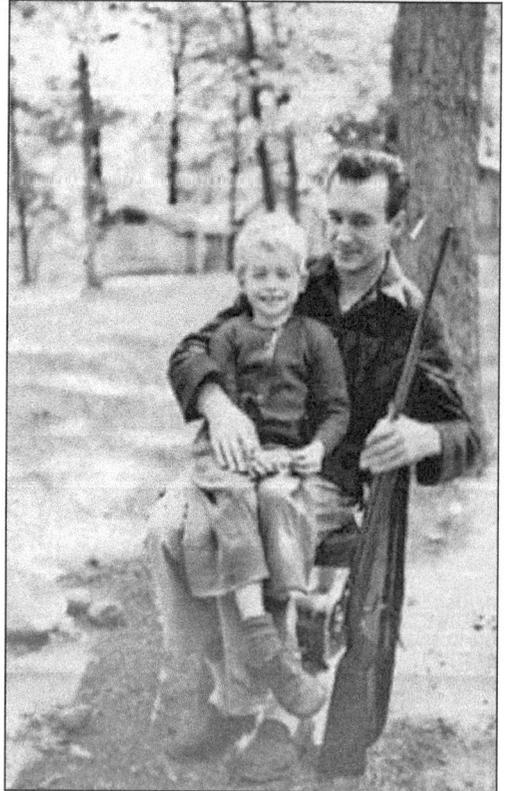

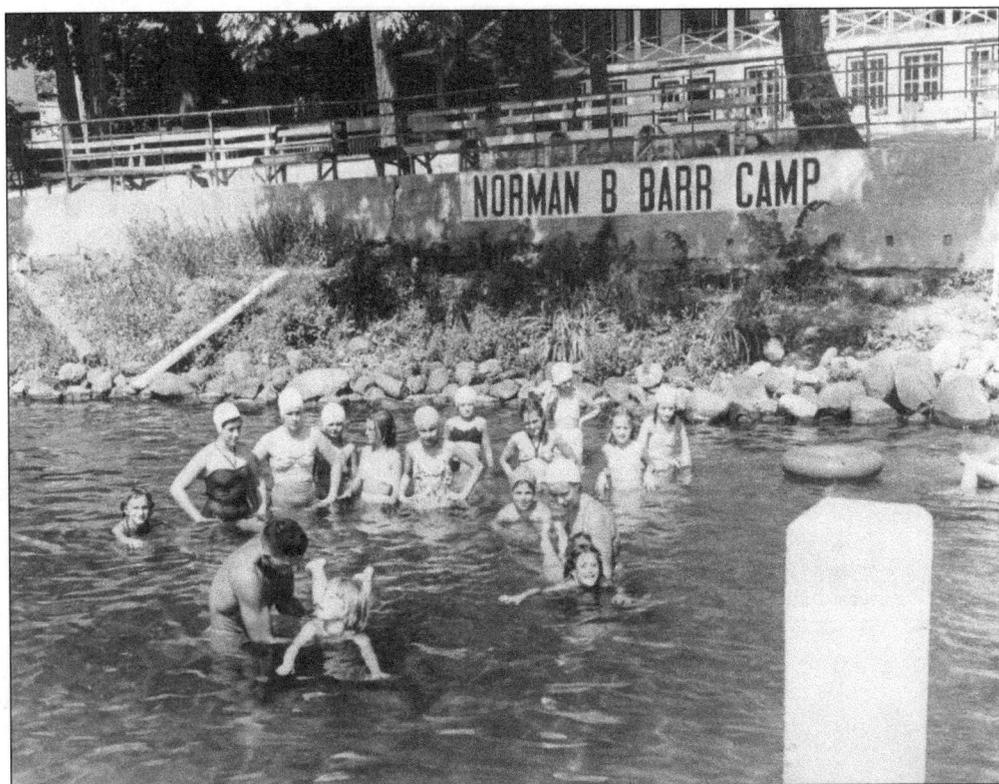

On hot, sunny days, campers spilled into the lake to cool off. Getting children out in time for dinner was sometimes a challenge, even for the weekly potluck. (Courtesy of Ethelyn Wolf.)

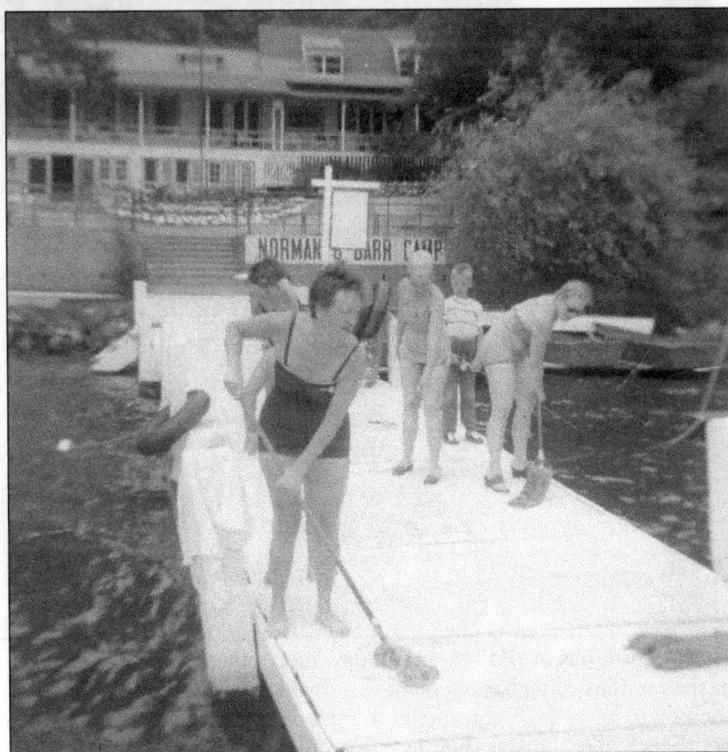

Maintaining the pier and beach was almost fun when surrounded by lifelong friends. At Norman B. Barr Camp, people now grow old with some of the same people they grew up with. (Courtesy of Ethelyn Wolf.)

Each summer, there are nine camp sessions at Barr Camp. Most of the campers come from economically disadvantaged homes. Rent from cottages and fundraisers continue to pay the campers' fees. The camp is "about the kids." Volunteering with and for the children brings the community together. (Courtesy of Ethelyn Wolf.)

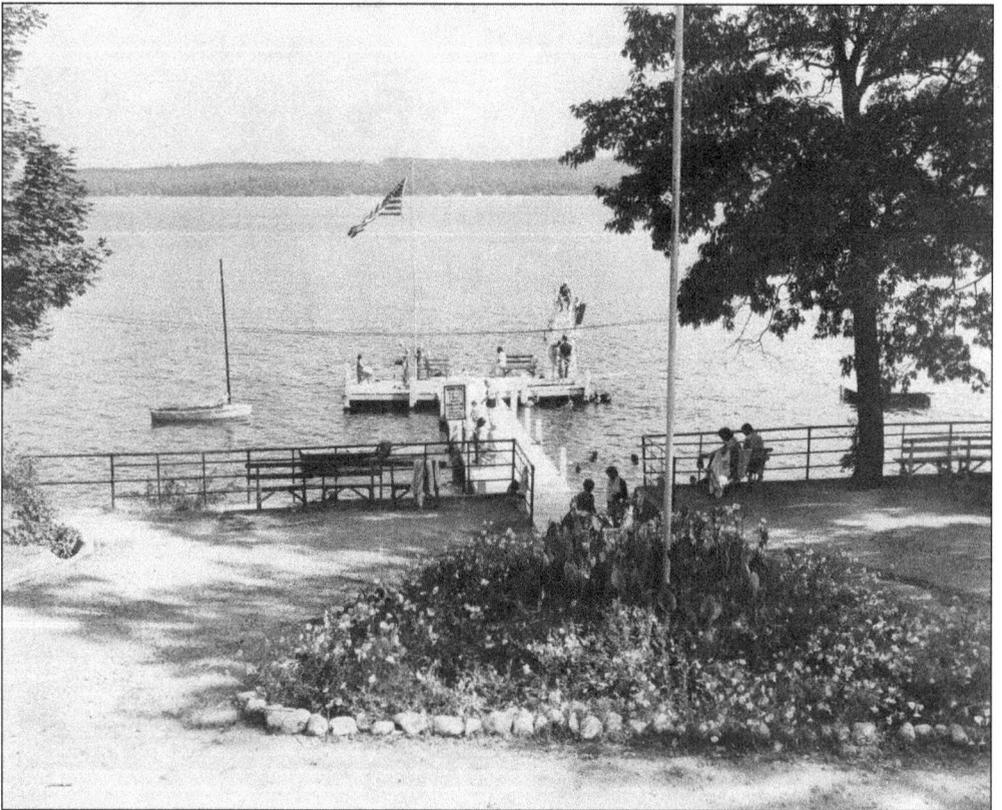

Nothing is fancy at Barr Camp. Today, most of the cottages are rented for the summer—many of the families going back generations. Even though some of the families could afford a home of their own on the lake, they prefer to remain at Barr Camp, contributing in some way to the lives of others while living as their grandparents did. (Courtesy of NBBC Archives.)

Five

A CAMP FOR
WORKING WOMEN
ELEANOR CAMP AND
WESLEY WOODS RETREAT CENTER

The mission of the Eleanor Women's Organization was to help single working women in Chicago achieve and maintain economic security and safety. Ina Law Robertson, a Washington State school principal, came to the area to study at the University of Chicago. She recognized there was a need for self-supporting women to have safe housing. In 1898, she founded the first residence for single women in Chicago and named it the Eleanor Club. The name Eleanor means "light," and the light represented the gifts these women brought to the city of Chicago.

By 1909, there were five Eleanor residences in Chicago, one on the Gold Coast. The Central Eleanor Club's tearoom served 58,000 people annually. Eleanor Club held classes in gymnastics, folk dancing, millinery, and English. Robertson also founded the camp on Geneva Lake so these women, with their limited incomes, could have quality vacations that were chaperoned: a must for the times. The cost to stay at Eleanor Camp was between $3.75 and $4.75 per week, depending on the accommodations.

Before investing in land, the organization experimented to see if women would travel to and enjoy a camping experience. The first campsite was at Kaye's Park, west of Black Point on the south shore. It hosted 45 women for their summer vacations. The next year, the camp moved across the lake to Camp Collie, where it spent three seasons.

The experiment was a success. In 1912, the organization acquired 10 acres of the former Stam property in Williams Bay. Florence Dibell Bartlett, who grew up on a summer estate on the lake, donated the dining room and kitchen. The camp hosted 120 women each summer, between 30 and 45 at a time.

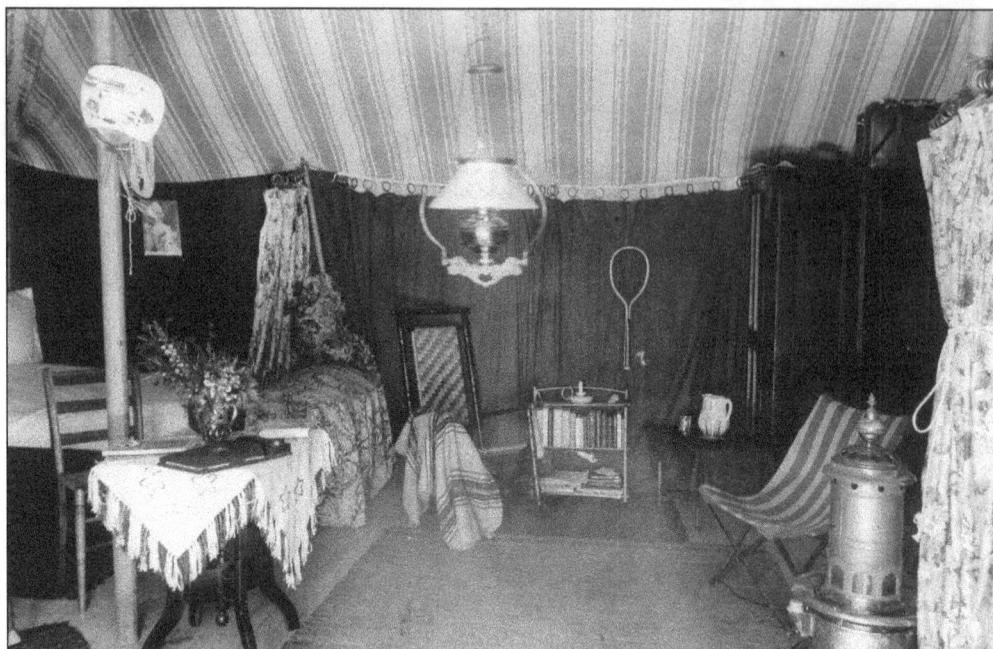

Roughing it was hardly the right term for sleeping in a tent at Eleanor Camp. According to an early brochure, tents were "artistically furnished, offered books, writing tables, and easy chairs for quiet afternoons." (Courtesy of Joy Peterkin Rasin.)

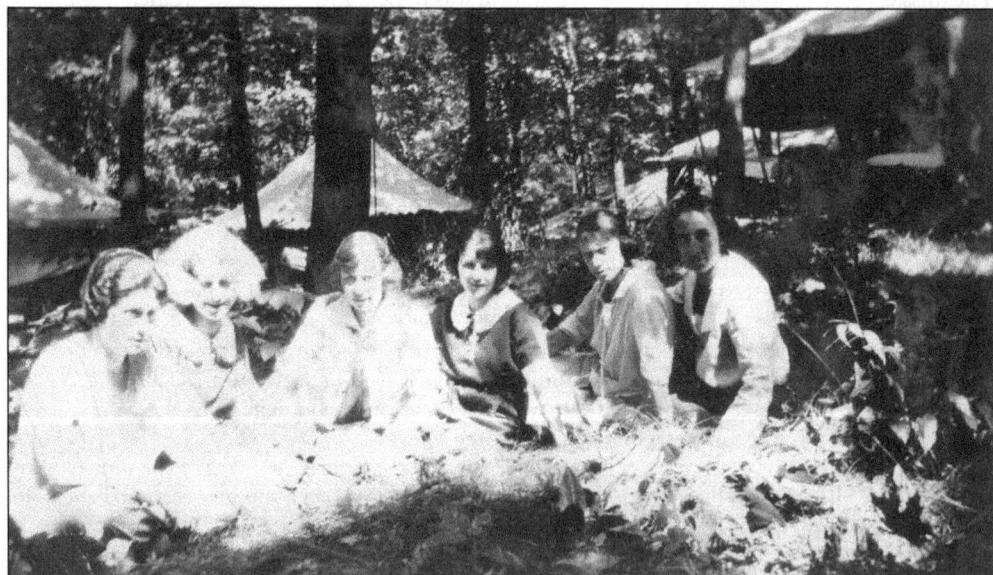

As with the resident houses, applicants for the camp needed to be of sound moral character. Women submitted letters of recommendation along with a credit check. They received a values and guidelines manual. The women were from all walks of life, and the camp provided opportunities for them to relax by the lake and "get to know one another." Mary King's grandmother is among those pictured here in 1922. (Courtesy of Mary D. King.)

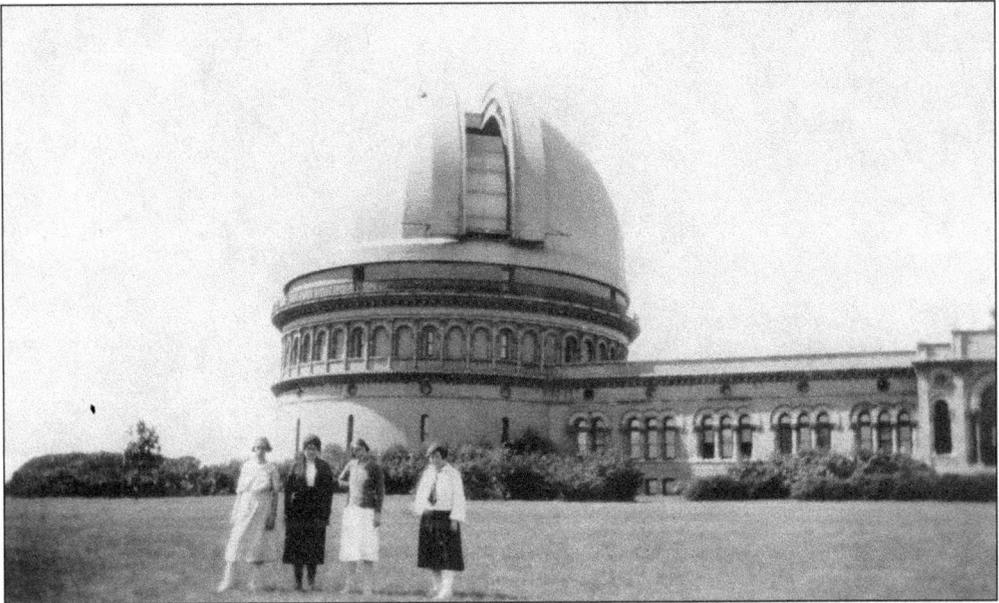

Women could take the Chicago & North Western train and arrive in Williams Bay in one hour and 45 minutes. A public yacht, costing 25¢, met the train, but some women chose to walk to camp from the station in Williams Bay. Either way, they could be at the camp in time for dinner. Eleanor Camp was also within walking distance of the YMCA Camp and Yerkes Observatory. (Courtesy of Mary D. King.)

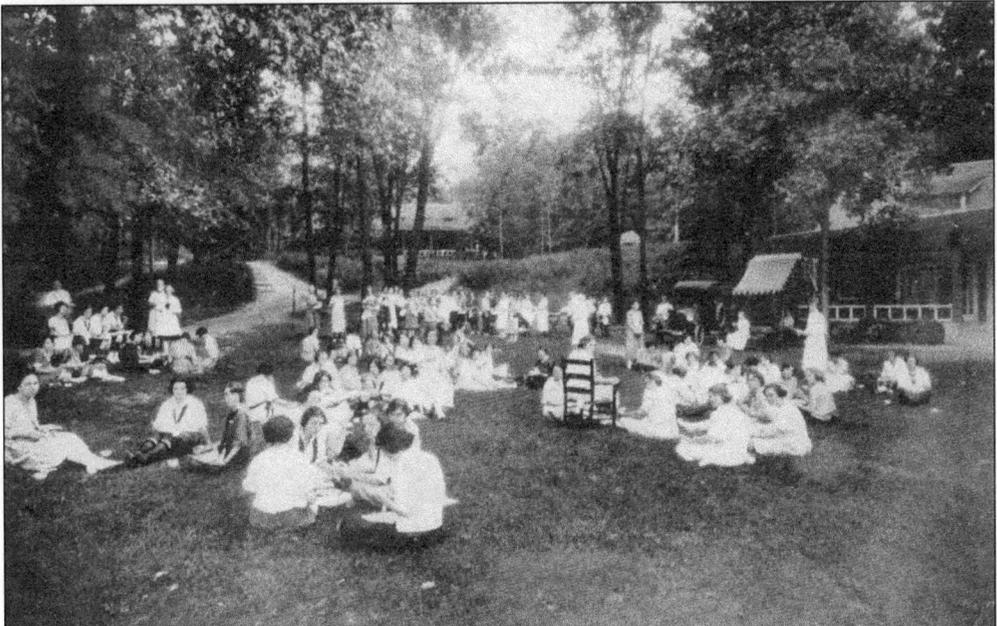

A PICNIC SUPPER ON THE CAMP LAWN, ELEANOR CAMP, ON-LAKE-GENEVA, WISCONSIN.

Camp diversions included bathing, boating, fishing, tennis, archery, and tramping. Weather permitting, they picnicked under the trees. In the evenings, bonfires blazed, and a whiff of roasted marshmallows could be detected. The women sang the "Eleanor Song" and chanted the "Eleanor Pledge." The camp's signature flower was the daisy. (Courtesy of Deborah Dumelle Kristmann.)

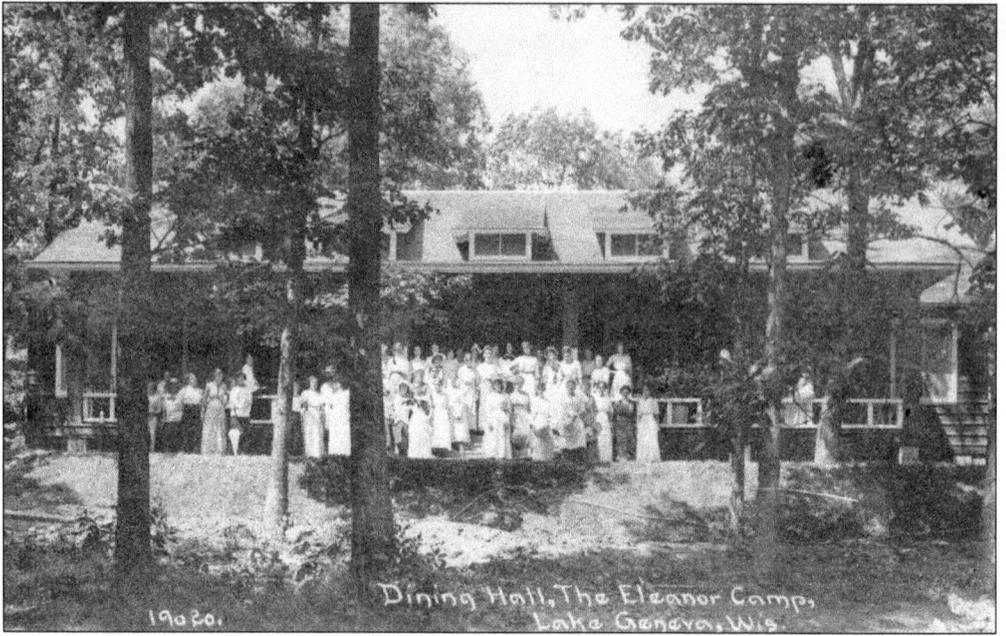

Dining Hall, The Eleanor Camp, Lake Geneva, Wis.
1920.

The camp owned 25 permanent tents, two office buildings, a splendid dining hall, and an artistic recreation hall. All structures blended into the woods. (Both, courtesy of Deborah Dumelle Kristmann.)

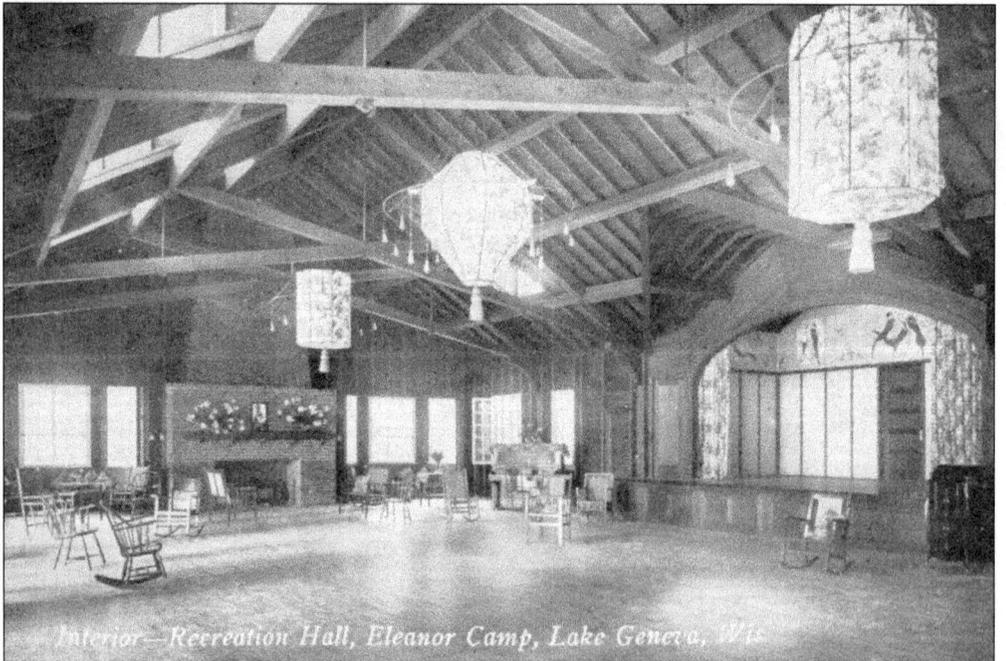

Interior—Recreation Hall, Eleanor Camp, Lake Geneva, Wis.

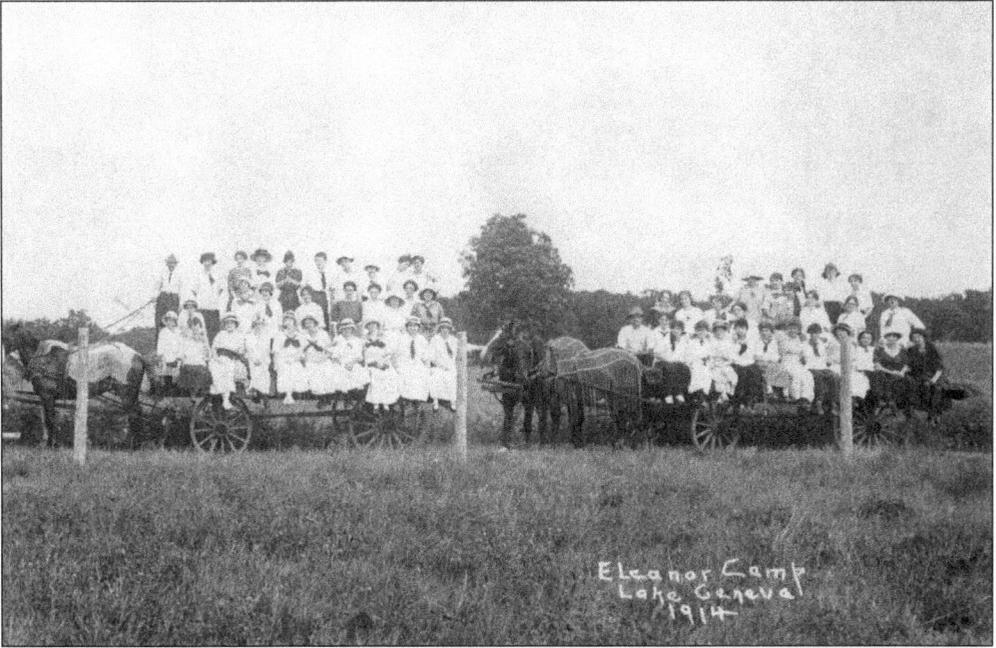

Eleanor Camp
Lake Geneva
1914

Hayrack parties were a favorite evening activity. Neighbors on Theatre Road watched three, sometimes four wagons, drive by on their way to Delavan. (Courtesy of the Geneva Lake Museum.)

The cabins were named for birds, including Flicker, Sandpiper, and Bobolink. (Courtesy of Deborah Dumelle Kristmann.)

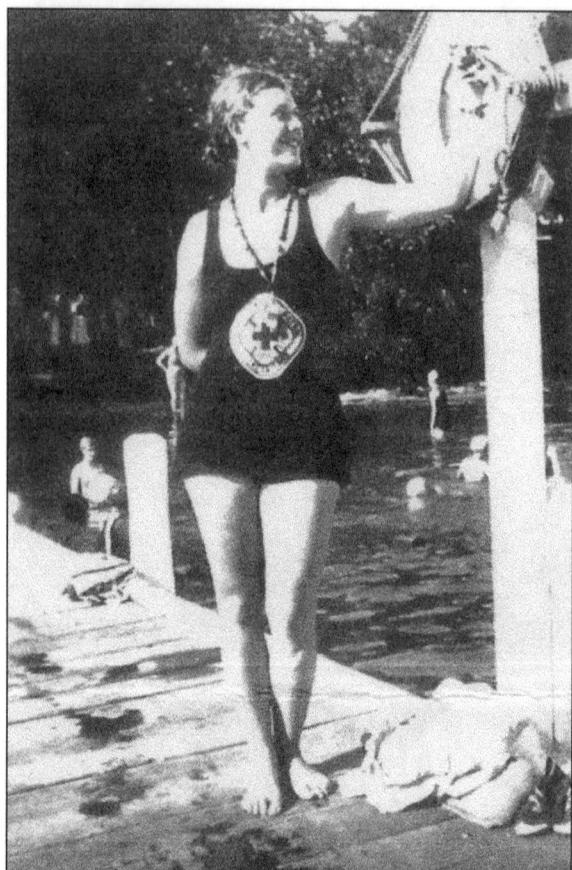

The biggest asset of every camp was the lake. Florence Carlson (pictured) was a lifeguard at Eleanor Camp beginning in 1927. She arranged for early-morning swims as well as water exercises and swimming lessons. Good swimmers wore yellow swim caps. (Both, courtesy of the Geneva Lake Museum.)

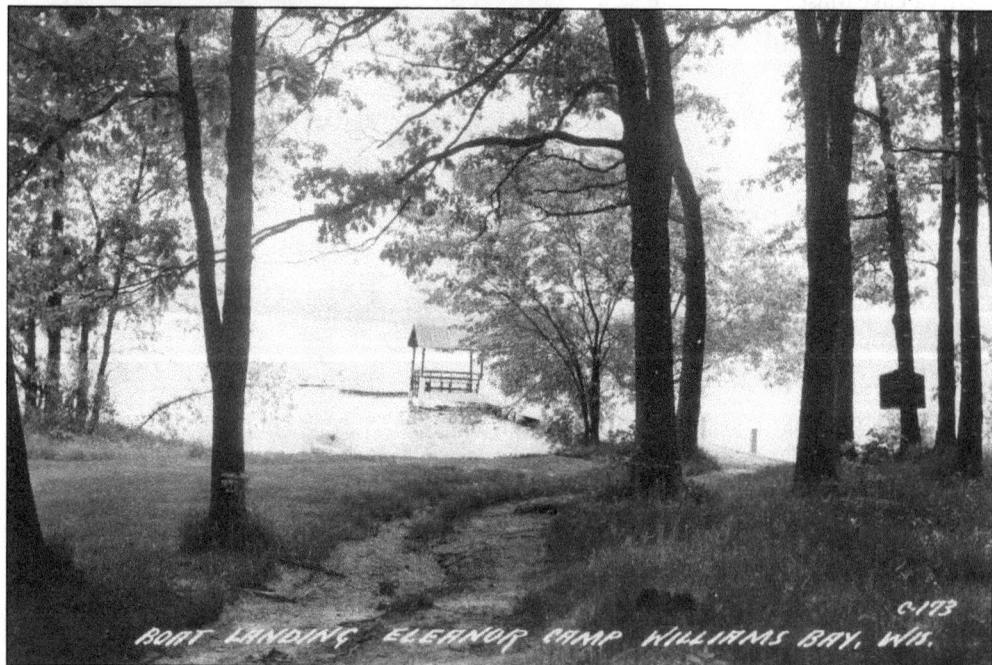

BOAT LANDING ELEANOR CAMP WILLIAMS BAY, WIS.

The camp closed in 1953 because society no longer deemed it necessary for single professional women to have chaperoned vacations. Also, travel to distant, more exotic places was easier. Opportunities were opening up to women. It was a bittersweet time. (Courtesy of Mary D. King.)

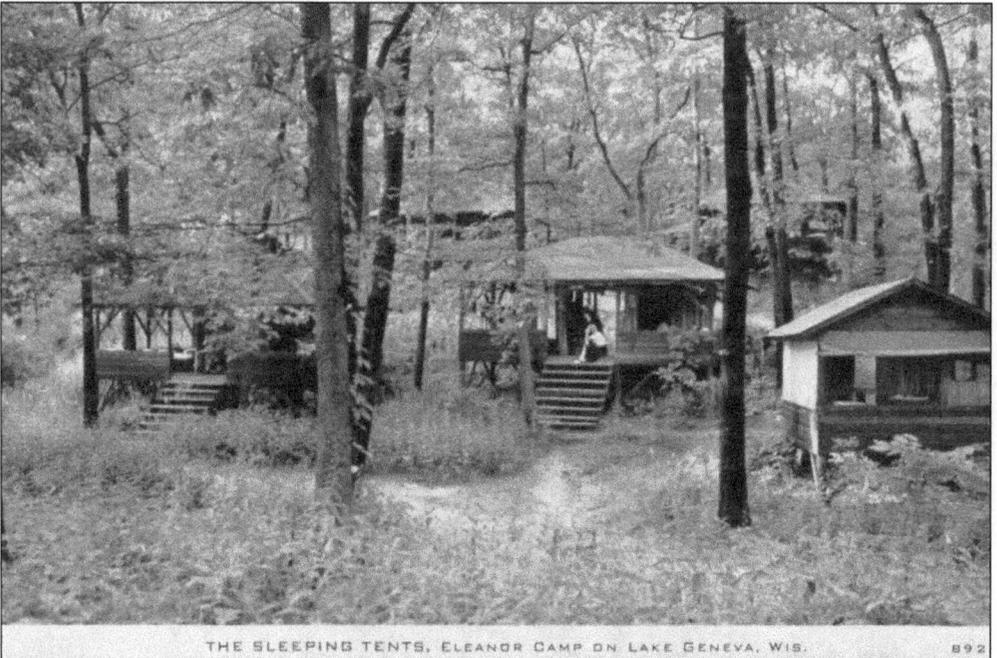

THE SLEEPING TENTS, ELEANOR CAMP ON LAKE GENEVA, WIS.

Eleanor Camp was sold in 1955 to the Rock River Annual Conference of the Methodist Episcopal Church. It is now run by the Northern Illinois Conference of the United Methodist Church. Eleanor Camp was renamed Wesley Woods. It began with the buildings from the buildings from Eleanor Camp, including the dining hall, 16 cottages, and 3 service buildings. (Courtesy of Deborah Dumelle Kristmann.)

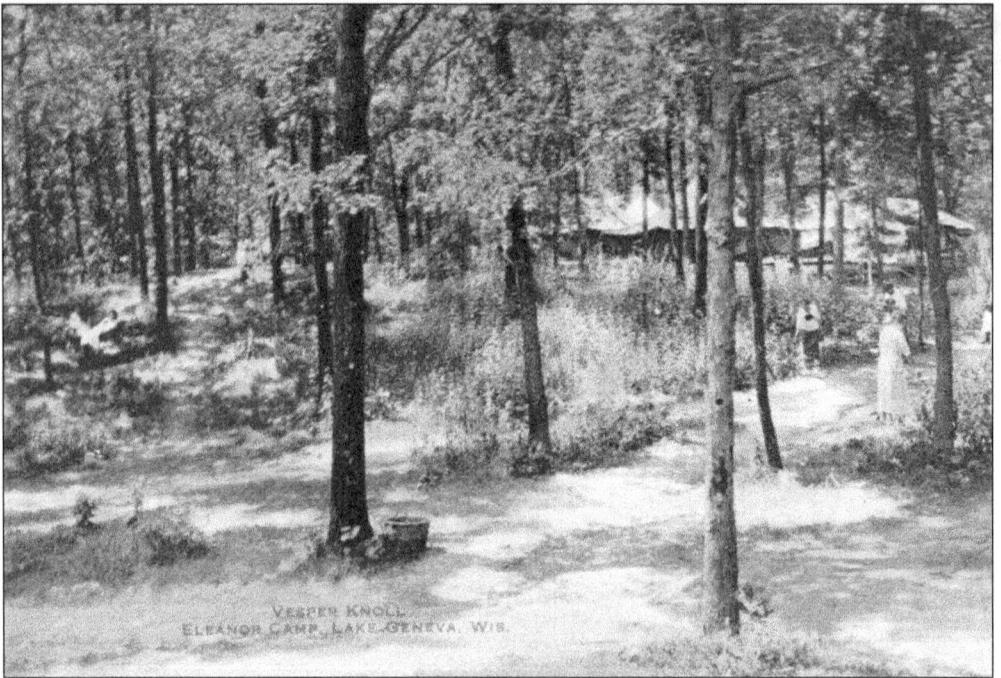

VESPER KNOLL
ELEANOR CAMP, LAKE GENEVA, WIS.

Wesley Woods provided an outdoor setting that brought people together for work, recreation, worship, study, and conversation. Through immersion in small groups, a closeness developed that overcame differences and misunderstandings based on culture, race, and economics. (Above, courtesy of Deborah Dumelle Kristmann; below, courtesy of the Wesley Woods Retreat Center Archives.)

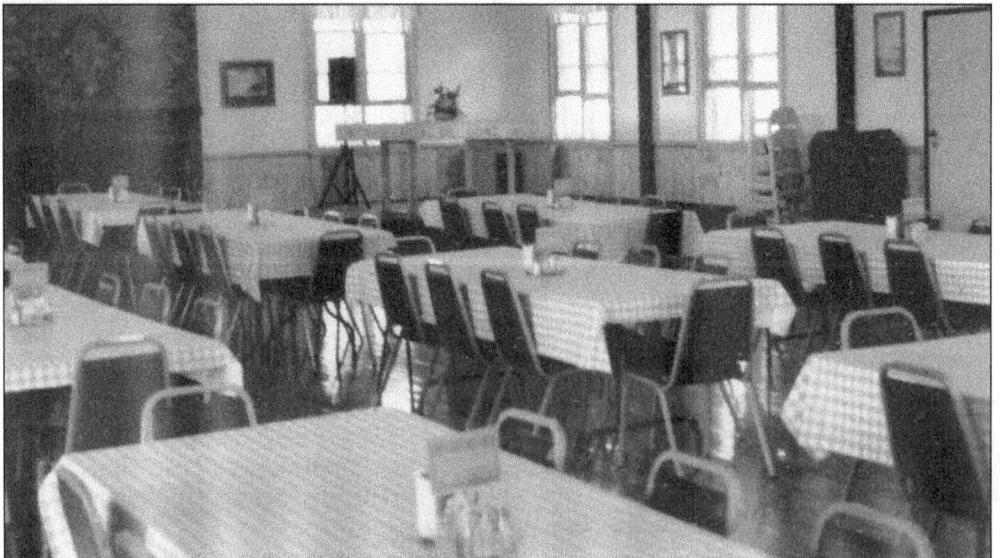

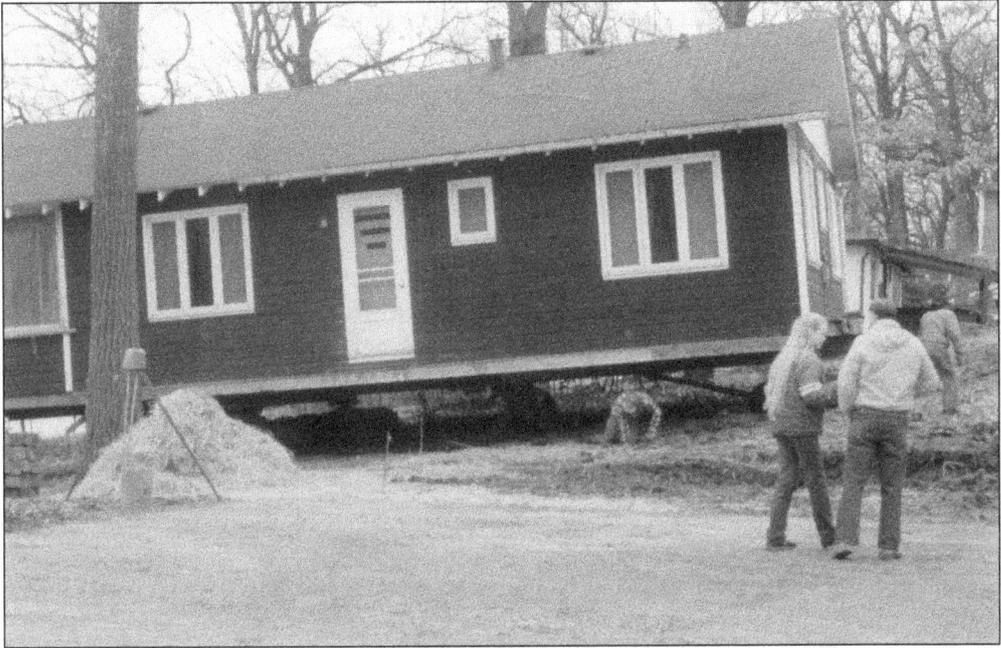

When the land from the neighboring Rockford Camp was sold, Mary Louise Miller donated her cottage to Wesley Woods. It was moved to the camp and situated by the lakefront. It became the second story of what was dubbed the Miller Cabin. (Courtesy of the Wesley Woods Retreat Center Archives.)

Gradually, the camp fell into disrepair. In the 1970s, the Mennonites made an arrangement with the Methodist owners to clean and repair the site in exchange for use of the camp. (Courtesy of the Wesley Wood Retreat Center Archives.)

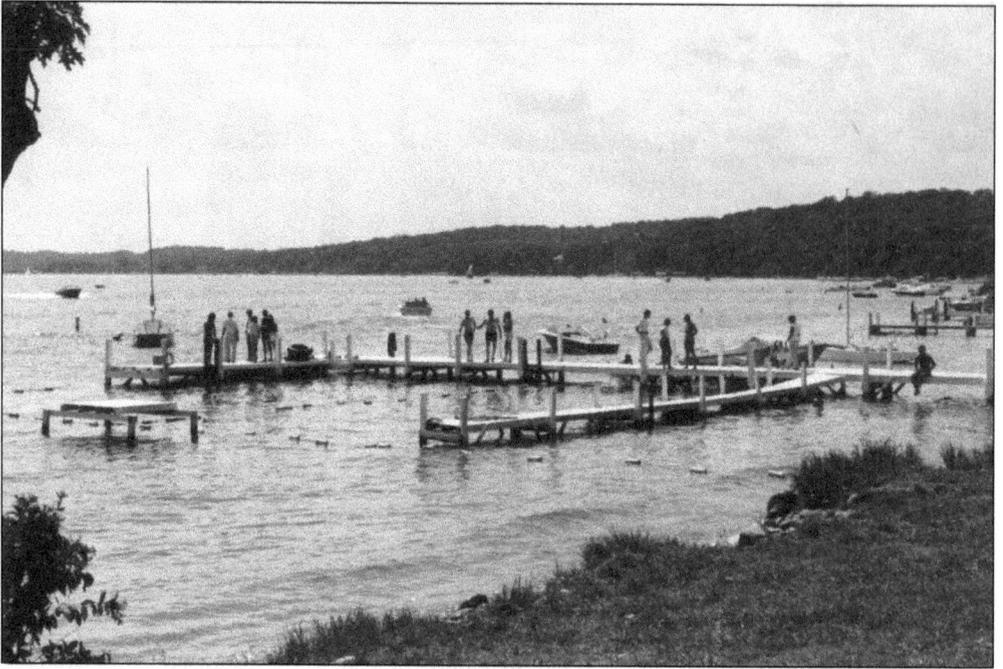

Campers enjoyed refreshing swims on sun-filled afternoons and shared stories on the lawn under the trees. They may have played a rousing game of volleyball or tennis to build up an appetite for an evening cookout. (Courtesy of the Wesley Woods Retreat Center Archives.)

Today, Wesley Woods Retreat Center has 500 feet of shoreline. It can accommodate 195 overnight guests all year long. It hosts religious gatherings, retreats, family reunions, and special events. Camps without property of their own can rent it. The camp is for both children and adults. Activities include hiking, swimming, canoeing, fishing, kayaking, and pontoon boating. (Courtesy of the Wesley Woods Retreat Center Archives.)

Six

HORSE-INSPIRED CAMP
CISCO BEACH CAMP AND
CAMP AUGUSTANA

In its early days, Camp Augustana was known as Cisco Beach Camp. It was created by the Inner Mission of the Swedish branch of the Lutheran Church, the Augustana Synod. The Reverend Dr. John Jesperson's desire was to give people relief from the city. Curiously, his idea seems to have been inspired by horses: horses who worked in Chicago were given time off to recuperate in the country. Dr. Jesperson was particularly interested in helping the sick and downtrodden city children have a respite by giving them a camp experience in the country.

In 1926, he put an option on 50 acres on Geneva Lake's north shore. The property was divided. The camp kept 16 acres, including a barn, a farmhouse, and 100 feet of lake frontage. The rest of the property was sold as lots for housing. The proceeds from the sale financed the camp.

Most of the lots were sold to families. However, the Immanuel Women's Association bought the Villa, formerly the Ara Glen estate, on the lake and additional lots for building the annex. The Immanuel Women's Home in Chicago was a place for young working women—elsewhere described as "lonely women"—to live. Geneva Lake provided a camp at which these women could vacation.

Dr. Jesperson's dream of helping "sick and downtrodden" children did not flourish. But other children and adults used the camp, beginning in 1927. Most groups or retreats (Lutheran and non-Lutheran) brought their own leaders, who organized all of the week's activities.

The second camp director was Axel Nelson. During his tenure, a girls' week and Luther League Camp (the Lutheran youth group) was created. Luther Leaguers had been meeting on Long Lake in Illinois. Granger Westberg, a former camper at Long Lake, fell in love with Geneva Lake while lifeguarding at Cisco Beach. He pushed to move the Luther League Camp to Cisco Beach. His argument was that "the moon shines brighter over Lake Geneva." In 1946, when the property was deeded to the Augustana Synod of the Lutheran Church, Cisco Beach Camp's name was changed to Camp Augustana.

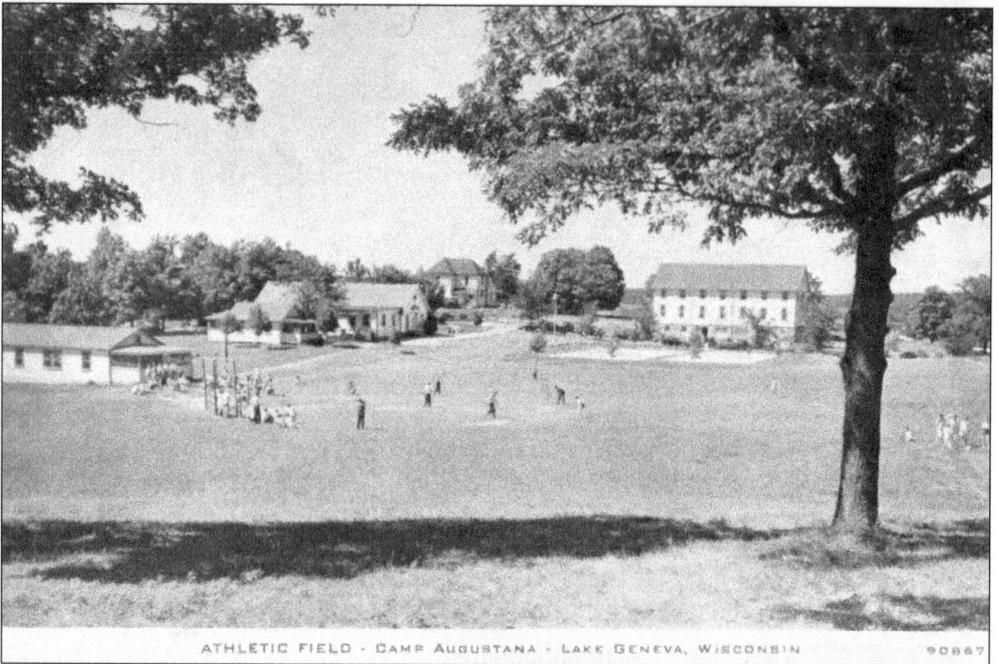

ATHLETIC FIELD - CAMP AUGUSTANA - LAKE GENEVA, WISCONSIN 90867

The former farm near Highway 50 was easily transformed into an athletic field. Surrounding the field were the dorms, the dining hall, the barn, and an office building. Additional dorms and a new chapel were later built on the property. (Courtesy of the Melvin family.)

The barn was transformed into the first chapel. Like at the other church camps on the lake, campers spent a good deal of time in chapel. Before breakfast, there was matins. After supper, there was vespers. Choir camps rehearsed in the chapel. (Courtesy of the Westberg family.)

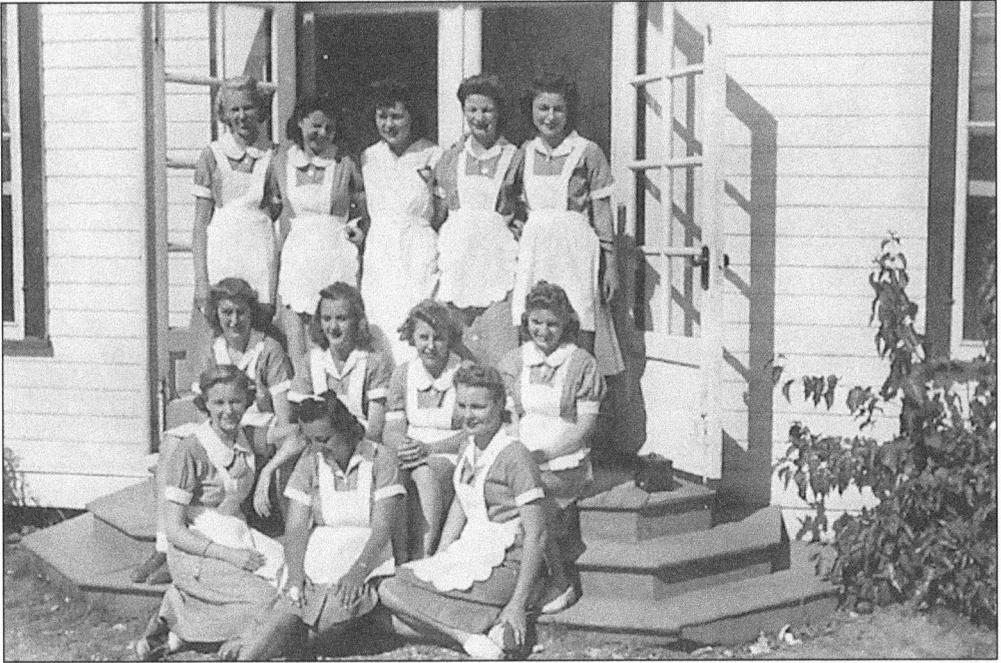

The dining hall accommodated 100 people and food was served family style. Songs sung by the staff and the campers were a big hit at mealtime. Campers kept a close eye out for anyone, particularly adults, who sat with their elbows on the table. If elbows were on the table, the campers burst into a chorus of, "Sue, Sue, young and able, get your elbows off the table. Round the table you must go." And yes, "Sue" had to walk around her long table in both directions until the song finished. Pictured here are waitresses from the 1940s (above) and the 1960s. In the 1966 image, Carol Melvin is in the third row, fourth from left. (Above, courtesy of the Westberg family; below, courtesy of the Melvin family.)

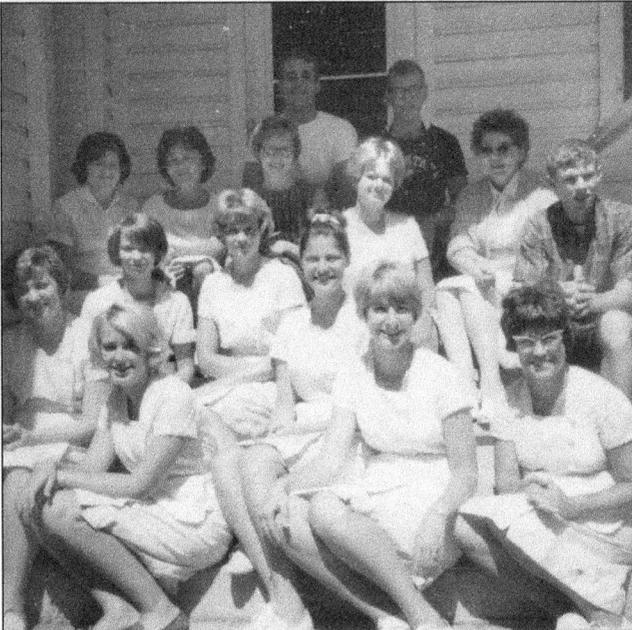

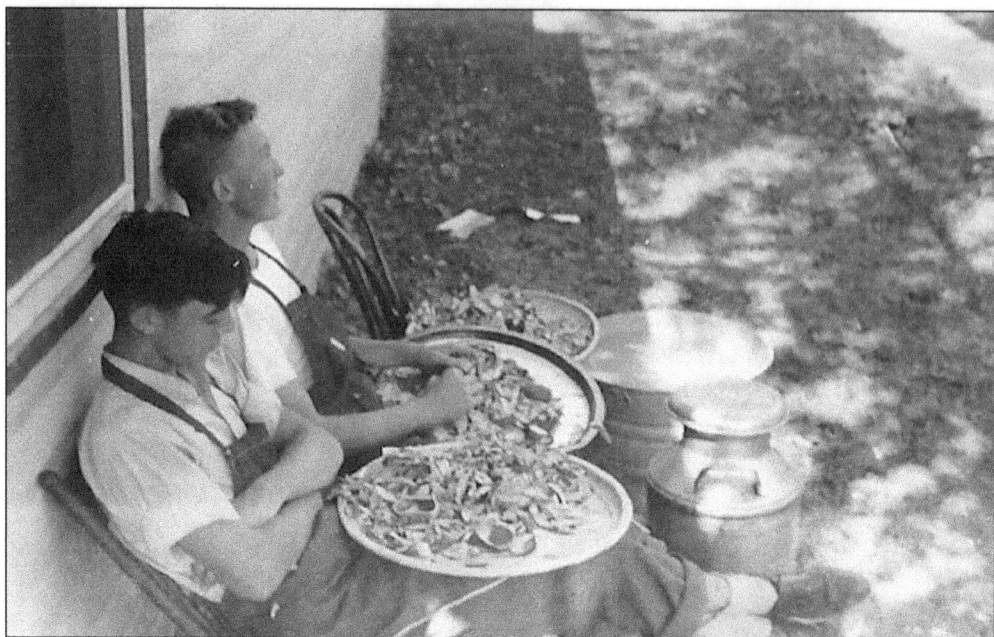

The two unidentified workers pictured are preparing food for a meal. The dining room would be nothing without the kitchen and the cooks. John Oliver did double duty on Sundays. He woke early to peel potatoes, then went to the chapel to play the organ. He first practiced with the choir and then played for services. After church, he returned to the kitchen to wash pots and pans. (Courtesy of the Westberg family.)

Each dormitory was named for a Lutheran college. Beds were squeaky, and blankets were thin. The dorms were far from fancy, but to campers it did not matter. What they loved were the activities. Awards were given for various achievements. John Westberg received the "neatest camper" award. His secret was that he never unpacked his suitcase. He wore nothing but his swimsuit and the outfit he arrived in. (Courtesy of the Westberg family.)

Families stayed in cottages with kitchenettes and bathroom but they did not have hot water. The cottages did not look like much, but to be able to spend a week on Geneva Lake was heaven no matter what. An ice truck drove among the cottages to fill the iceboxes that were on the porches. The tilt of the "ice sign" indicated to the iceman how much ice was needed. (Courtesy of the Westberg family.)

Whether campers in dorms or families in cottages, people walked down this road to get to the lake. After evening bonfires on the shore, campers hiked back up, surreptitiously singing songs not taught at the bonfire, such as "99 Bottles of Beer." (Courtesy of the Westberg family.)

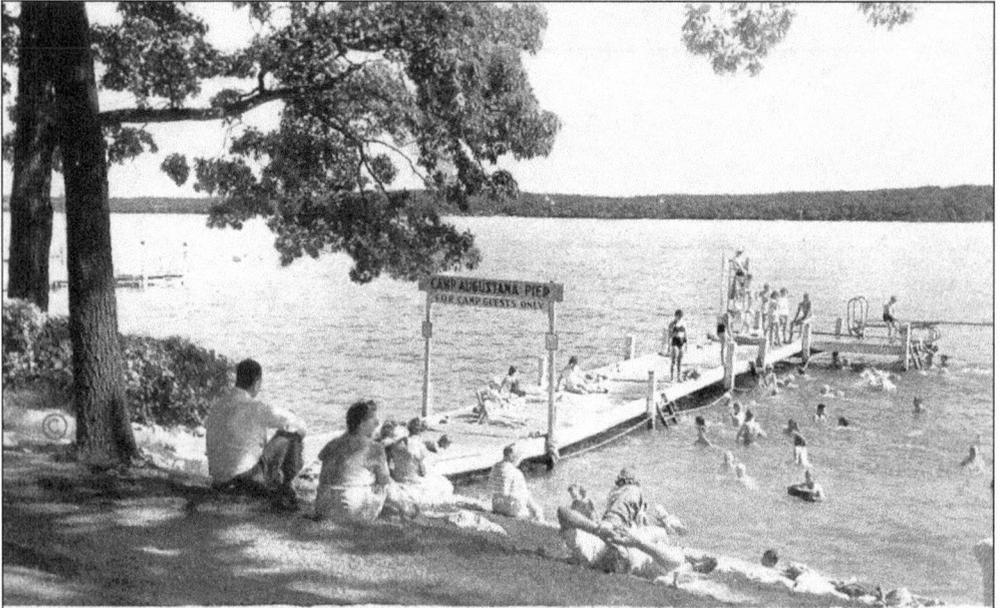

THE PIER AND WATERFRONT · CAMP AUGUSTANA, LAKE GENEVA, WISCONSIN 93132

Of course, the most important feature of Camp Augustana was the waterfront and pier. The camp was located in Cisco Bay, which was named after the tasty cisco fish that surfaced in June to spawn. The ciscoes were small fish that lived in the depths of the lake. When they surfaced, they were caught by the hundreds. (Courtesy of the Westberg family.)

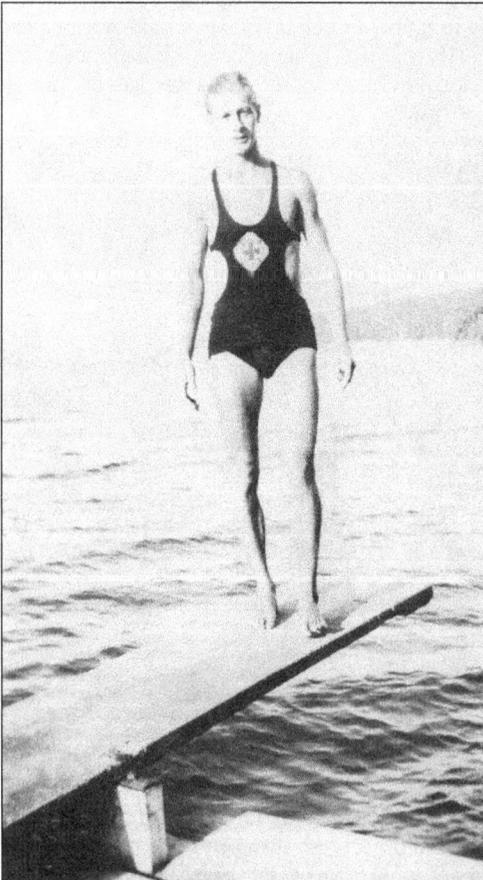

The clear cool waters of Geneva Lake erased any memories of heat, humidity, and mosquito bites. The shouts of kids in the lake was a constant, spanning the years from the cumbersome swimming costume to the bikini. Pictured here is Granger Westberg as a lifeguard in 1932. (Courtesy of the Westberg family.)

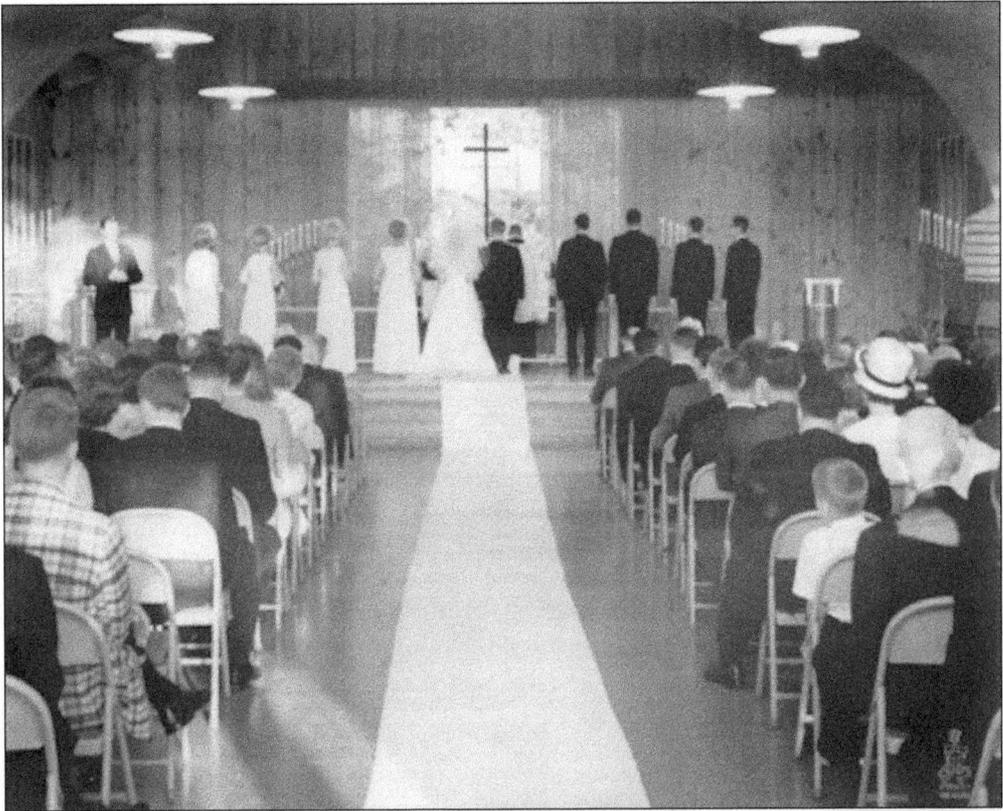

A new camp chapel was built in 1953. The camp chose not to install stained-glass windows so that the congregation could appreciate the beauty of the woods. Sunday services were packed, with some people spilling out onto the lawn. Since there were no campers on Sundays, attendees were people from around the lake area or folks who had come up for the day. The church soloist in the 1960s, Charles Johnson, was a performer in the Dells. Because of his strong ties to the Melvin family, he drove down after his Saturday night shows to sing at both services. Pictured here is the 1966 wedding of Grace Melvin and Jim Hanny. The soloist on the left is Johnson. (Above, courtesy of the Melvin family; right, courtesy of the Evangelical Lutheran Church of America Archives.)

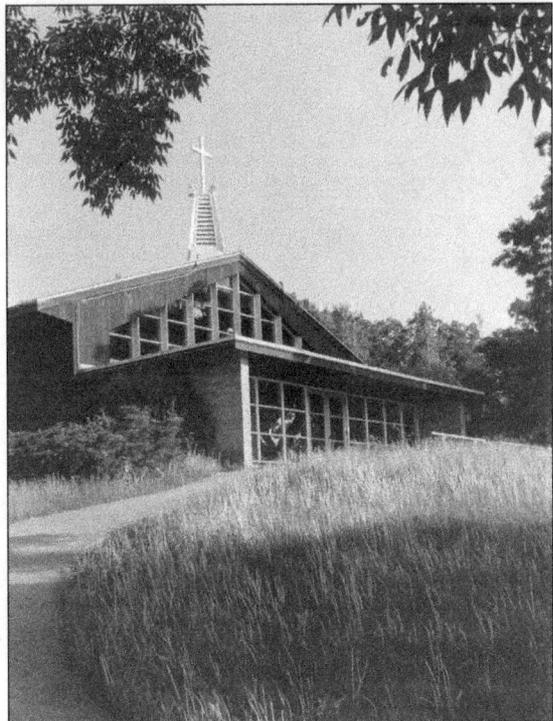

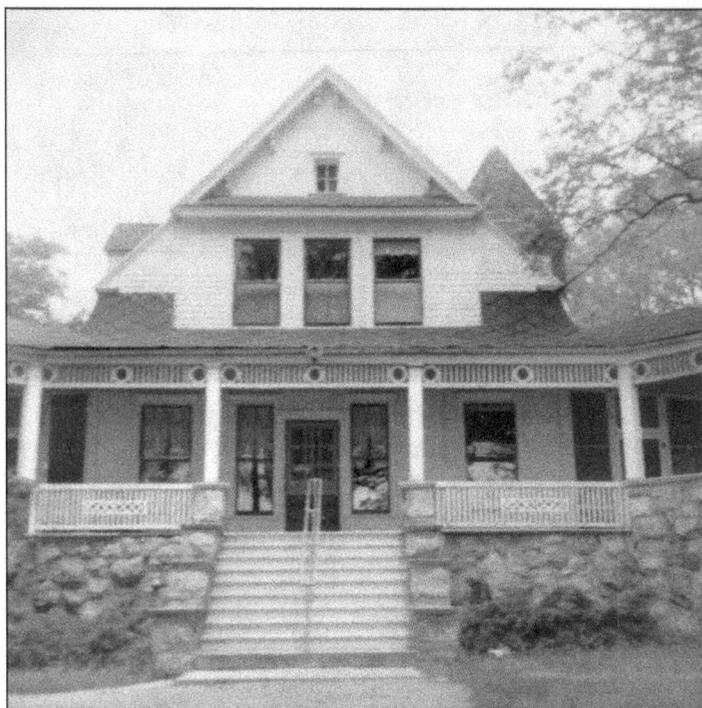

Camp Augustana bought the Immanuel Women's Home Villa in 1955. This gave the camp more housing, an additional dining room, and a total of 400 feet of lakefront. Just west of the villa was a clay tennis court. Chicken was served every Sunday at noon. Afterward, people sat in the Adirondack chairs by the beach drinking coffee and eating cake. Many families from the Chicago and Rockford Lutheran churches came for the day. The bride standing on the intricately carved stairway is Carol Melvin Raabe. (Both, courtesy of the Melvin family.)

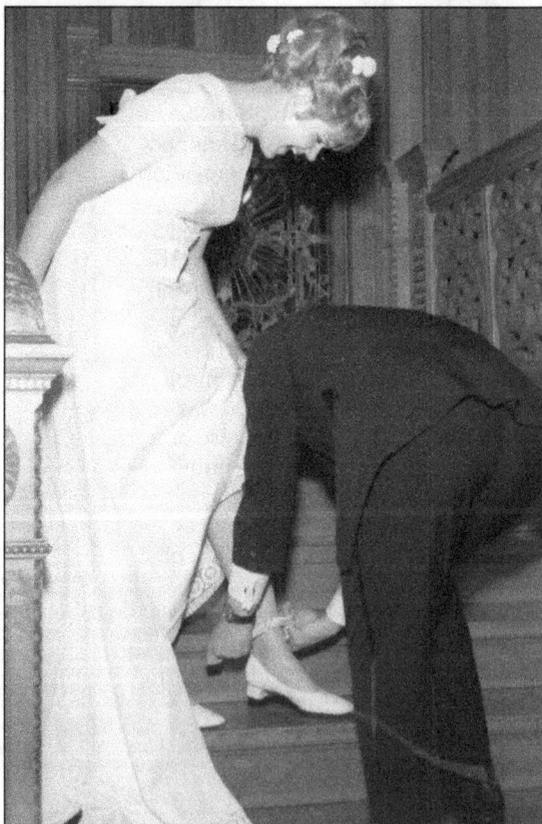

In 1960, Pastor John Melvin (above) became the camp's director. His mission was to turn Camp Augustana into a year-round camp. His wife, Pearl, and all three of their children worked at the camp. Pearl played the organ. Their son, Bruce, went by the name of "Ole Tuneberg" so that people would not figure out that he was related to the director. Among Bruce's many responsibilities was cleaning the water tank, which was in the lake, about 100 feet from shore in 20 feet of water. Their daughters, Grace (left) and Carol (pictured with their dog), held almost every job at camp. From September through May, the camp functioned with a skeleton crew—the Melvins and two other families. They cooked, cleaned, and washed the dirty linen all week long. On weekdays, when no guests were present, they ate the weekend leftovers together in the dining hall like one family. (Both, courtesy of the Melvin family.)

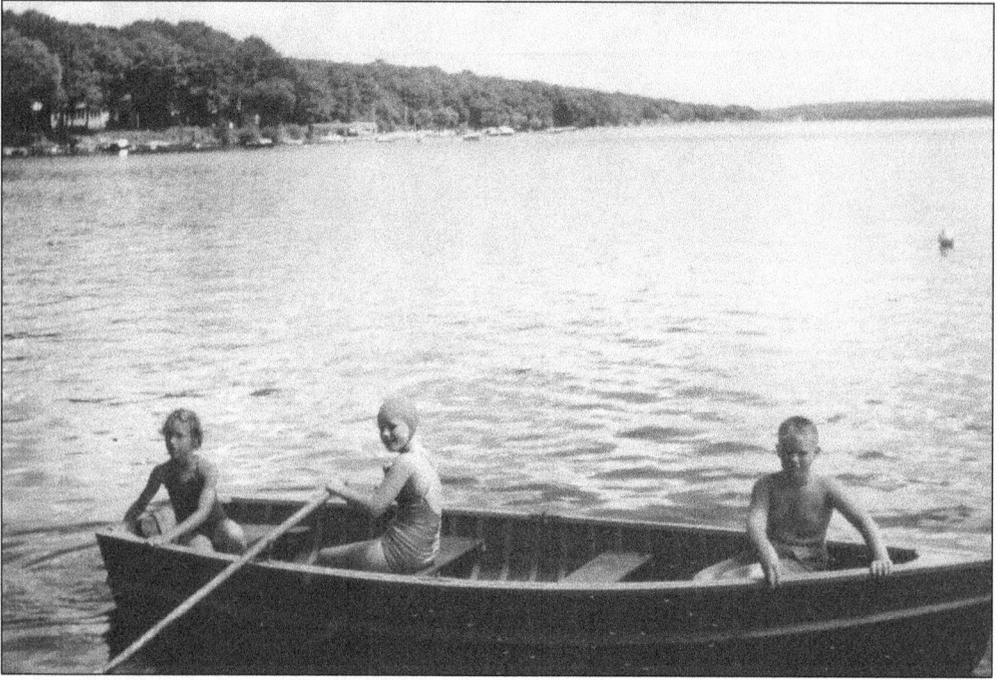

Rowboats at Camp Augustana were popular. At the end of each summer, rowers accompanied the staff who wanted to swim across the lake. The Brissman children are in the above photograph. Their father, a physical education professor at Augustana College, ran the facilities in tandem with the camp pastor. In 1977, the camp moved to Oregon, Illinois, and sold its lake property to developers. The chapel remains in its wooded setting on the hill. In the photograph below, from about 1950, Helen Westberg is holding Joan, with Jane and John seated in the front of the boat. (Both, courtesy of the Westberg family.)

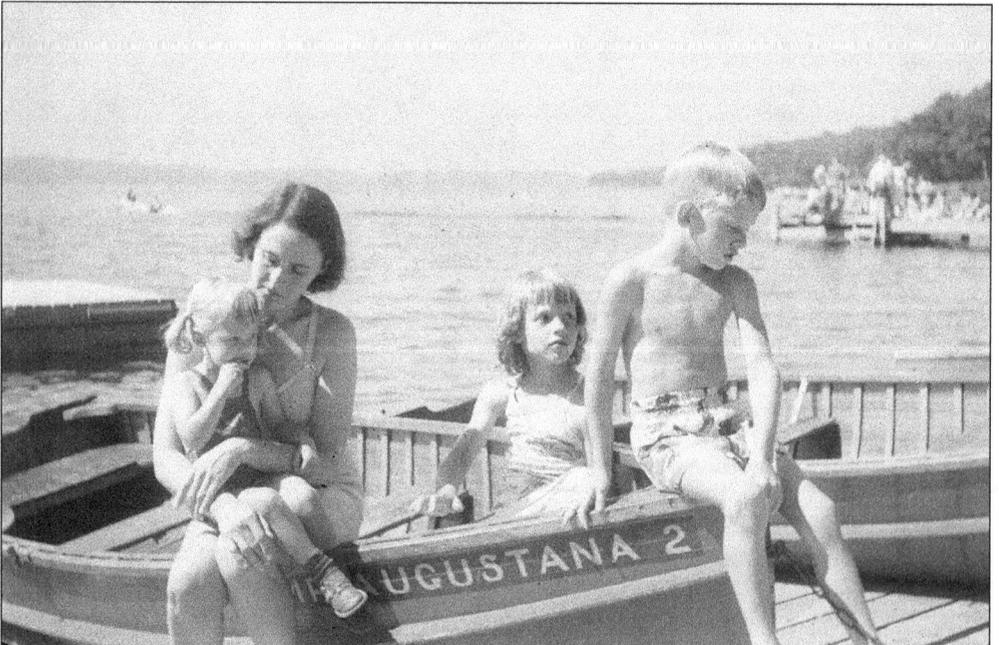

Seven

SPIRITUAL LIFE AND GROWTH
WILLIAMS BAY BIBLE CAMP AND CAMP WILLABAY

The Norwegian branch of the Evangelical Free Church had always rented camp facilities. In 1946, it was ready to buy a camp of its own. A secret meeting was held to buy 20 acres of weedy marshland in Williams Bay from the Chicago & North Western Railway. This land was being used by the local Boy Scouts, who had built a log cabin on it. The cost of the property seemed considerable: $5,000. The church raised the money and bought the railroad property. It held the dedication in the Boy Scouts' log cabin. The official name was Evangelical Free Church Bible Conference, or Williams Bay Bible Camp for short. Rolf Egeland was the first camp manager.

Over 50 churches in Madison, Milwaukee, Chicago, Moline, and Rockford areas participated in Camp Willabay. It became a place for evangelism, training, outdoor education, conferences, revivals, and fellowship for the entire family. Carl Weir, the executive director in 1971, remarked, "Camping offers the greatest outreach for evangelism we have today." Camp Willabay provided an immersion into Christian community for young people. The purpose of the Bible camp was for campers to learn more about the scripture, memorize Bible verses, and be in fellowship with other Christians.

A year of hard work was required before the camp could open. Up to 125 volunteers worked Saturdays. Thousands of volunteer hours along with hundreds of thousands of dollars in donations (financial and material) built the cabins, sports areas, and meeting spaces.

A plumber was hired to connect a water line to the camp, but he did not feel the need to finish the project in a timely fashion. Out of desperation, the staff took on the challenge of completing the water line themselves. They tunneled underneath the road to bring water from a fire hydrant. The workers were down about 12 feet when they accidentally cut the telephone cable. They finished the work, digging on their hands and knees. Eventually, they reached the other side of the road and connected the pipes. That was at 5:00 p.m. on the day camp opened in 1947.

Over the years, volunteers continued to build and repair several structures at the camp, including the tennis court and, later, the swimming pool. The Omans were among the many families who helped out. In the image below, C. Wilbur "Bill" Oman is second from left; his son Joe is in front of him. (Above, courtesy of Camp Willabay Heritage Files; below, courtesy of Wendell Oman.)

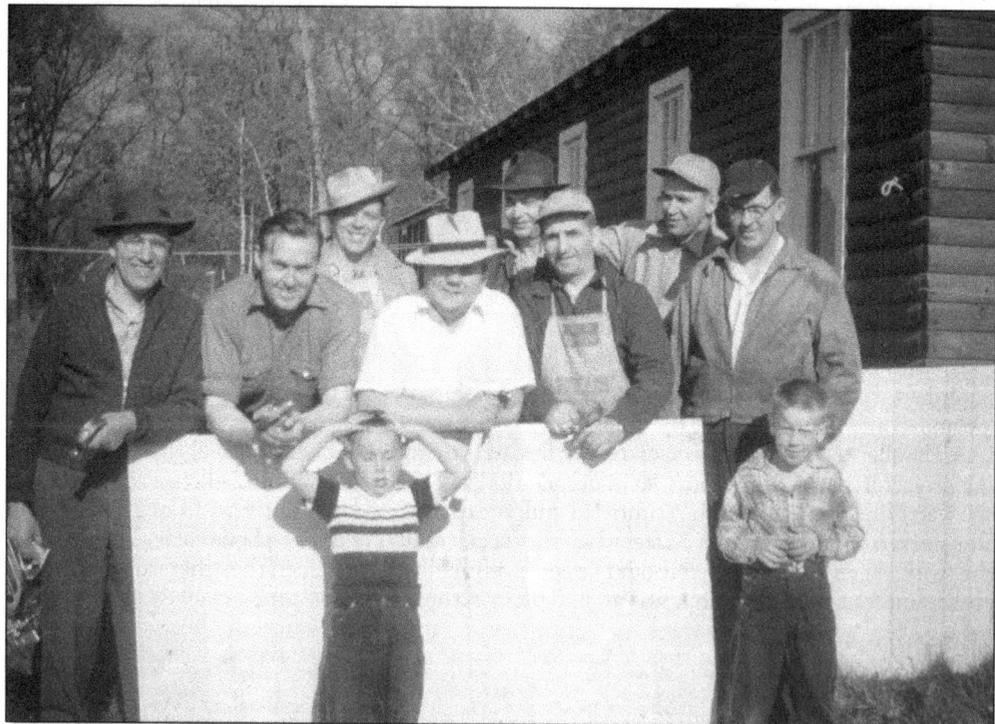

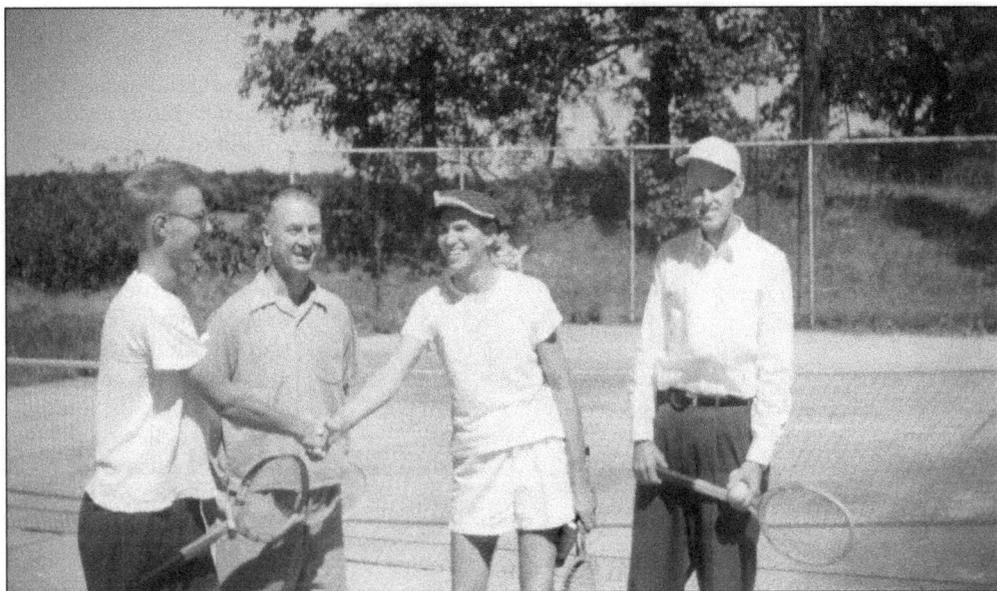

Men from Rockford built the tennis courts—a long, tedious job. Due to lack of space, a compound for covering the cement was stored in the kitchen. It was white, powdery, and looked like salt. The cook flavored one Saturday night's meatballs with it. The men enjoyed the meatballs, but soon complained of stomachaches. Pictured here, post-stomachache, is Joel Oman (left) shaking hands with Edwin Oman. Bill Johnson is on the right, and the man second from left is unidentified. (Courtesy of Wendell Oman.)

With World War II recently over, the War Assets Administration had plenty of tents to sell, which is how Willabay got 20 tents for the campers. In addition to the tents, the camp bought surplus blankets, bunks, mattresses, and powdered drink by the truckload. Wooden platforms were designed and built for the tents. Each tent held four bunk beds. Within a few years, cabins were built, replacing the tents. (Courtesy of Camp Willabay Heritage Files.)

The original dining hall began its life as a garage in Illinois. Men cut it into six-foot sections and hauled it up to Wisconsin. Since the kitchen did not have a dishwasher, the staff learned to wash dishes quickly. They could hand-wash dishes for 150 people in one hour flat. After meals, John Ingersall collected the leftover food and fed it to the pigs on his farm. On Friday nights, after scrubbing the floors of the kitchen, dining room, and porch, the staff sat back and treated themselves to "throat-cloggers"—thick malts or shakes made in the potato mixer. Dining room stories were abundant. For instance, when the campers were served canned peaches, each counselor received a raw egg yolk instead. Michael Oman is the taller boy on the steps of the dining hall in 1958. (Left, courtesy of Wendell Oman; below, courtesy of Camp Willabay Heritage Files.)

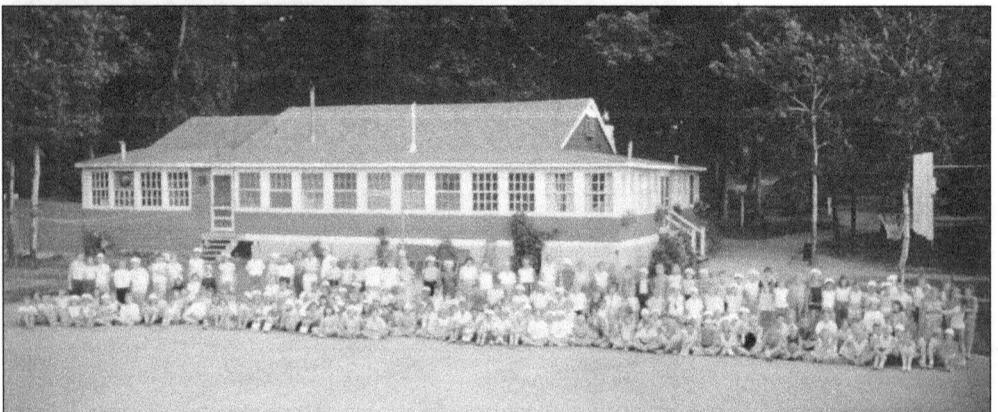

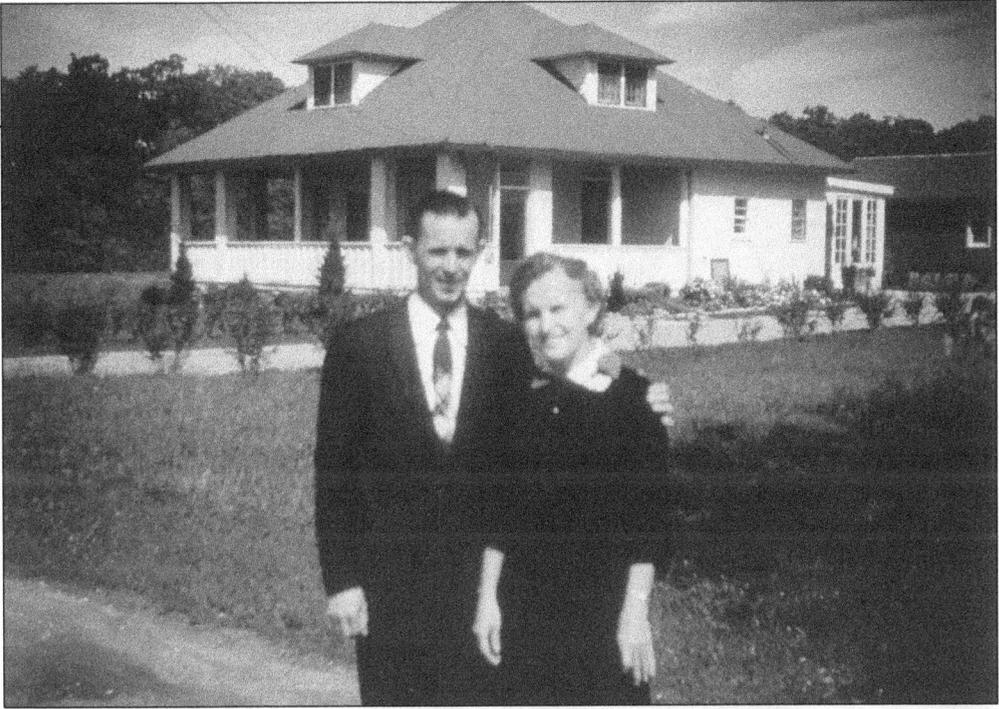

In 1955, Ed Ouland became first year-round camp manager. Ouland started a new ministry with weekend retreats. One weekend, Young Life leaders brought 13 gang leaders to camp. The staff was fearful and prayed much. Sunday at noon, after a big steak dinner, the leader of the Cobra gang (and speaker for the group) said, "Never in our lives have whities shown us as much love as all of you have this weekend." Pictured are Ouland and his wife, Ruth. (Courtesy of Wendell Oman.)

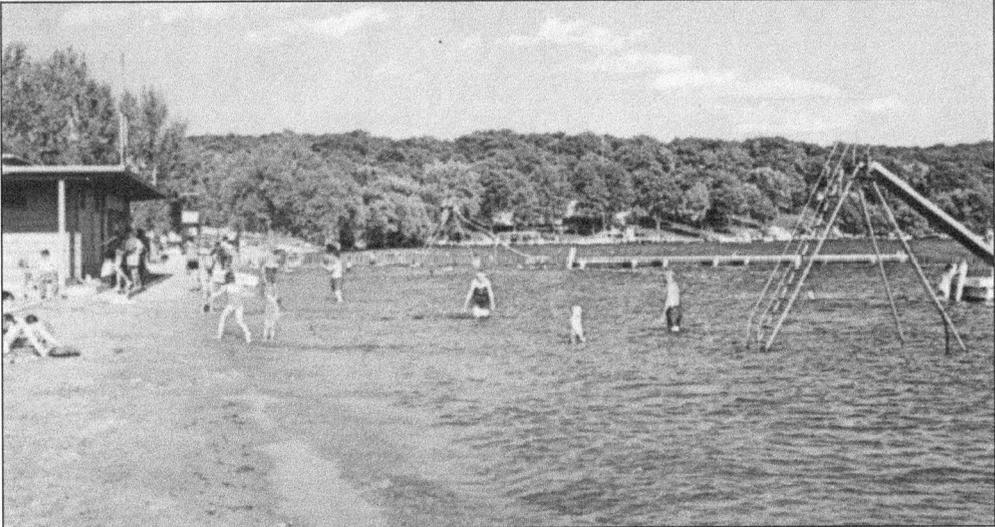

Camp Willabay did not own lake frontage. At first, campers swam free of charge at the public beach. A counselor walked as many as 200 campers to the beach, crossing the road one camper at a time. In the 1950s, the camp began paying $400 a year for use of part of the beach. As the beach became more crowded, the days and times campers could swim became restricted. (Courtesy of Camp Willabay Heritage Files.)

Camp Willabay offered to build its own pier, but permission was refused. By 1960, it was clear the camp needed a swimming pool. The $30,000 was acquired through fundraisers and by setting out dime banks in the churches. Volunteers constructed the pool. All went well until workers came upon a sinkhole. Somehow, they were able to plug the hole so they could continue with the construction. (Courtesy of Camp Willabay Heritage Files.)

One of the camp's goals was to teach every camper to swim. Administrators hired Red Cross–certified instructors. Each year, about 1,000 children passed from one swimming level to the next. Camp Willabay had a higher success rate than all the other camps and beaches on the lake combined. (Courtesy of Camp Willabay Heritage Files.)

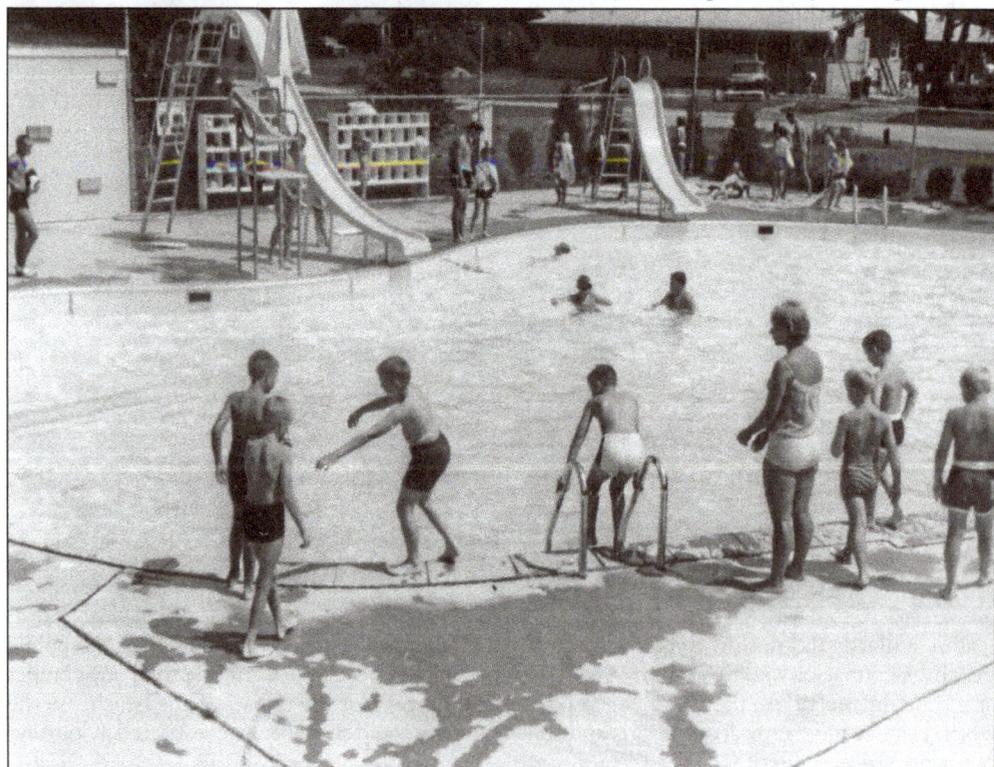

Camp was often a pivotal time for youth. Many made decisions for Christian vocations such as pastorates and the mission field. Wendell Oman was one such camper. He went on to be ordained in the Evangelical Free Church of America and become a hospital chaplain. Every summer, he looked forward to coming to camp to be with friends, swim, ride horses, and play tug-of-war in the mud. (Courtesy of Camp Willabay Heritage Files.)

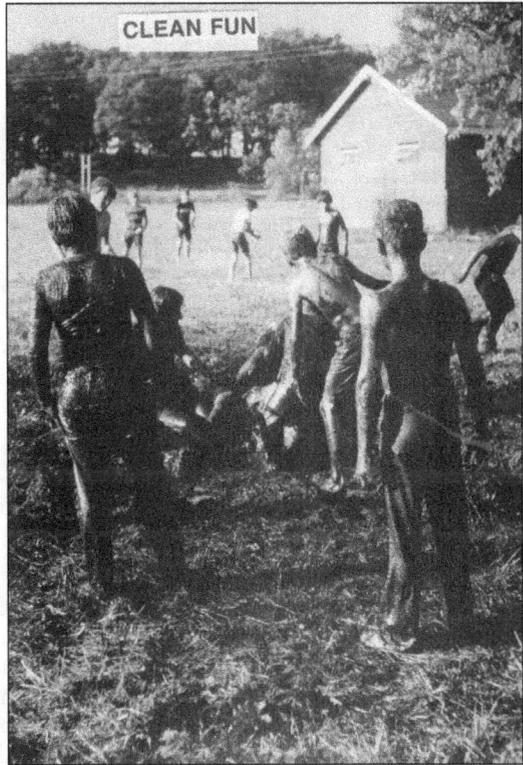

CLEAN FUN

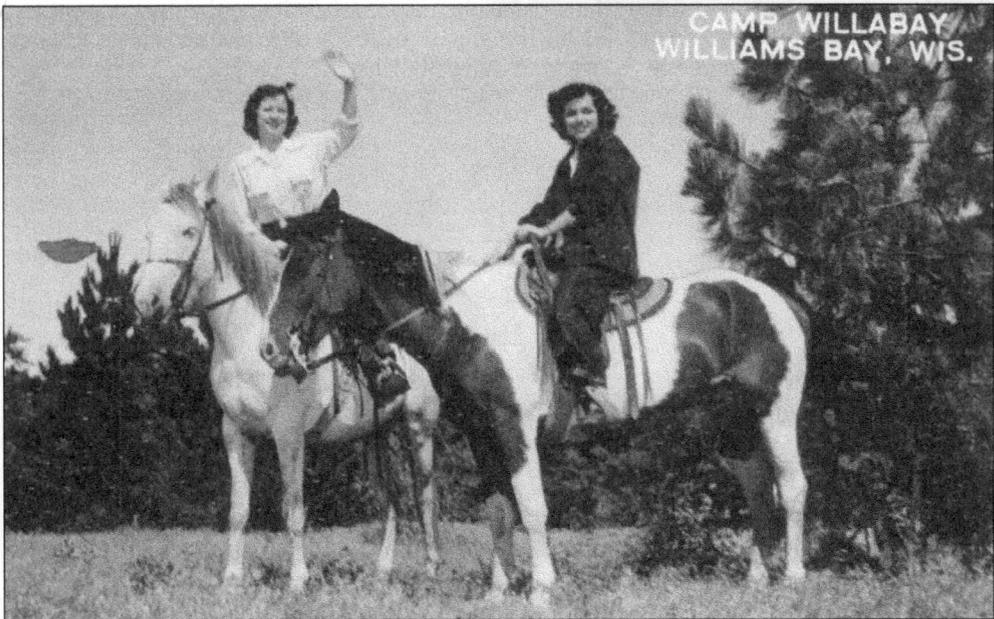

CAMP WILLABAY
WILLIAMS BAY, WIS.

An outstanding feature of Camp Willabay was the horsemanship program. Ed Ouland proposed it, but the board members were leery, remembering their own spills. So, Ouland bought two horses, and his brother-in-law bought another two. The board acquiesced in 1960 when members saw that horseback riding could be carried out safely. Within a year of offering the horsemanship program, the number of campers increased by 1,000. (Courtesy of Camp Willabay Heritage Files.)

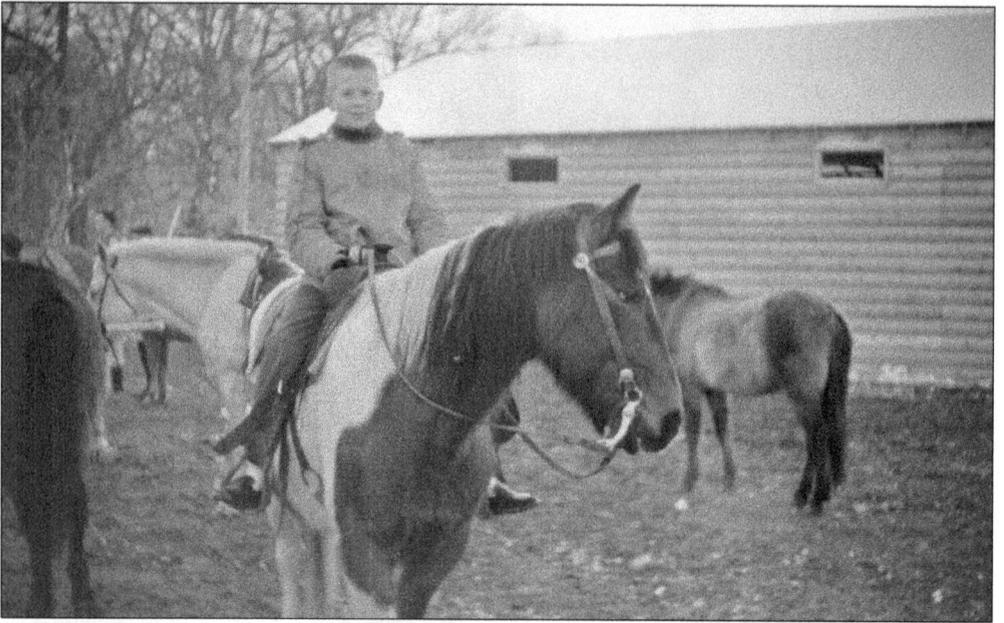

Wendell Owen describes riding Battleship, a wild, uncontrollable horse who would not stay on the trails. The horse gave a "mean ride." During the ride, Wendell screamed for his mother. One night, two boys locked a few horses in the girls' bathroom. About midnight, when some girls made a bathroom trip, the entire camp was awakened by their screams. In the morning, the culprits were discovered and brought in for a discussion with Ed Ouland. He told the boys to clean up the horses' mess. Harold Hansen was in the room as the boys were justifying their actions but had to leave when he broke into uncontrollable laughter. Randall Owen is pictured above. (Above, courtesy of Wendell Oman; below, courtesy of Camp Willabay Heritage Files.)

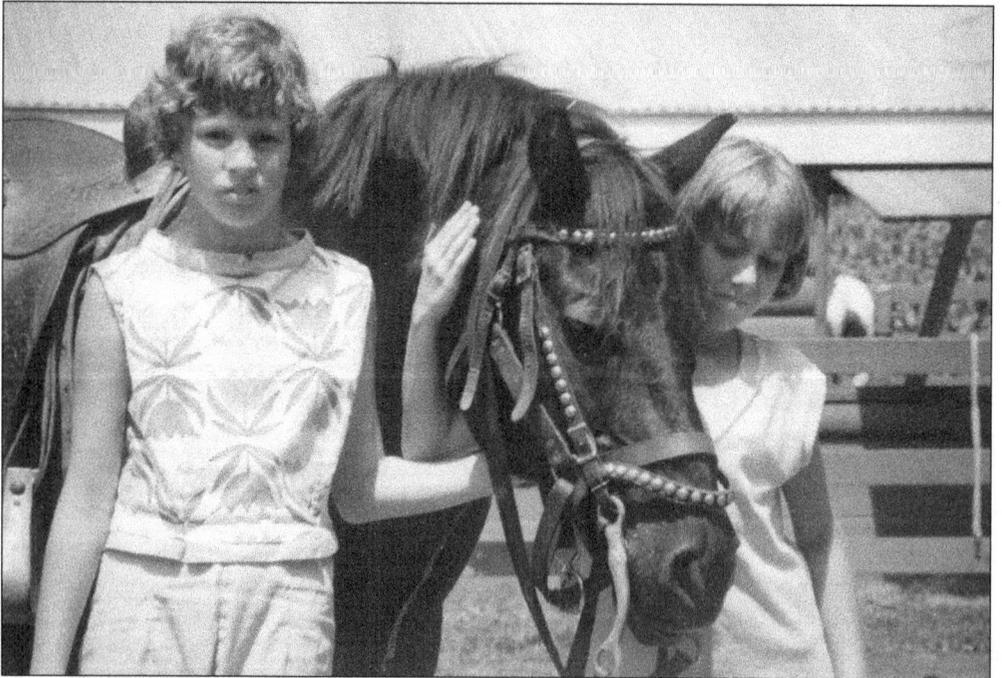

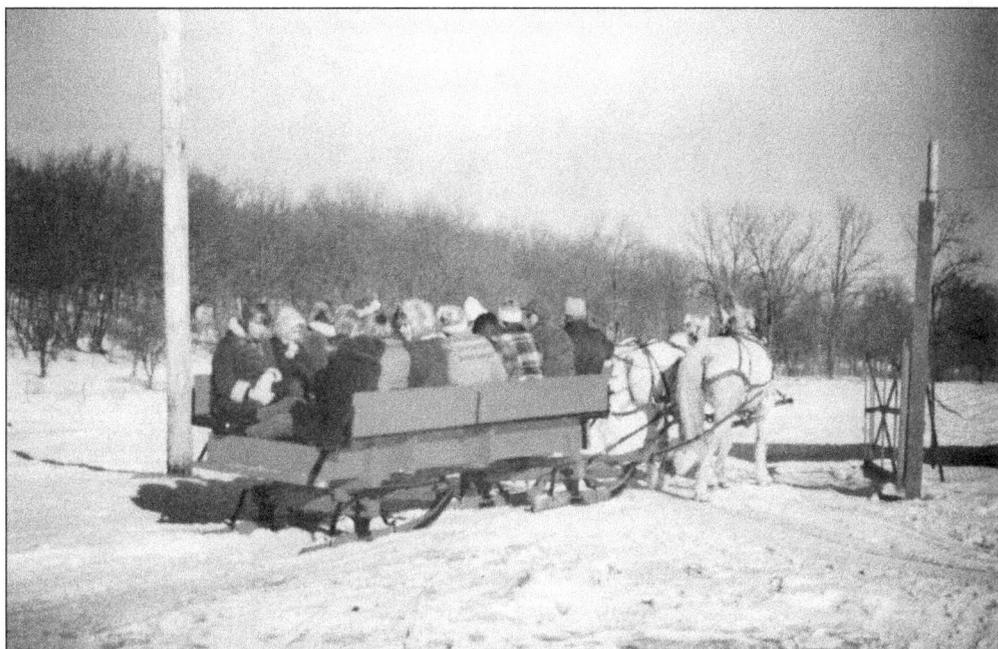

Snow Camp was a delightful weekend winter retreat for families and church groups with sleigh rides and a toboggan run. The toboggan slide was also in use during the summer. Paul Hanson and another staff member made the toboggan slide their cabin. At the top of the slide, up about 40 steps, was a small room—just right for two beds. The room had an electric outlet for a lightbulb and radio. They hung their clothes on nails. (Above, courtesy of Camp Willabay Heritage Files; below, courtesy of Wendell Oman.)

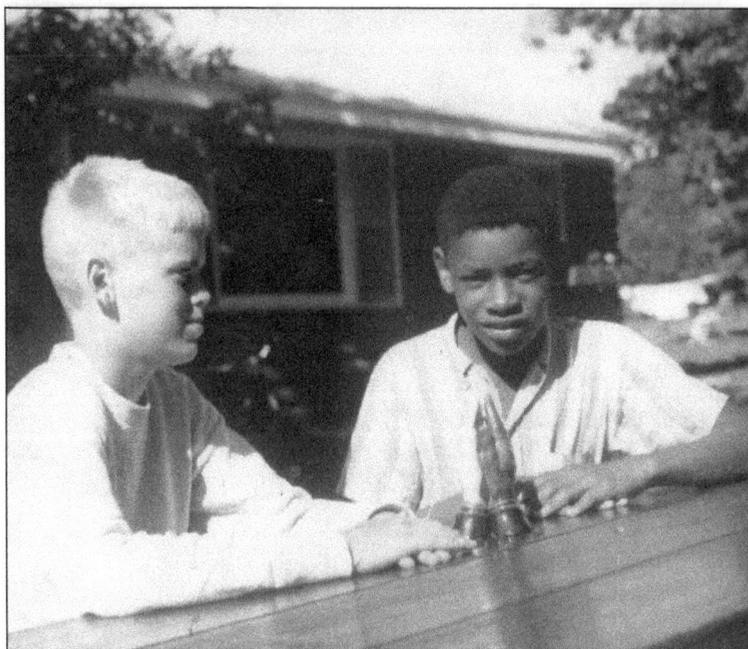

Among the crafts to choose from were ceramics—shapes already molded and ready to paint. An African American boy chose the praying hands. He painted one hand white and one hand black. When asked to explain he said, "This is the first place I've been to where blacks and whites could pray together." (Courtesy of Camp Willabay Heritage Files.)

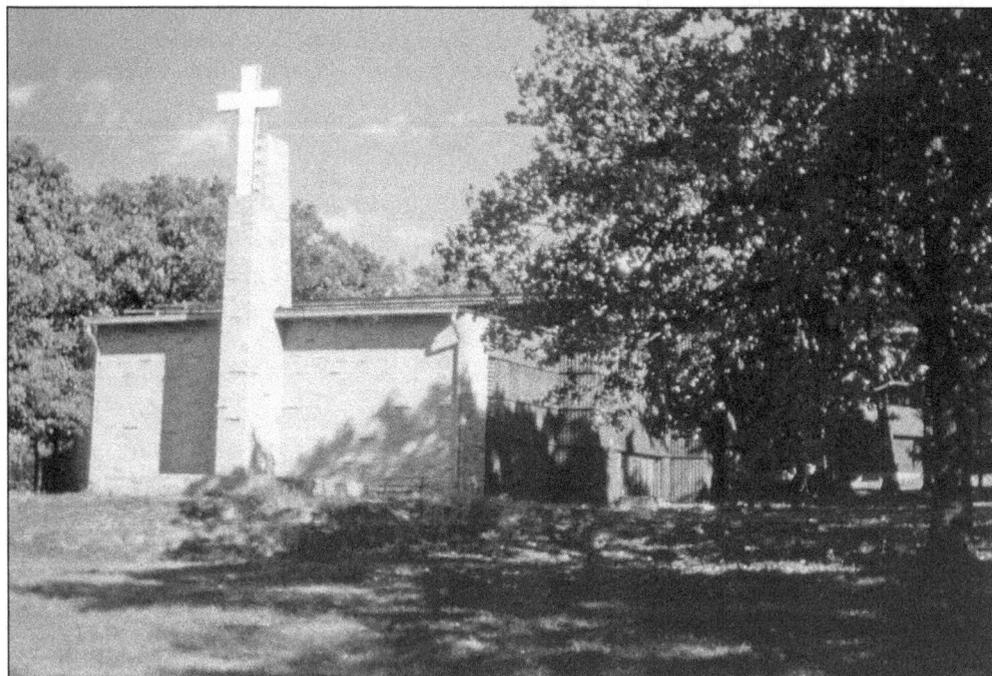

Worship services, talent shows, and musical events were held in the auditorium (also known as Camp Willabay Tabernacle). These events were open to the public. The camp had music conferences with choirs from Evangelical Free churches. But by 1972, Camp Willabay had outgrown its land. The Camp Willabay property was traded for 550 acres in East Troy. The new camp was named Timber-lee Christian Center. (Courtesy of Wendall Oman.)

Eight

Snug Harbor Estate Turned Bible Camp
Covenant Harbor

Early in the 1900s, the Evangelical Covenant Church in America got the camping bug. Although the Central Conference did not own a camp, the Young People's Mission Society held Bible conferences at camps belonging to other organizations.

Then, in the fall of 1939, the Snug Harbor estate, near the city of Lake Geneva, went on the market. The price was $75,000—a fair price for 53 wooded acres and 1,106 feet of lakefront. Including the stately mansion, there were seven winterized dwellings, which could house 200 people. But the Great Depression was still hanging on, and the churches clutched their purses. Instead, they bought a camp on Center Lake. Getting it ready for use was slow—people were still recalling the land on Geneva Lake they had passed on. Meanwhile, in 1947, Snug Harbor was for sale again. This time, the churches agreed to buy it, but they had to pay twice the earlier price. The deal was closed on November 1, 1947.

Furnishings for the camp were not difficult to come by—but building permits were. The city council and many residents of Lake Geneva had grievances about a camp within the city limits. For instance, would there be sanitation problems? Building plans for the camp were put on hold.

Other than that, the camp sessions went smoothly, with Victor "Uncle Vic" Person acting as the first camp manager. Early managers were primarily maintenance people who reported to the board of directors. Program staff were only hired for the summer. Each session cost between $13.50 and $17. The counselors and program staff volunteered their time. Covenant Harbor always welcomed groups outside of its denomination. The primary requirement was that the organization have a spiritual purpose.

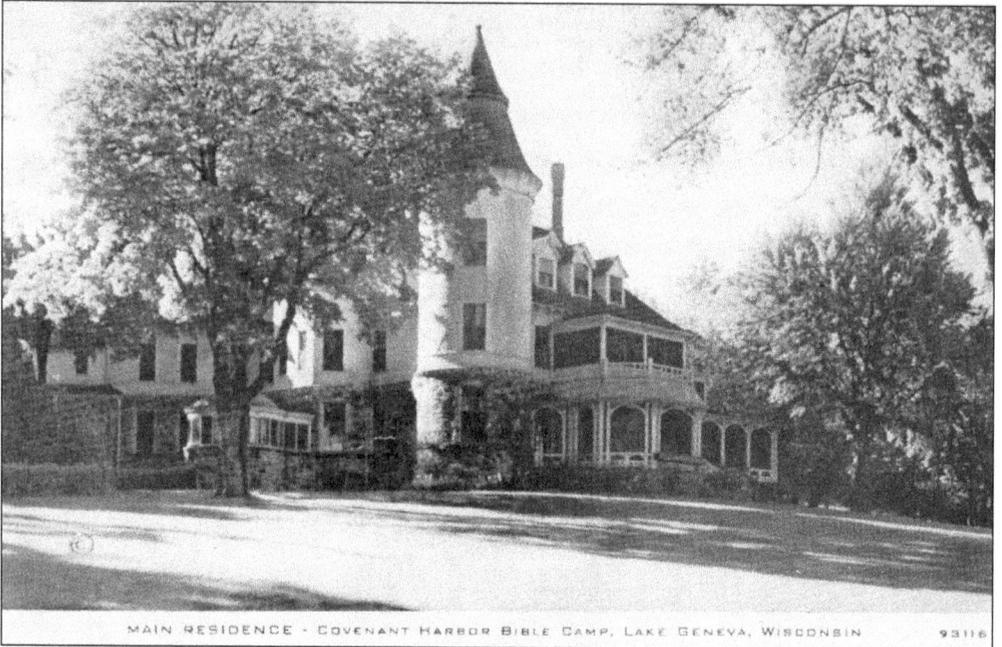

MAIN RESIDENCE · COVENANT HARBOR BIBLE CAMP, LAKE GENEVA, WISCONSIN 93116

The big house held the administration offices and slept 90 campers. It was three stories high, with a tower, a secret passage, 26 large rooms, and 11 bathrooms. Since the city would not grant permits for a new dining hall, all of the meals were eaten in the mansion. Along with the house came the legend of the "Red Hatchet Lady." She had been the cook on the estate when the Bordens owned it. The Red Hatchet Lady was furious that Snug Harbor had been sold for a camp. She lurked in the woods and grabbed kids who dared to go near her. (Both, courtesy of CAHL.)

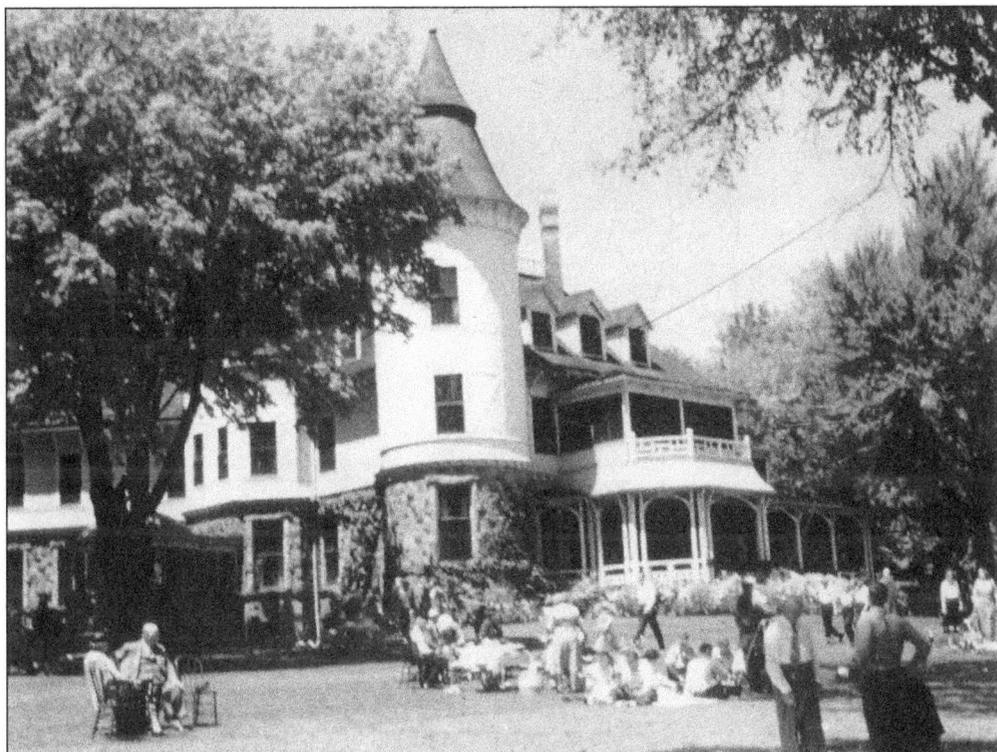

Typically, families from the Rockford and Chicago churches drove up on Sundays for a day at the camp—worshipping, picnicking on the lawn, and swimming. The photograph above shows the camp on Dedication Day. This tradition of Sunday worship and picnics was rejuvenated in the 1980s. Sometimes, close to 1,000 people participated. The girls at the right are playing box hockey. (Both, courtesy of CAHL.)

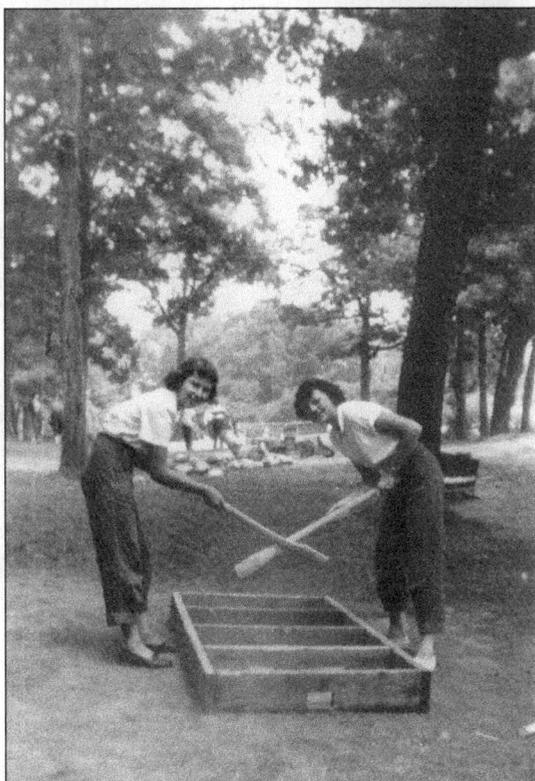

Bunk beds were set up for campers. Living in an old mansion brought its own kind of fun. A few boys discovered the secret passage. What they did not bargain for was that it led downstairs into the camp manager's room. (Courtesy of Covenant Harbor.)

The permit for the dining hall was approved after a struggle with the city. It became known as the "building that coffee built," since coffee was the fuel for the volunteer labor. The men of the conference donated 349 workdays. The new kitchen and dining hall seated 425 people and was ready by the summer of 1949. (Courtesy of CAHL.)

From the beginning, groups came to Covenant Harbor a few weekends every winter. Children as well as adults enjoyed tobogganing and the novel experience of fishing, walking, and skating on a frozen lake. (Both, courtesy of Covenant Harbor.)

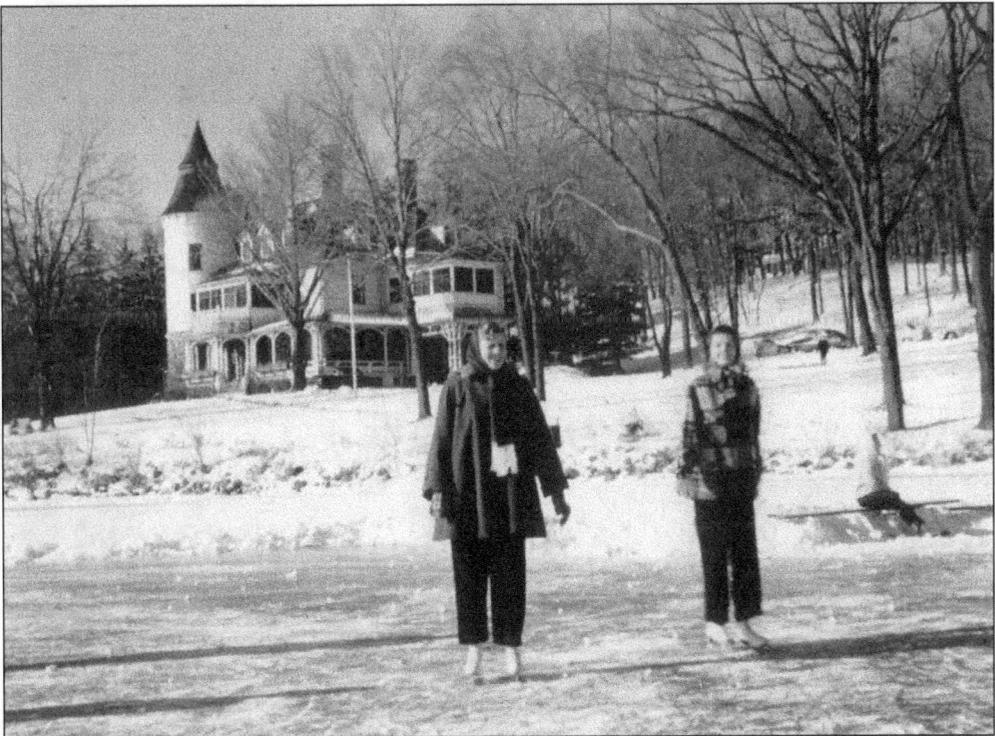

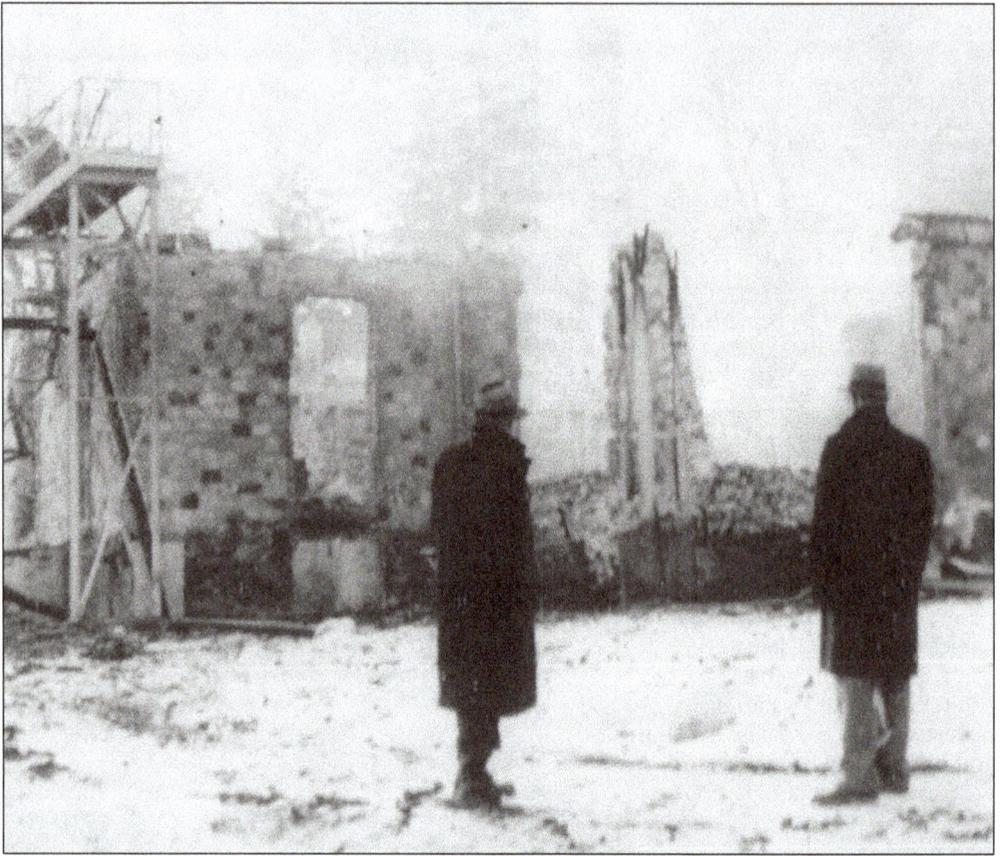

The big house was lost to a fire in January 1957. Poor wiring was most likely the cause. The fire department was called when the power company spotted flames in the basement. Because winter temperatures had frozen the fire hydrants, water had to be pumped from the lake. Still, with the high winds, it was impossible to contain the blaze. By losing the big house, the camp lost its winter retreat center and two-thirds of its summer lodging. (Both, courtesy of Covenant Harbor.)

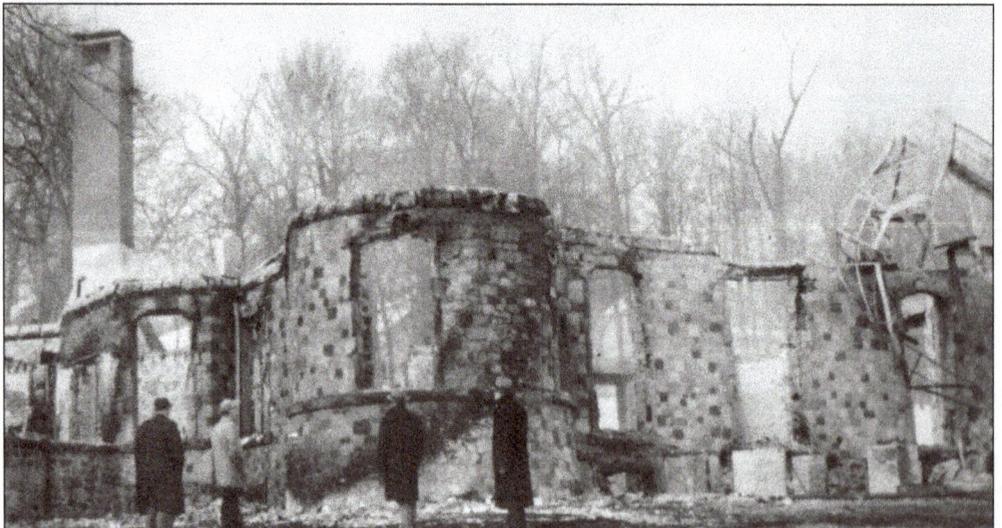

Among the treasures lost in the fire were two grand pianos and 12 original paintings by Warner Sallman. Sallman is most famous for his *Head of Christ*. (Courtesy of CAHL.)

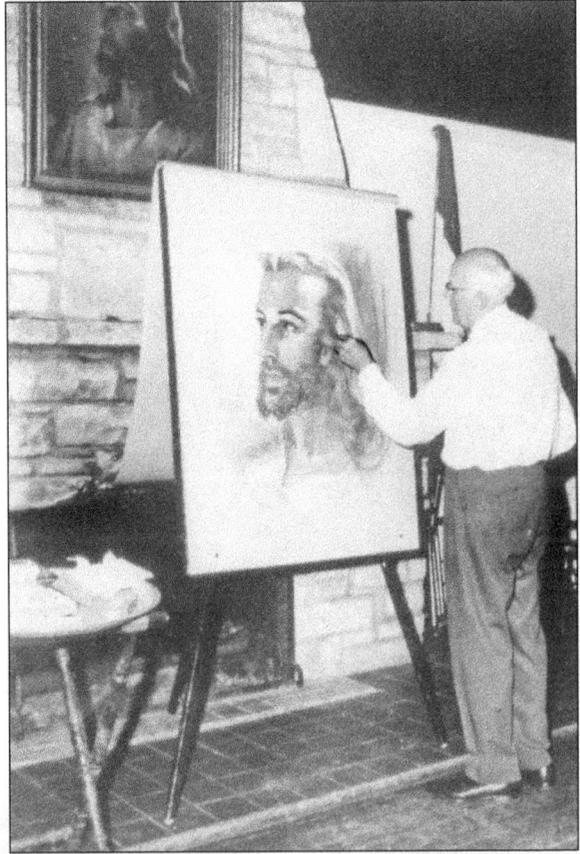

After the fire, the camp was closed for one year (youth camps were held elsewhere) while Covenant Harbor fought in the courts for the right to rebuild. The fight took a year, ending at the Wisconsin Supreme Court. Two cabins, the Twins, were moved together, and a center area was built between them. Rather than build six new cabins (which the courts had granted), Covenant Harbor added sleeping rooms to the ends of the dining hall. (Courtesy of CAHL.)

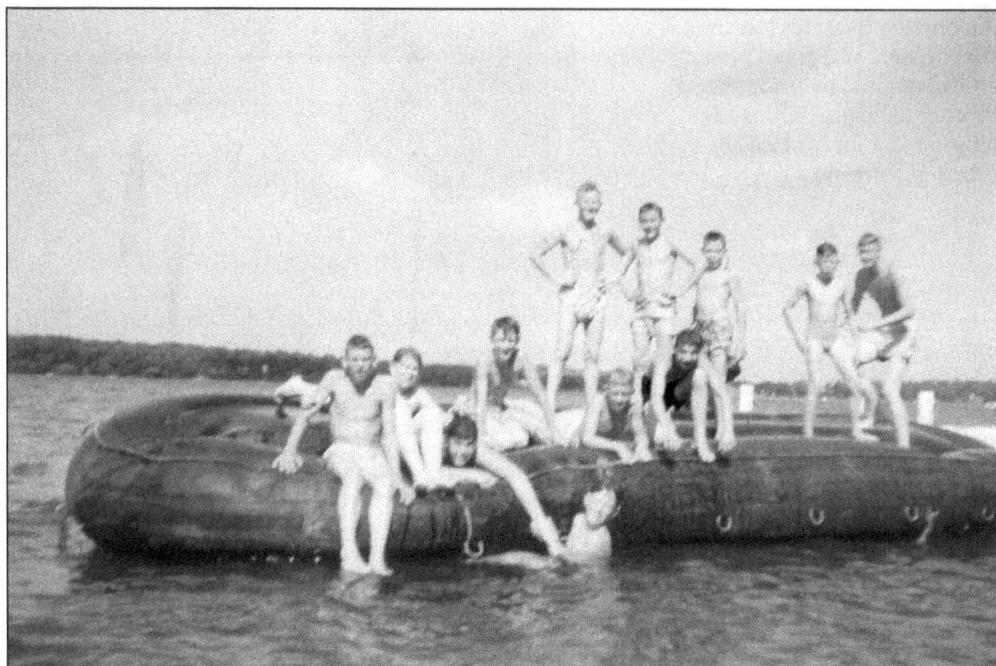

Covenant Harbor's raft was enormous, a challenge to climb on, and feet-burning hot until splashed with water. (Courtesy of CAHL.)

Inez Olander, a physical education teacher at North Park Academy (now North Park University), slathers a watermelon with lard in preparation for a game in which two teams try to capture it, one from the other. (Courtesy of CAHL.)

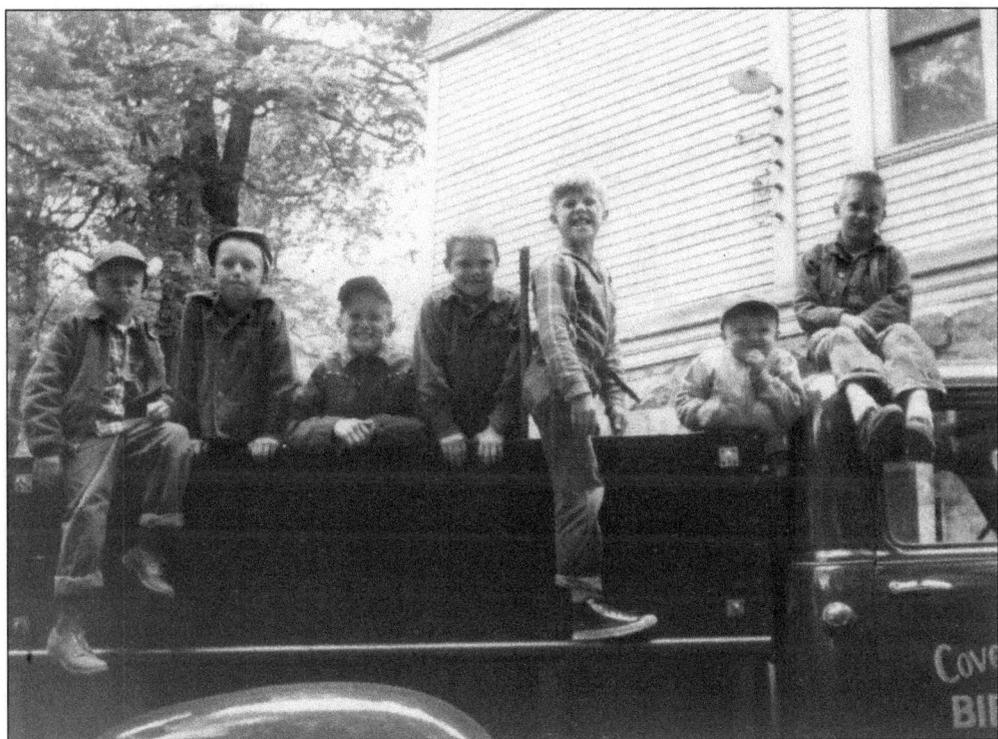

Most kids went to camp to play. The three Klockars brothers did, too, until they were teenagers. Their parents were immigrants from Finland. In the summer of 1961, they left their sons at Covenant Harbor while they returned to Finland for a visit. The boys stayed free of charge in exchange for labor. The three boys worked on the waterfront, in the kitchen, and on the grounds. Above, Bob is the boy sitting on the truck's cab. The photograph at right shows Bob (left), his twin brother, Bruce, and their older brother Karl. (Both, courtesy of Robert Klockars.)

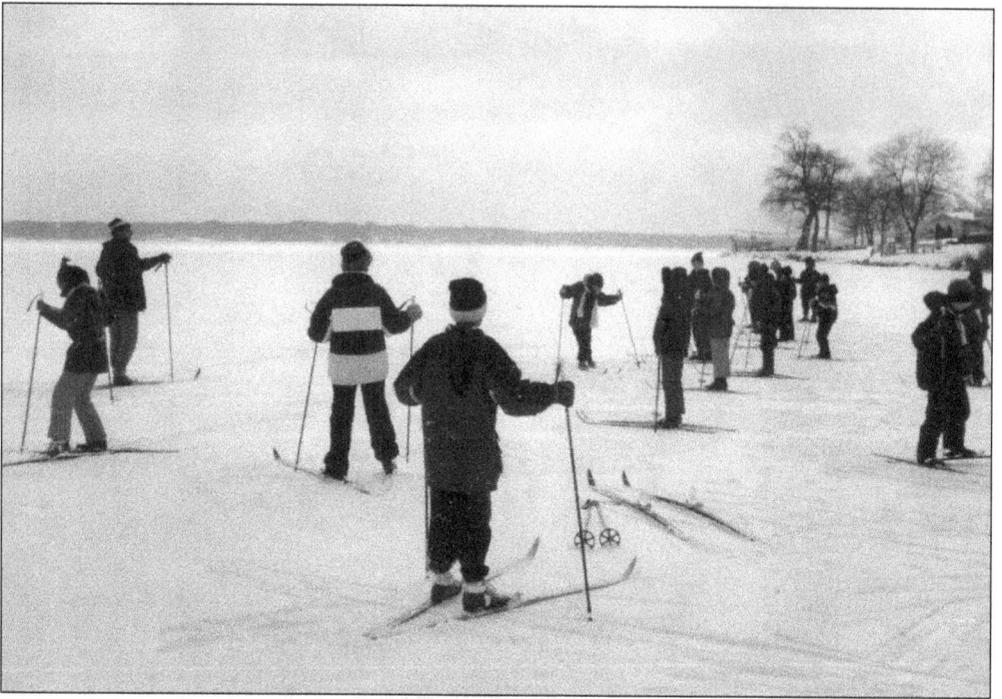

Under the direction of Pete Heintzelman (1979–2001), the camp saw significant growth in buildings, remodeling, staff, and rentals. Geneva Bay Lodge was built with a year-round Elderhostel program in mind. Outdoor education programs began. According to Heintzelman, camp was a life-changing experience for many. People got a sense of belonging to something bigger than their immediate group of friends. (Both, courtesy of Covenant Harbor.)

In the spring of 1986, the camp built its first ropes course. This came about through a donation from the American Diabetes Association, which had moved from Holiday Home to Covenant Harbor. One of its features was a trapeze. (Courtesy of Covenant Harbor.)

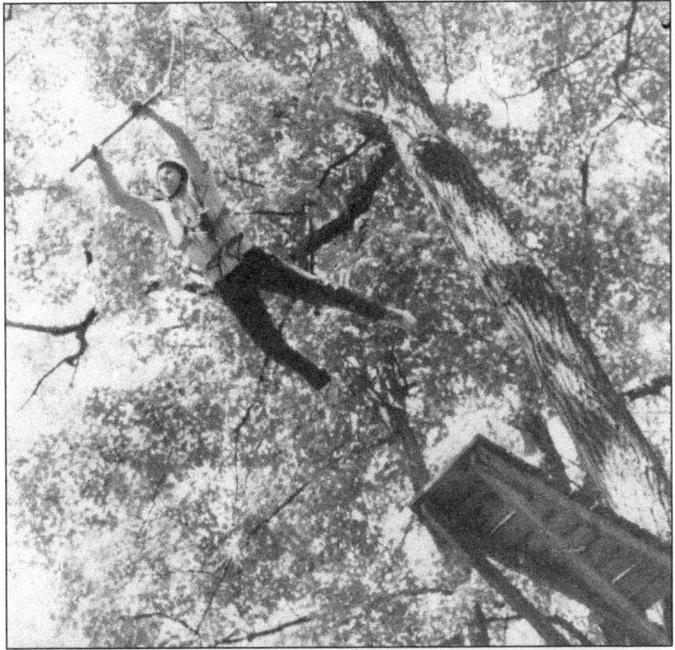

Another product of the 1980s was Maple Fest. At first, it was a small affair, designed to bring families to camp at the end of March. The first year, the sap was boiled in the kitchen. To the surprise of all, the residue from the sap settled on the wallpaper when it was boiled. The next year, they boiled the sap outdoors. When the event gained in popularity, organizers built a maple shed for boiling the sap into syrup. Naturally, a pancake breakfast followed. Eventually, it opened to the public. Pictured in 1980 are Pete Heintzelman and his daughters Katherine (left) and Caroline. (Courtesy of the Heintzelman family.)

Today, Covenant Harbor serves over 25,000 registered guests each year. In the summer, over 2,500 youth participate in day and overnight camps. During the rest of the year, people of all ages enroll in midweek conferences and weekend retreats. Senior adults participate in the Road Scholar programs, and students from public and private schools attend outdoor education classes. Every Sunday during the summer camp season, the front lawn is filled with people enjoying a picnic lunch after worshipping together outside, just as they did decades ago. (Both, courtesy of Covenant Harbor.)

Nine

LIFE-CHANGING EXPERIENCES THROUGH CHRIST
LAKE GENEVA YOUTH CAMP

Lake Geneva Youth Camp (LGYC) opened in 1950 to serve young people. It was considered a place where "children could find a way out of the city and learn about God's love for them." In 1948, five Chicago businessmen, all Plymouth Brethren, bought the land. One of them, Charles Pollard, had been born on the property in 1898. His father, Thomas Pollard, had managed the farm for the Ceylon Court Estate.

Ceylon Court was a Singhalese temple built for the World's Columbian Exposition of 1893 by natives of Ceylon with native materials. When the fair closed, Anna and Frank Chandler purchased the temple and had it rebuilt on the bluff above Button's Bay. When the Mitchells purchased the estate in 1901, they added nearby farmland for their Belgian draft horses, poultry, hogs, and cattle. The ownership transferred to the Maytags in 1928. The Maytags remodeled the stables into a kennel for their champion Pekinese dogs.

Charles Pollard learned that the estate's farm was for sale in 1947. With the help of his friends John Heick, Jim Humphrey, Winfield Scott, and William McCartney, Pollard formed the Lake Geneva Foundation. It was able to raise the money to buy the farm the following year. Three families bought homes on the property to help defray camp expenses. For two years, crews of volunteers from Plymouth Brethren Assemblies in the Chicago area worked to prepare the camp. This included renovating farm buildings for camp purposes. Paula Heick, John Heick's sister-in-law, and her young children Lori, Fred, and John cooked and served lunches for the workers.

Because Charles Pollard had kept in touch with the local people with whom he had attended school in Lake Geneva, he was trusted, so there was little resistance to establishing a camp. During that first year, almost 400 children enjoyed the beauty of the camp.

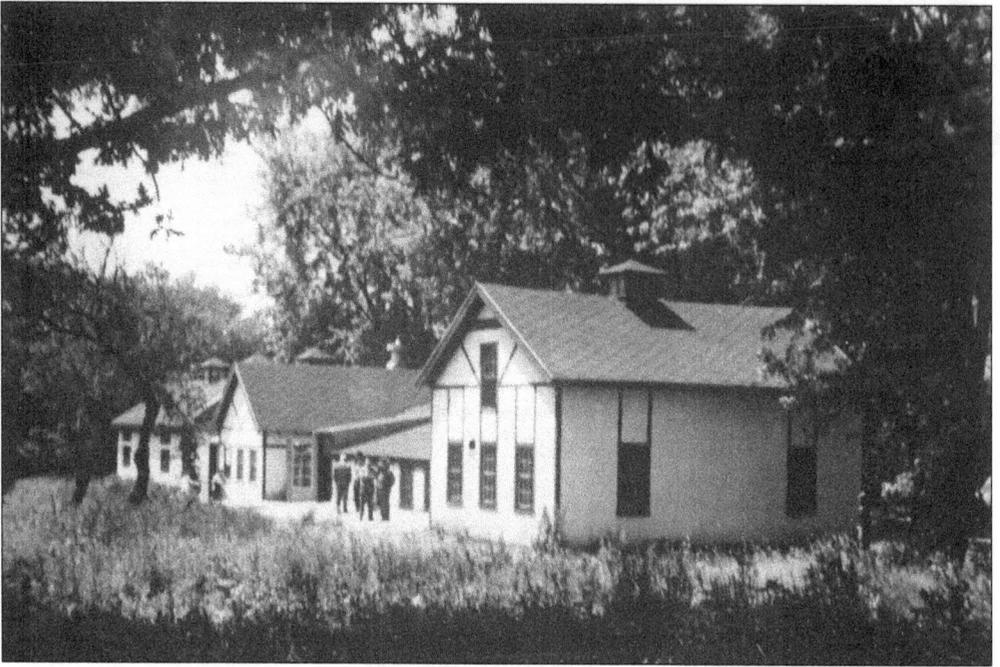

Having once been a farm for a grand estate, the Lake Geneva Youth Camp began with several elegant buildings. Notice the half-timbered stucco exterior on the former coach house (above) and the carriage house (below). These buildings serve as dining rooms, chapels, offices, and meeting rooms. (Both, courtesy of Lake Geneva Foundation)

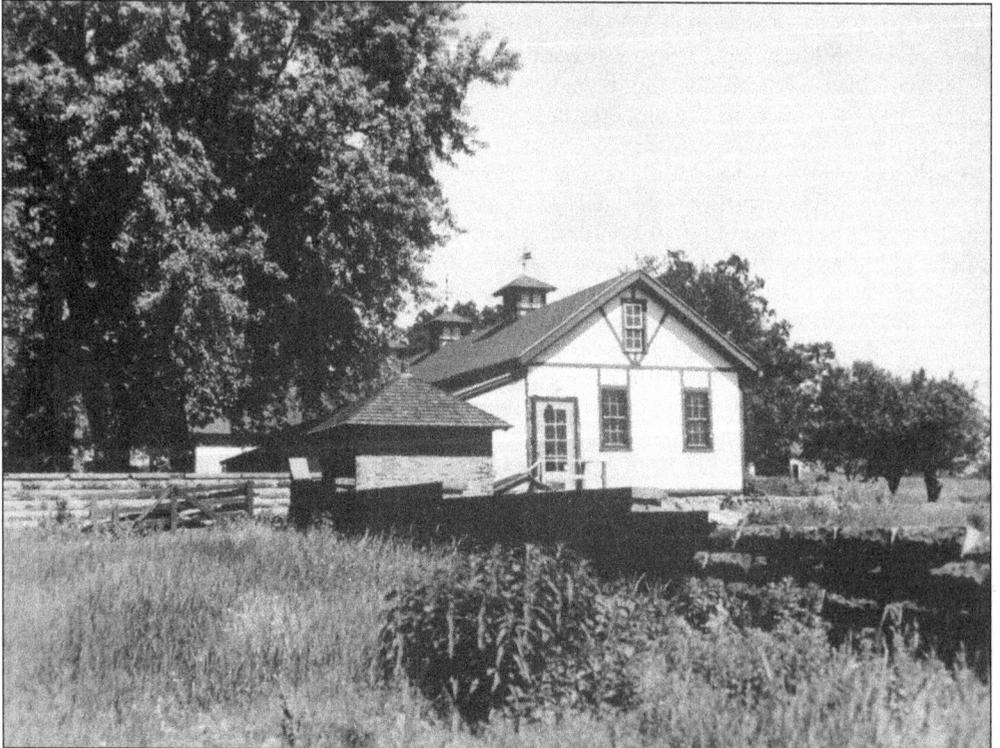

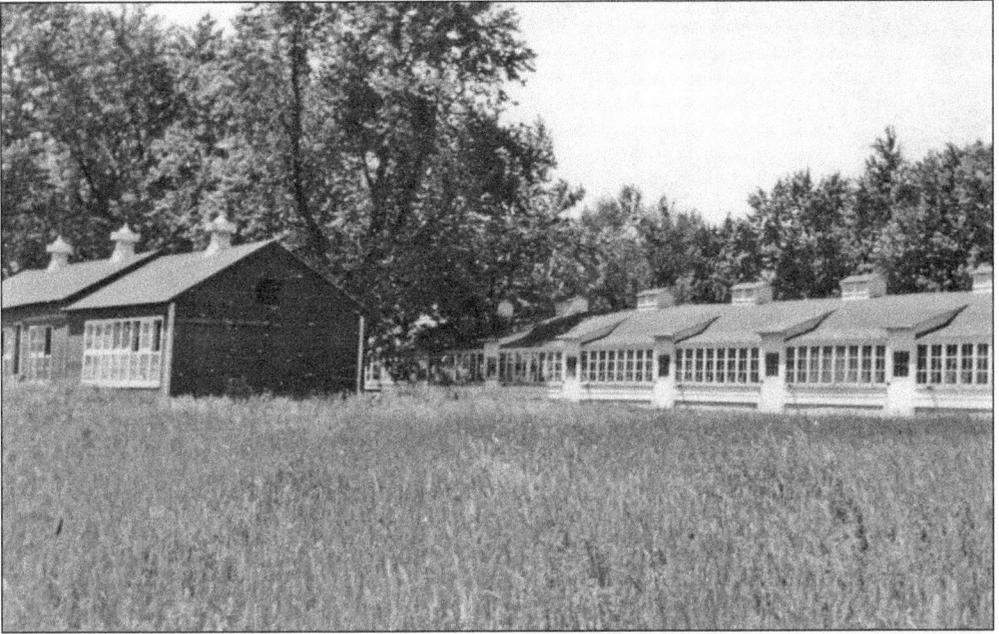

One camp on the lake joked about having chicken coops for cabins. At LGYC, it was a fact. The younger children stayed in Teepee and the older kids stayed in Hogan. Despite the thorough cleaning beforehand, chicken feathers were found by campers, drifting into the dorms and the storage areas. As for the hanging lights, one camper was lazier than most: rather than get out of bed, he used his BB gun to shut them off. (Both, courtesy of Laurie Meisner.)

Later, new cabins were built, mostly with volunteer labor from the Plymouth Brethren Assemblies. Johnny Everding brought his cement mixer along when foundations were being laid. (Courtesy of Laurie Meisner.)

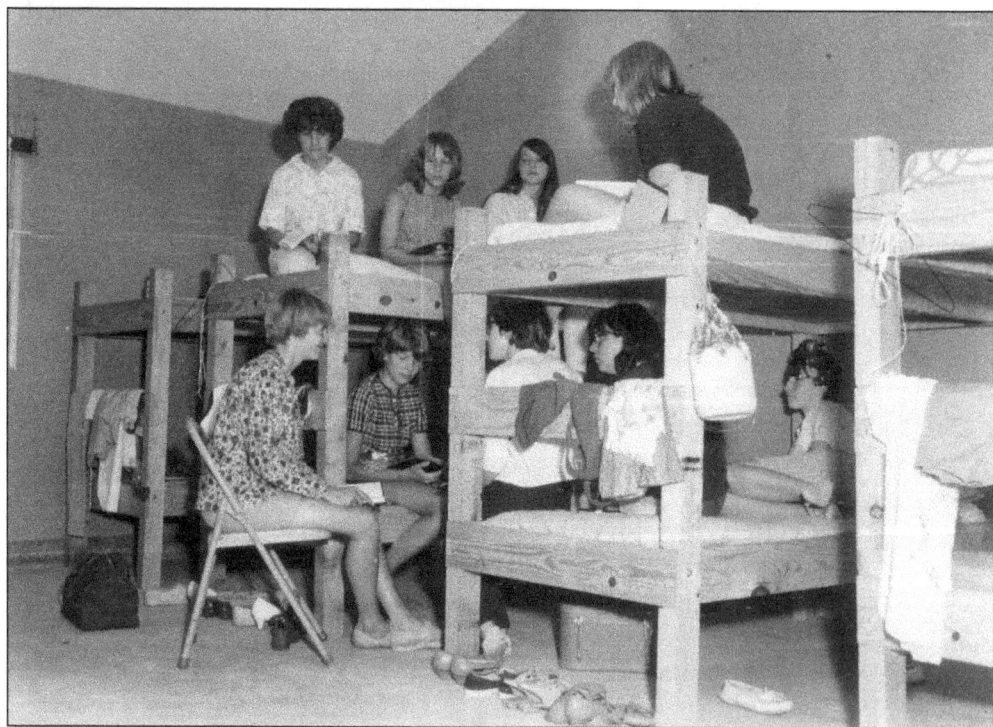

Counselor Lee Heron is pictured here leading devotions before lights out. During teen week, campers anticipated being awakened in the middle of the night for a party at the roller rink. But never knowing when that night would come, the girls slept in full makeup every night. (Courtesy of Laurie Meisner.)

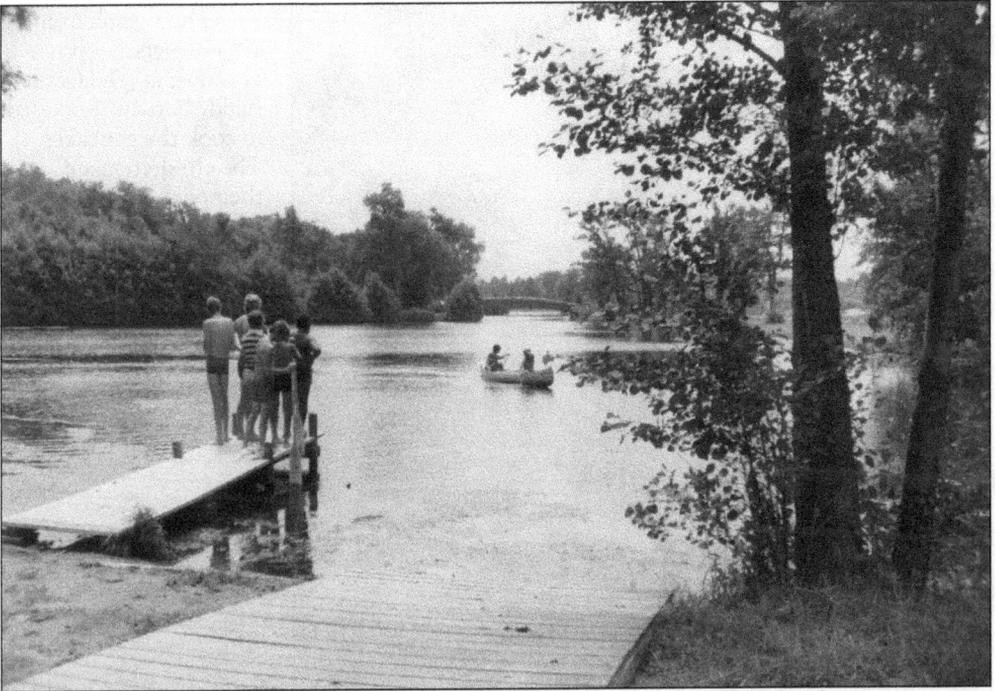

When the Maytags owned the estate, they had the marshland dug out so that its shape was roughly the same as Geneva Lake. The job provided badly needed work during the Great Depression. LGYC shared the lagoon with Big Foot State Park. It offered calm waters for canoeing—something that could not be counted on in the lake. (Above, courtesy of the Lake Geneva Foundation; below, courtesy of Laurie Meisner.)

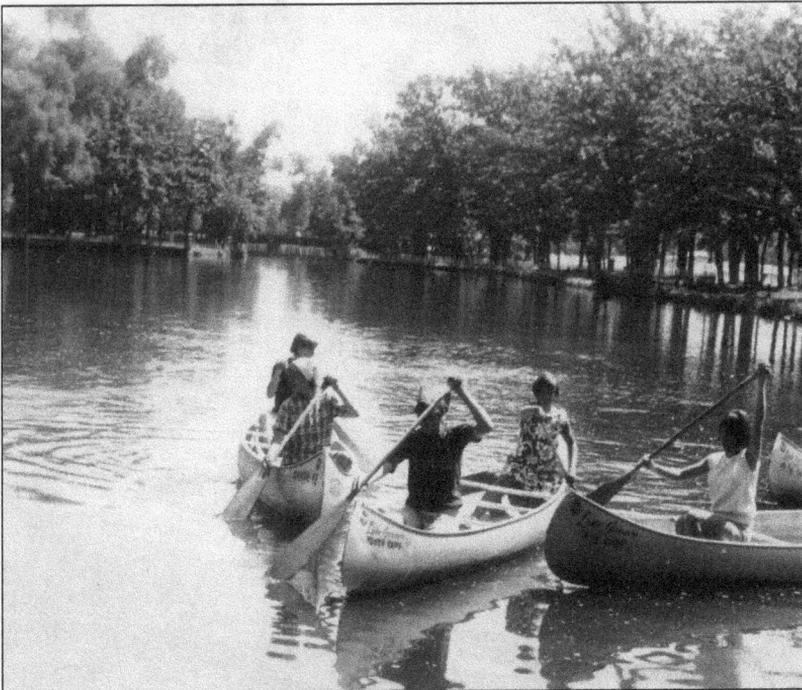

This photograph from 1954 depicts a hobo breakfast at the lagoon. Buddy burners were used to cook the pancakes. The children made their own burners using a can, corrugated cardboard, and candle wax. (Courtesy of Laurie Meisner.)

Before the pier was built, the lifeguard stood on a rock. With or without the pier, the lifeguards kept careful watch. The buddy system was commonly used at camps to keep track of the children. Periodically, the lifeguards blew their whistles and counted back from 10. By zero all swimmers had reached their buddy and raised their hands together to show the lifeguards they were safe. (Courtesy of Laurie Meisner.)

In order to reach the LGYC beach, campers walked across South Lake Shore Drive. Since it was literally feet from the shoreline, the camp's beach was visible to all who drove past. The giant slide in the water was the envy of non-campers who checked it out as they drove past. (Right, courtesy of Laurie Meisner; below, courtesy of the Lake Geneva Foundation.)

Hazel Moldenhauer was part Native American and had a deep respect for nature. She started the nature crafts program. Moldenhauer taught the children about plants and animals and was instrumental in the camp's canoeing program. Campers earned patches for their crafts and ability to memorize scripture. Some of the patches and awards were based on Native American culture. On this jacket are Scout, Indian, and Warrior patches. (Both, courtesy of Laurie Meisner.)

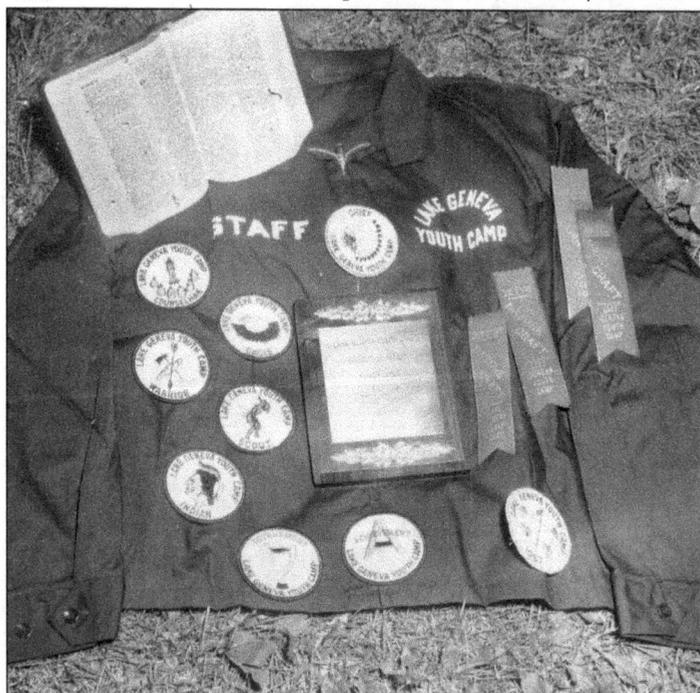

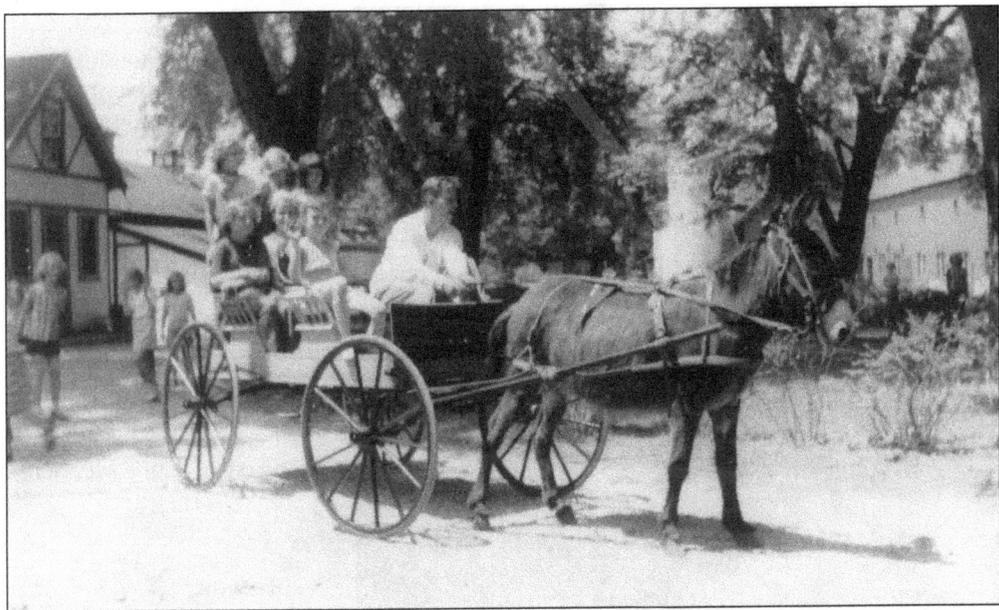

Although the chickens were gone, other farm animals remained for a time. There is a story of a bull and a cow disturbing the peace of Sunday worship with their bellowing. A few people also kept horses and ponies at the camp. James Humphrey, one of the founders, owned Powder Puff the donkey. On weekends, he hitched her to the wagon and gave rides to campers. (Both, courtesy of Laurie Meisner.)

Both men and women cooked at Lake Geneva Youth Camp. Almost all staff volunteered their time. Each was given $1 a day to purchase snacks. Paula Heick, who over time earned the name "Grandma Heick," was the camp cookie mom. Children walking back from the lake could stop by her cottage, the cookie house, to have freshly baked cookies. Grandma Heick also comforted homesick children with her baking. (Courtesy of Laurie Meisner.)

Since the 1970s, Lake Geneva Youth Camp has been nondenominational. Its mission continues to be that of introducing children to Christ. In addition to children from churches related to the camps, campers include children from disadvantaged homes and foster homes. (Courtesy of the Lake Geneva Foundation.)

Ten

GONE BUT NOT FORGOTTEN

CAMP NORTHWESTERN, ST. ANNE'S SCHOOL-CAMP, CAMP AURORA, TIMBER TRAILS CAMP, AND CAMP OFFIELD

Five additional camps are acknowledged in this last chapter—Camp Northwestern, Camp Aurora, St. Anne's School-Camp, Timber Trails Camp, and Camp Offield. The authors only learned about three of these camps while scouring old newspapers and files.

Like all the camps, each told a different story and served a different population. St. Anne's was for the well-heeled. Its colossal mansion (now known as Stone Manor) had once been the Younglands'. In its ballroom, children learned dance and music. Camp Offield, a Boy Scout camp, celebrated sleeping outdoors and cooking over fires. Camp Aurora, a Presbyterian camp, made its home at the former Hotel Minier in Fontana. Timber Trails taught farming in addition to the more typical camp activities. Camp Northwestern started as an encampment where young cadets could practice military maneuvers.

Looking at the large homes and developments that surround Geneva Lake now, it is hard to imagine that it used to be populated with resorts where a family could pitch a tent and camp. There are not even places left where people can beach their rowboat for a picnic. Of the 18 camps highlighted in this book, only seven remain.

The memories of a few camps have all but disappeared. Perhaps their buildings were torn down and replaced with subdivisions. Images of the camps might have vanished, and oral history is increasingly hard to come by. Still, bits and pieces of the history can be captured through newspaper articles, archived photographs, documents, scrapbooks, and recollections. Chances are a few camps still are hidden beneath the trees and houses that line the lake.

What all of the camps offered, though, were the lake, the shore path and fresh air—the great equalizers. Everyone swam, or at least cooled off, in their spring-fed waters. And all campers could hike the shore path, breathing fresh air. The campers' experiences left them with strong—many times lasting—friendships, memories, and magical days in the sun.

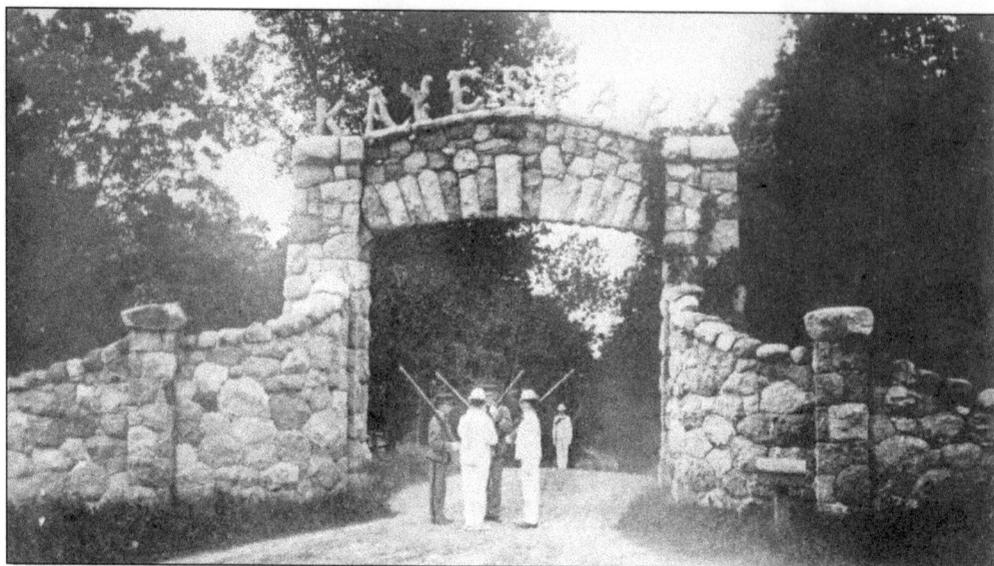

Northwestern Military and Naval Academy came to the south shore of Geneva Lake for fall and spring encampments at Kaye's Park beginning in 1909, when the academy was still located in Highland Park, Illinois. The academy negotiated with Anna Kaye to buy some of her land. Within a few years, it bought 85 acres, including one-third of a mile of shore. This image from 1913 shows the original entrance to the academy. (Courtesy of SJNMA.)

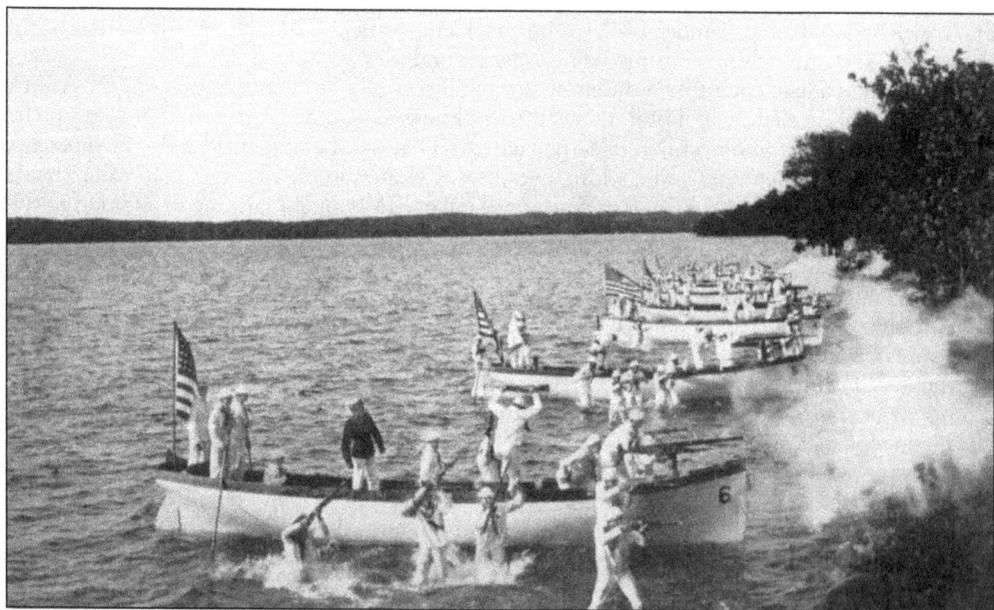

The fall encampments lasted until November. The cadets lived in tents, even after the weather turned brisk. In addition to their studies, cadets practiced naval maneuvers. Northwestern acquired cutter boats, which demanded a large and strong crew to maneuver. (Courtesy of Chris Brookes.)

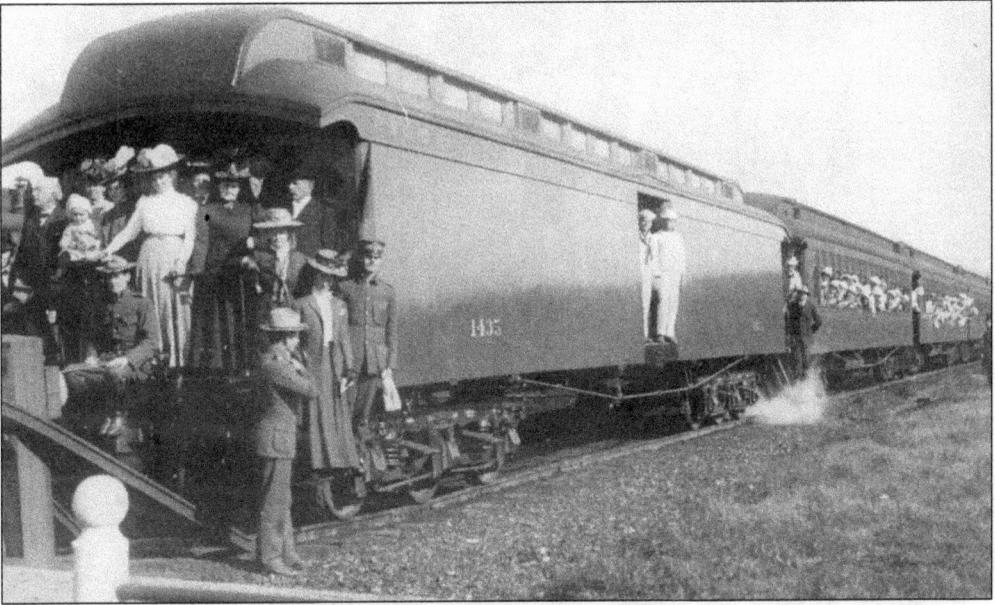

Northwestern's move to Lake Geneva was hastened by the burning of the academy in Highland Park on May 1, 1915. Although the construction of Davidson Hall had already begun on Geneva Lake, it was far from complete. The cadets lived under canvas for the rest of the school year and again from September until Christmas. Waving from the back cars are the cadets arriving at the station. (Courtesy of Chris Brookes.)

In 1917, in cooperation with College Camp, Northwestern hosted a two-week War Work School. Pres. Woodrow Wilson had commissioned the YMCA to prepare enlisted men in body, mind, and spirit. Three afternoons a week, YMCA men crossed the lake to Northwestern, where they practiced military drills and instruction. After two weeks of training, they traveled to military base camps to train enlisted men. (Courtesy of SJNMA.)

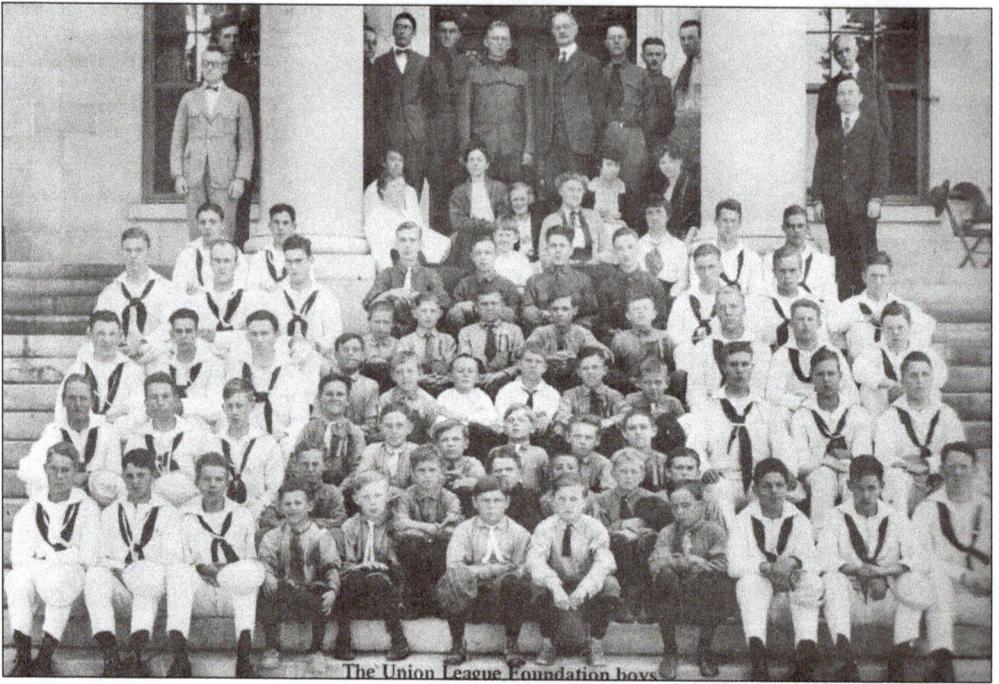

The Union League Foundation boys

In 1920, Col. Royal Page Davidson encouraged the cadets to collect money to fund a camp experience for underprivileged boys in Chicago. They partnered with the Union League Boys' Club and sponsored 110 boys during four 2-week sessions that summer. These camps were held again in 1921 and 1924. The experience was so rewarding that the Union League Boys' Club soon bought a camp of its own. (Courtesy of SJNMA.)

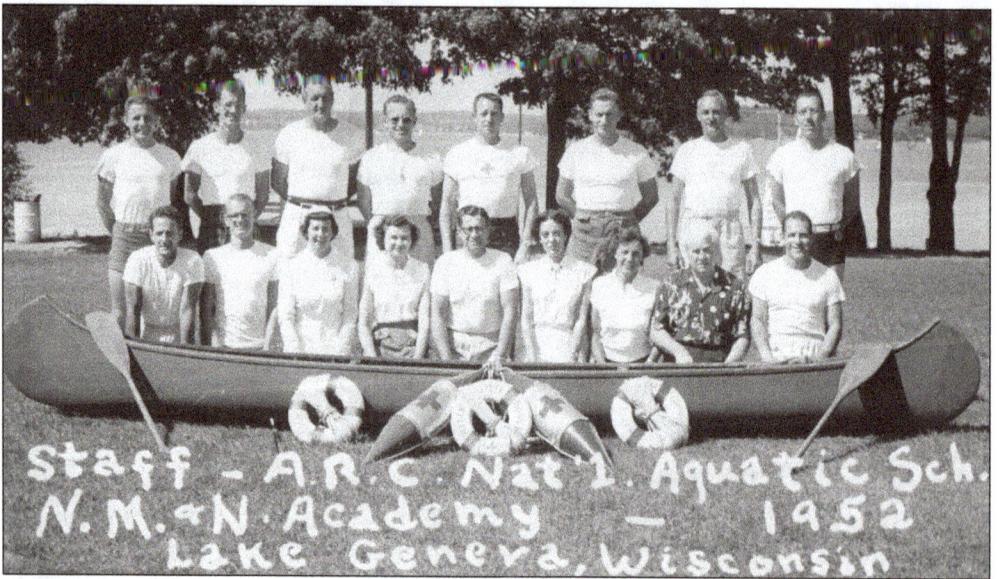

Staff - A.R.C. Nat'l. Aquatic Sch.
N.M. & N. Academy - 1952
Lake Geneva, Wisconsin

During the summers of 1916 and 1919, Northwestern served as a Red Cross training camp for women. Three decades later, in the 1950s, the American Red Cross trained its leaders at Northwestern. Scores of men and women learned how to train others in lifesaving techniques. (Courtesy of SJNMA.)

The academy affiliated with the Episcopal Church in 1942. Father James Howard Jacobson (center) came on board. Two years later, he became the superintendent-headmaster. In warm weather, worship services were held outside. (Courtesy of SSJNMA.)

In 1942, the summer camp for boys began; in later years, it opened to girls. The leadership and the times determined how heavily it leaned toward a military and naval emphasis. At camp, age groups were divided into groupings known as Destroyers, Cruisers, and Battleships. (Courtesy of SJNMA.)

Activities abounded at Camp Northwestern: swimming, soccer, tennis, baseball, reading, horseback riding, computers, and math. And even at a military camp, there was plenty of time to be silly. The frog's name is Clarence. The nurses' names are unknown. (Both, courtesy of SJNMA.)

Camp Northwestern had a fine sailing program. With it being a naval academy, there was an emphasis on boating, be it the early cutter boats, rowboats, motorboats, or sailboats. (Courtesy of SJNMA.)

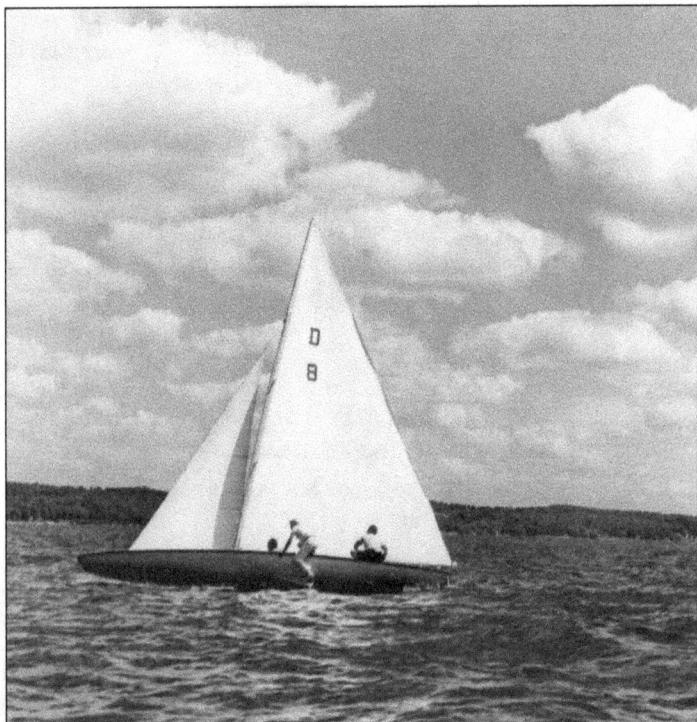

In 1973, Northwestern began recruiting campers and counselors from all over the world. In 1992, there were 67 campers from other countries. Pictured in the center is J.D. Brookes. The camp ended in 1995 when Northwestern merged with St. John's Military Academy and moved to Delafield, Wisconsin. (Courtesy of Chris Brookes.)

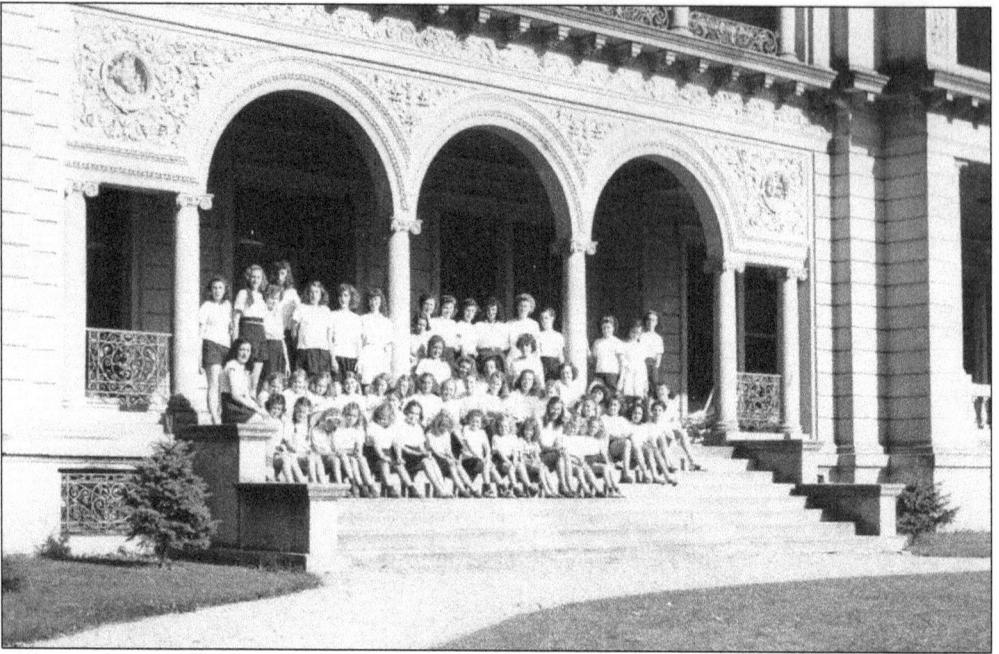

Stone Manor has been a private estate, girls' school, rooming house, French restaurant, Christmas tree museum, and condominiums. But hidden behind its Beaux-Arts facade is its life as a camp. When the original owner, Otto Young, died, his granddaughter inherited the estate. She donated the mansion to the Episcopal Order of St. Anne in 1939. The order operated it as a girls' school and a summer camp until the early 1940s. (Courtesy of Deborah Dumelle Kristmann.)

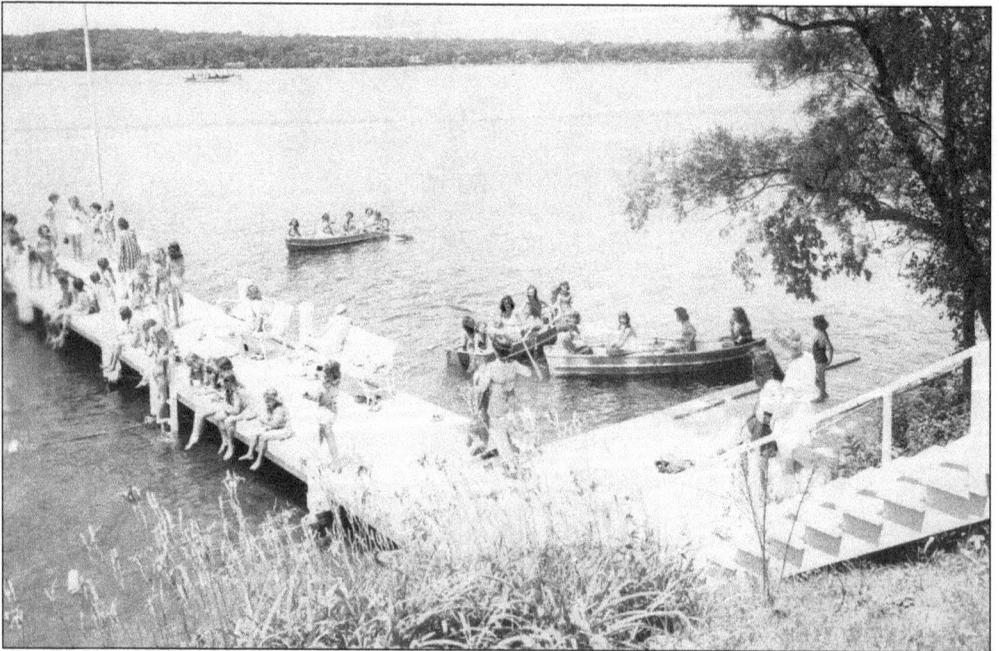

Originally known as St. Anne's School-Camp, the camp became Stonemanor Camp when it included boys. It combined cultural and physical development at the Italian villa. (Courtesy of Deborah Dumelle Kristmann.)

According to the brochure this image was taken from, St. Anne's School-Camp advertised music, drama, horseback riding, sketching, and drawing. The girls learned to dance in the ballroom, which boasted gold-plated fixtures, an ornate marble fireplace, and a crystal chandelier. In 1940, the camp brought in the Jack and Jill Players from the Chicago Civic Opera House to present *Heidi*. (Courtesy of the Geneva Lake Museum.)

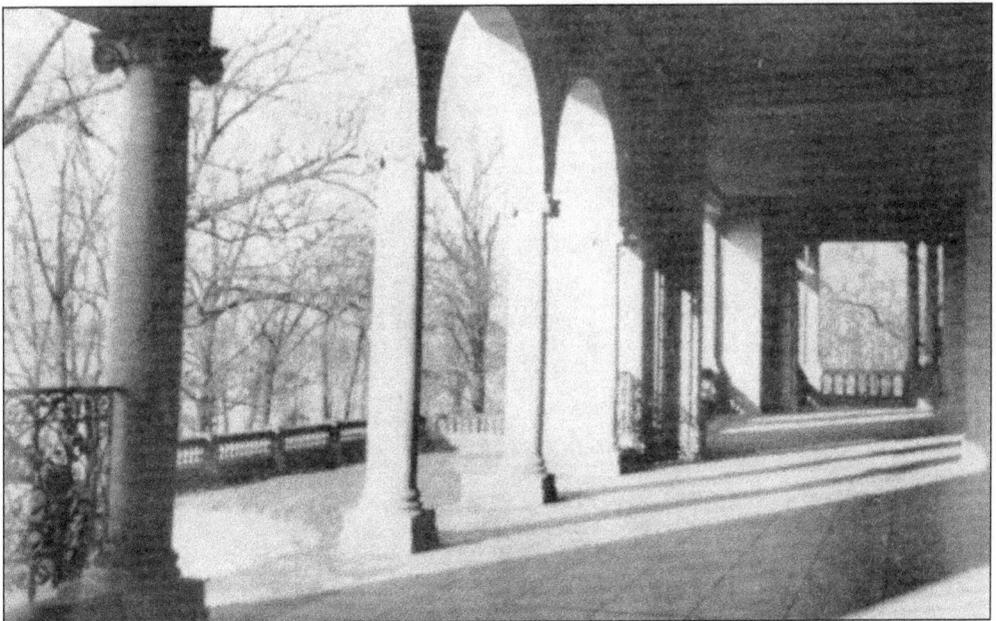

There were no dorms or tents for the campers at Stone Manor. They slept in luxurious accommodations. When they slept outdoors, it was not in a tent, but on the wide porches of the villa. About as close to nature as they got was eating freshly caught fish. All of this cost $45 dollars a week or $180 for five weeks. (Courtesy of the Geneva Lake Museum.)

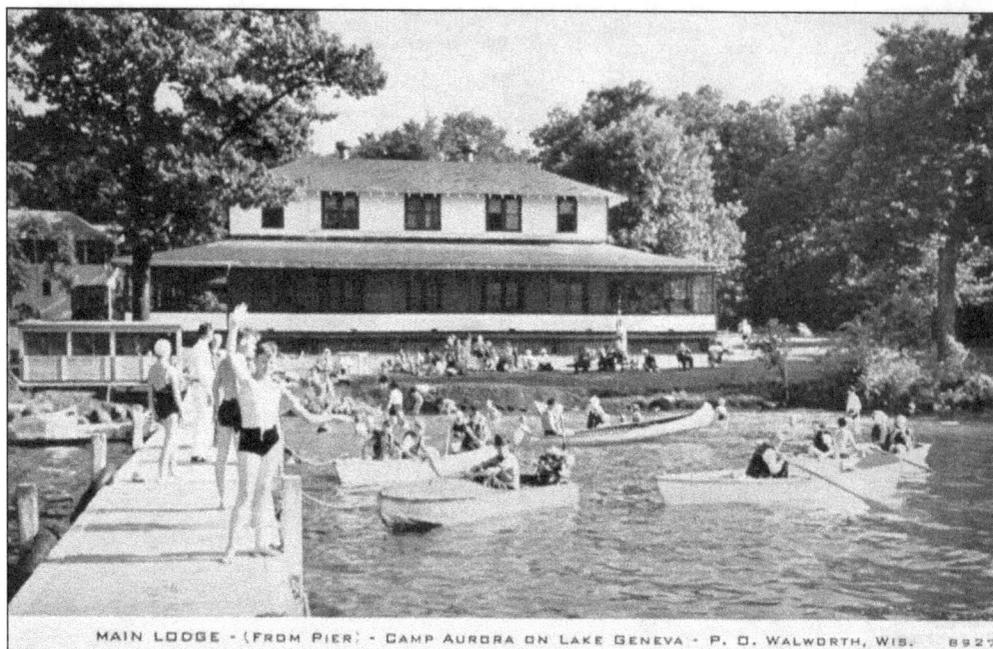

MAIN LODGE - (FROM PIER) - CAMP AURORA ON LAKE GENEVA - P. O. WALWORTH, WIS. 8927

Camp Aurora (1934–1941) was the dream of Dr. James Congdon, the pastor of First Presbyterian Church in Aurora, Illinois. With financial contributions, a strip of land west of the Harvard Club was purchased. The camp was used by First Presbyterian, other churches, the Future Farmers, and physically handicapped children from Evanston. Later, Camp Aurora purchased the farm across the road and the Ayer estate, bringing the total acreage to 320. (Courtesy of the Geneva Lake Museum.)

The main building had been Hotel Minier. It contained the huge meeting/dining room, lobby, and snack shop. Upstairs was a dorm room nicknamed "Heaven." Joy Hulting remembers it as "a mass of wet towels and laundry." Camp Aurora had several buildings, including the Buena Vista Building, the annex, and a cottage called Hilltop. Little evidence of Camp Aurora remains. This photograph was found in the church's newsletter. (Courtesy of First Presbyterian Church of Aurora.)

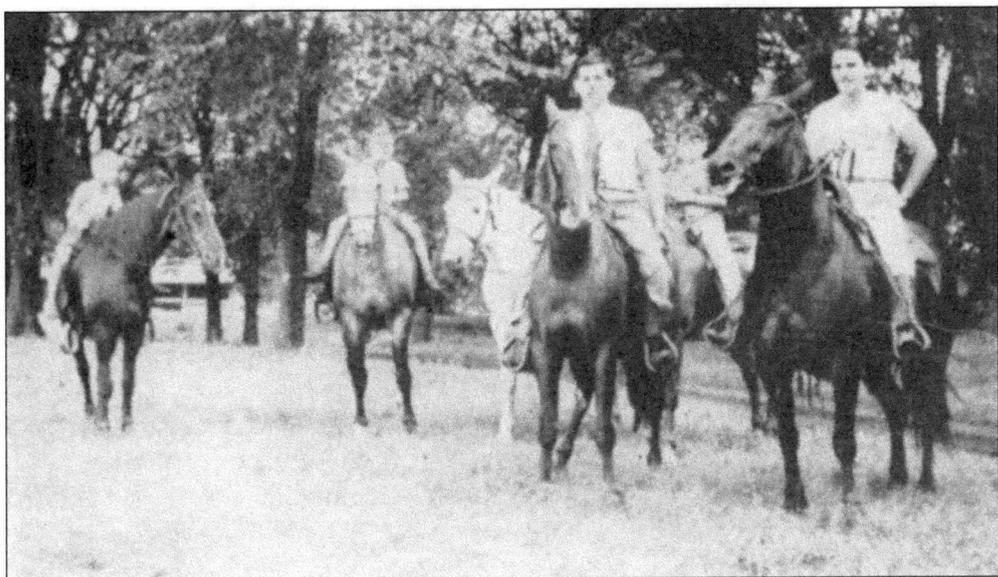

Camp Aurora thrived until the mid-1940s. Most of the property became Ayers Park, which existed until the early 1970s, when it was sold to developers. At Ayers Park, a camp called Timber Trails opened, which combined lakefront activities, farming, and horseback riding. Timber Trails was dedicated to Christian recreation and character building. This image is from a brochure, the only clue the authors found that this camp existed. (Courtesy of the Geneva Lake Museum.)

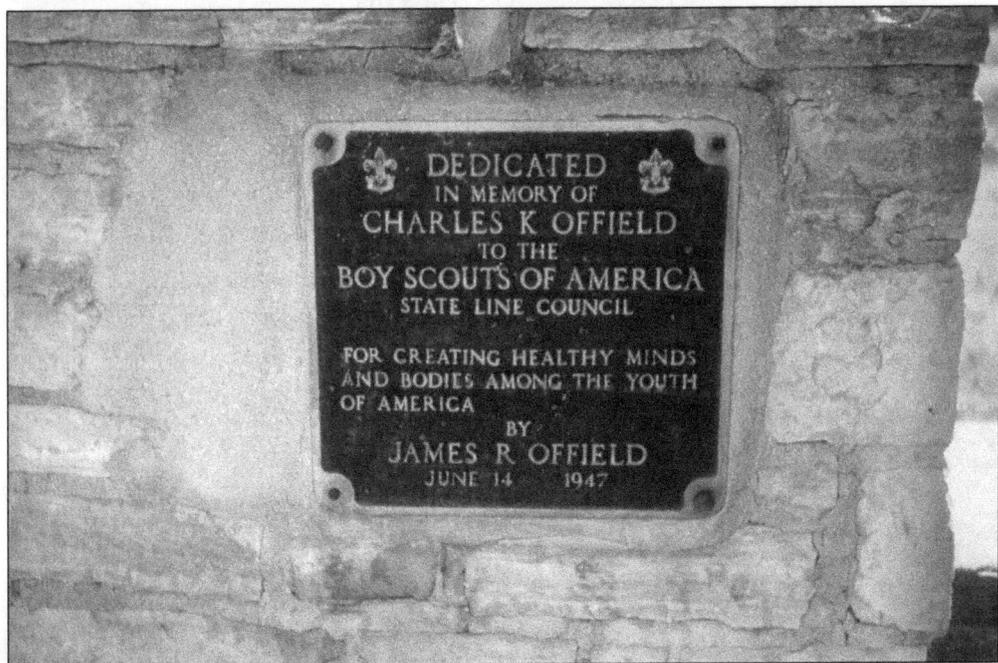

Camp Offield was owned by the State Line Council of Boy Scouts in Beloit, Wisconsin. The 55 acres of land, just east of the yacht club, was donated by James Offield, the son-in-law of William Wrigley. Named for his father, Charles Offield, the camp operated from 1947 to 1962. On one of the stone pillars that marked the entrance to the camp was a bronze plaque. (Courtesy of Robert Aspinall.)

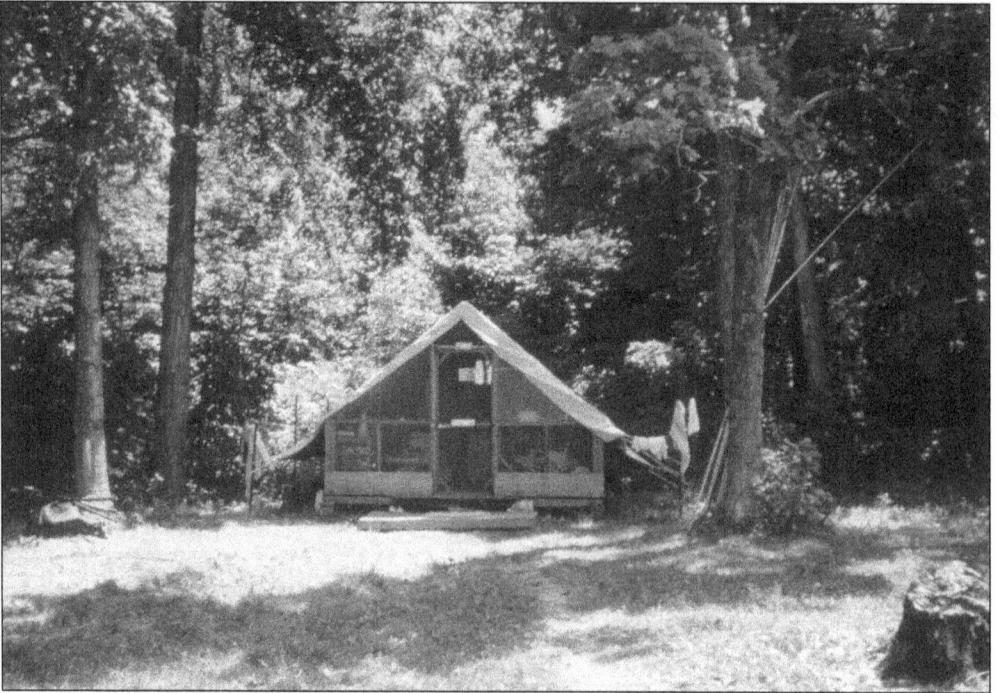

Rather than clear the land of trees and build dormitories and tennis courts, the Boy Scouts opted to leave the wooded site natural so that it would feel like wilderness. There were five campsites nestled back in the woods, each housing about 25 campers. Each campsite had four-man platform tents clustered around a fire pit. Most of the camp was south of South Lake Shore Drive. (Both, courtesy of Robert Aspinall.)

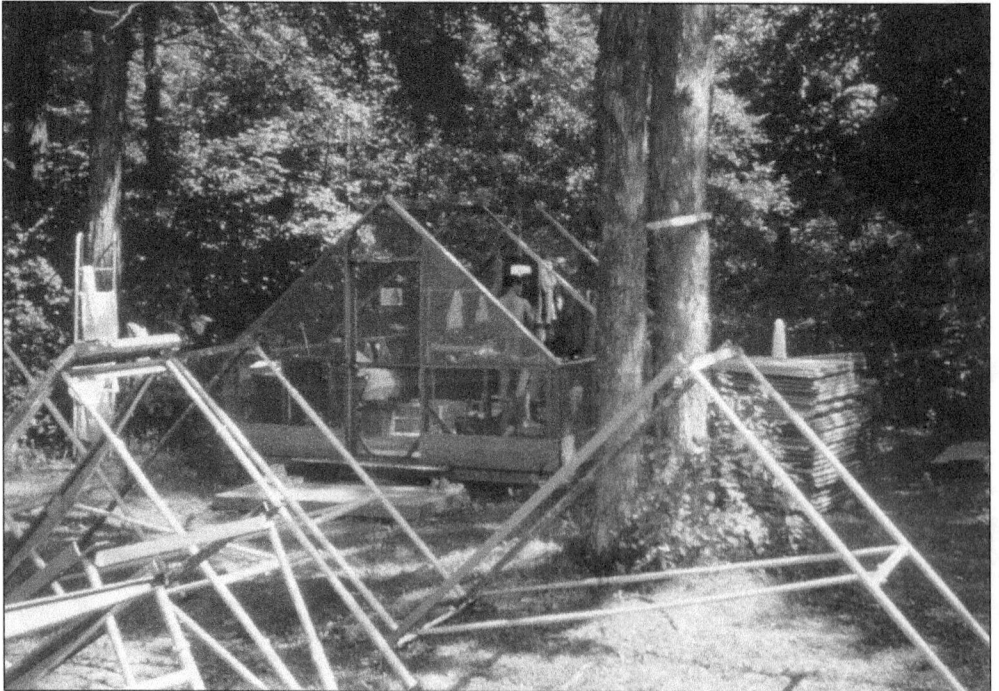

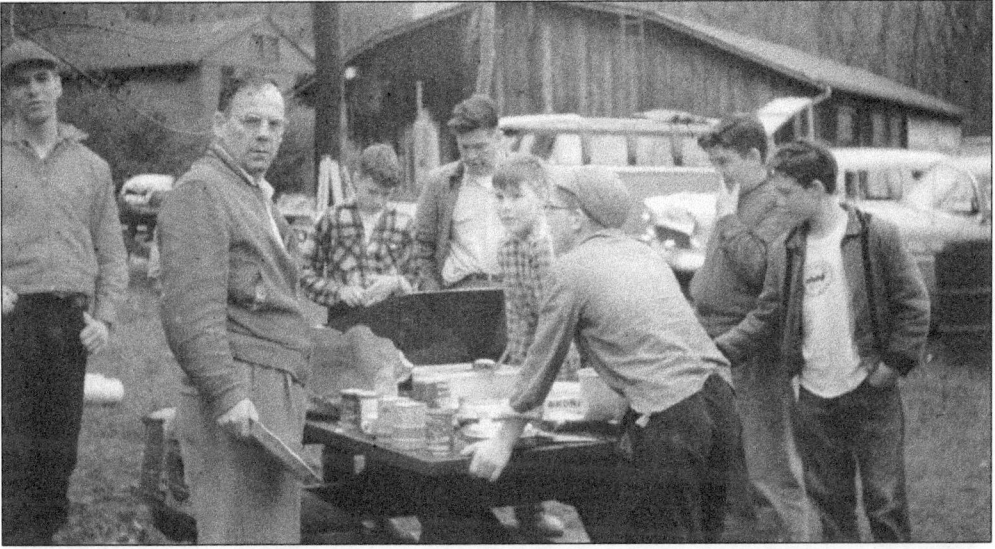

The main buildings were near the parking lot—a mess hall, the cook's cottage, a trading post, a handicraft shelter, a shower house, and a health lodge. There was a consensus among campers that Ma Hopper was the best cook in the Midwest. Florence "Ma" Hopper was a cook at Beloit College during the school months. Though Offield was a Boy Scout camp, the Girl Scouts used it two weeks each August. (Courtesy of Allan Button.)

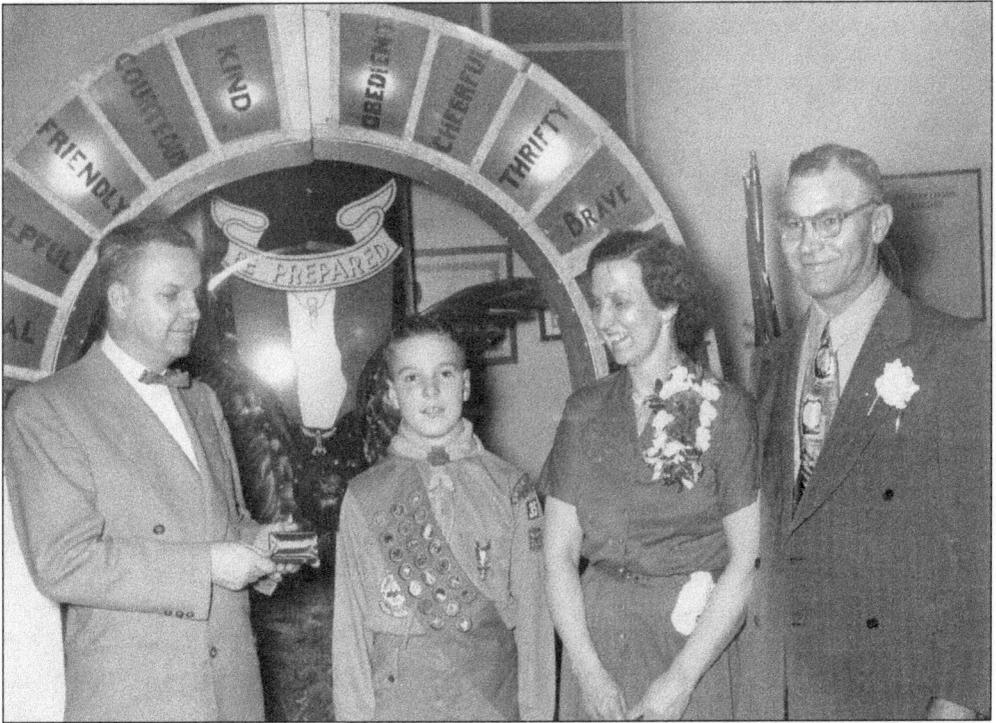

The three Button boys all attended the Boy Scout camp. Allan Button is pictured at his Eagle award ceremony with his parents and Scout leader, a Mr. Herrick, in 1952. In Troop 35, there were four Eagle Scouts—Elbert Aspinall, Allan and Fritz Button, and Bill Danielson. Aspinall went on to be an executive in the Boy Scouts of America. (Courtesy of Allan Button.)

On the lake side of the road was Borg Lodge. It was completely winterized, so it was used throughout the year for weekend camps. Borg Lodge had a small kitchen and bunks. When extra room was needed, boys unrolled their sleeping bags in front of the fireplace. Borg Lodge was also used for meetings and other gatherings. (Courtesy of Robert Aspinall.)

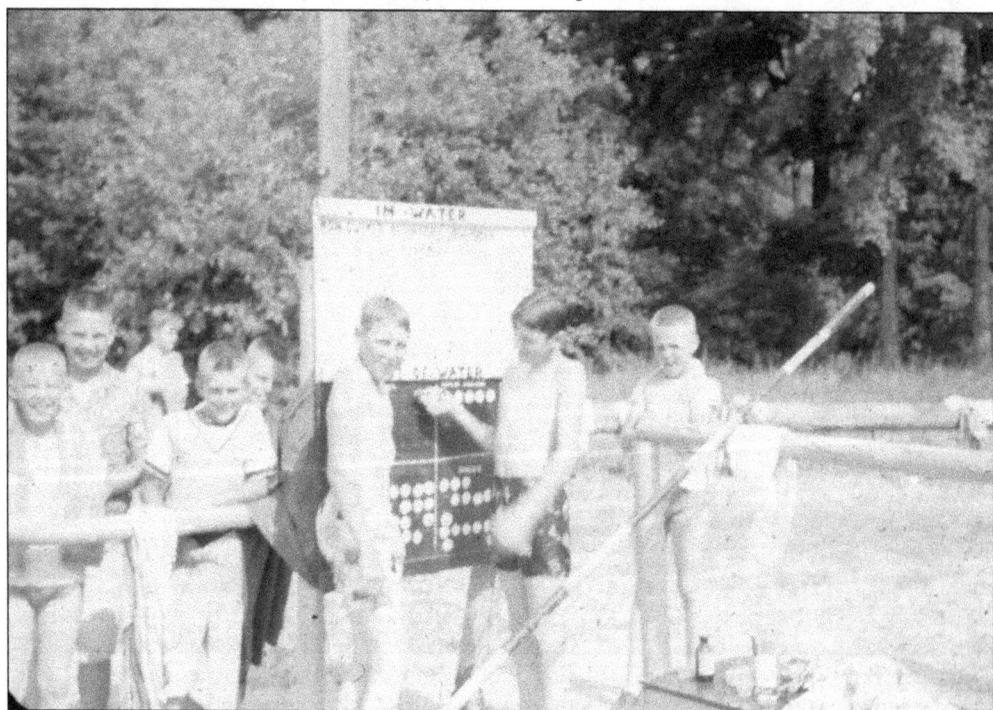

Pegboards tracked the swimmers. Each Scout was paired with a buddy for safety. The names of those pairs were listed on this board. (Courtesy of Robert Aspinall.)

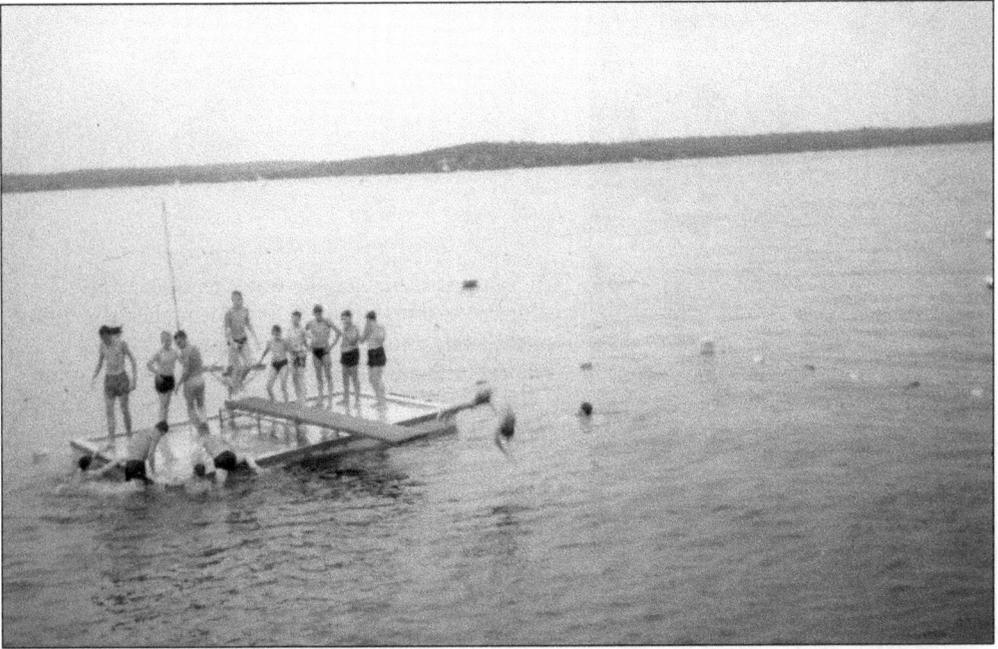

On hot days, there was nothing like being in, on, or around the lake. The Scouts, with their boundless energy, could have spent all day at the lake fishing, swimming, canoeing, and playing rag tag. But after hours at the lake, there was still so much else to do. (Courtesy of Robert Aspinall.)

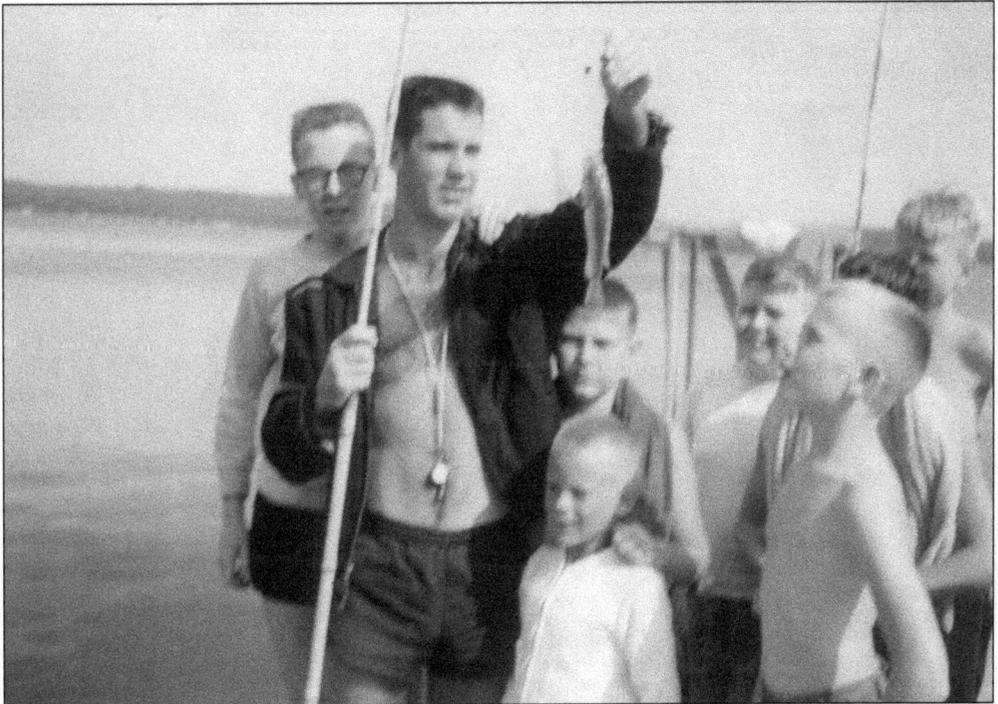

Back in the woods, campers practiced archery. They built campfires and sometimes cooked their meals over the coals. At the completion of camp, the Scouts were each given a round, red-white-and-blue patch to sew on their uniforms. (Courtesy of Robert Aspinall.)

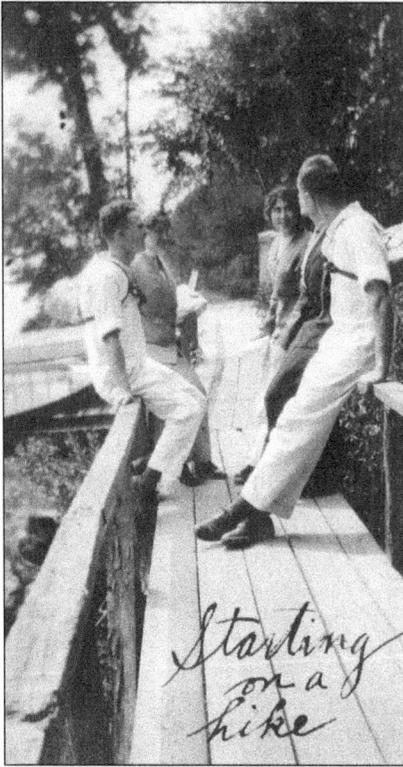

Starting on a hike

Camping at Geneva Lake was memorable. The camps served up fun while promoting healthy living for the body, mind, and spirit. They welcomed children and adults from all walks of life. For some, it was a retreat or vacation. For others, it was an opportunity for continuing education or getting closer to God. All the camps offered the experience of living in close community with others. The campers participated in similar activities, taking advantage of the lake's remarkable resources. Camps enriched the Geneva Lake community by opening up programs like worship, education, and music to the public. They helped to protect the land and the lake, yet at the same time made it possible for thousands of people to enjoy the lake each year. (Left, courtesy of Peg Williams; below, courtesy of Holiday Home Archives.)

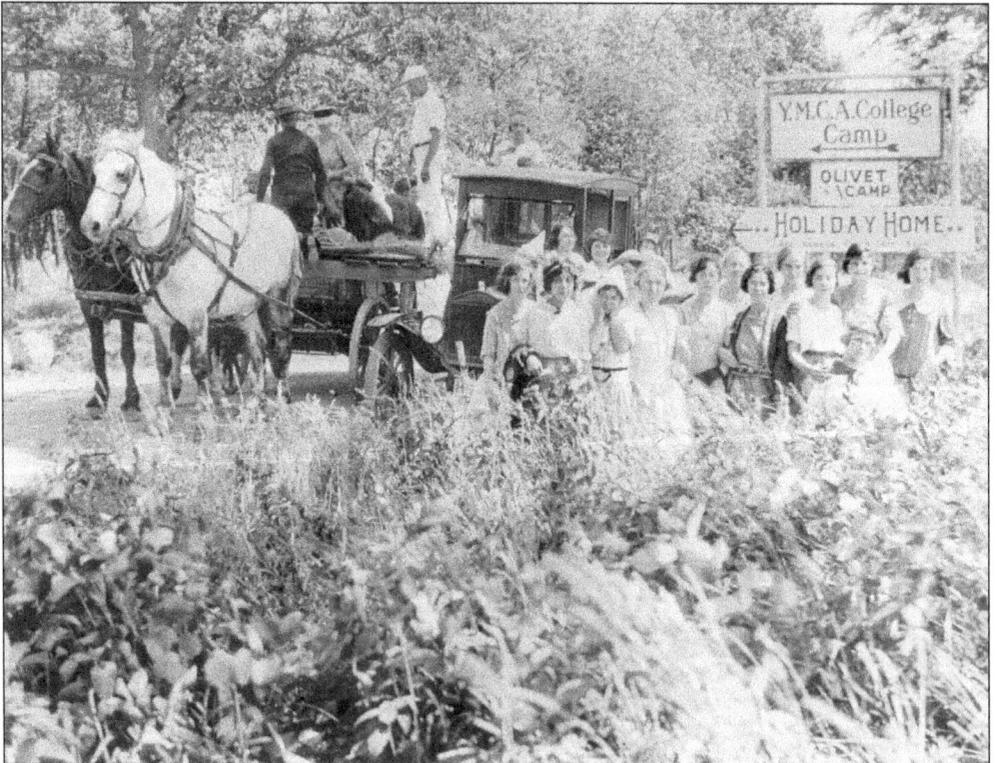

Selected Bibliography

Anderson, Philip J. "Covenant Harbor—The Early Years." Unpublished paper, May 10, 2004.

Bay Leaves/Observer newspapers. Williams Bay, WI: 1933–1940.

Camp Willabay. "35th Anniversary Commemorative Booklet Outline." Unpublished paper, 1981.

College Camper Yearbook, various editions, 1920–1970.

Covenant Harbor Bible Camp. *Covenant Harbor Chronology: 1947–1997*. Lake Geneva, WI: 1977.

Frohna, Anne Celano, *Geneva Lake, Geneva Lake Reflections: More Stories from the Shore*. Williams Bay, WI: Nei-Turner Media Group, 2010.

———. *Geneva Lake: Stories from the Shore*. Williams Bay, WI: Nei-Turner Media Group, 2009.

Gray-Fow, Michael. *Boys and Men: A Hundred Year History of Northwestern Military and Naval Academy 1888–1988*. Lake Geneva, WI: 1988.

Hanafee, Valerie and Patrick. *Norman B. Barr Camp 1909–2009*. Self-published, 2009.

"The History of Holiday Home Camp." Unpublished paper, 2009.

McDowell, Lois Miller. "A History of Conference Point Center 1873–1994." Unpublished paper, 1994.

Naumann, Herbie Gamertsfelder. "My Eight years in Camp Family." Unpublished paper, February 25, 2003.

Nelson, Emery M. "College Camp—Lake Geneva," Graduating thesis, Dept. of General Administration, 35th Annual Commencement of the Young Men's Christian Association College, 1925.

Quinn, Patrick. "Camp Offield: A Lost Geneva Lake Icon." *Lake Geneva Regional News*, May 6, 2014.

"A Sketch of the History of George Williams College Lake Geneva Campus in Williams Bay, Wisconsin." Unpublished paper.

Smeltzer, Carolyn and Martha Cucco. *Lake Geneva in Vintage Postcards*. Charleston, SC: Arcadia Publishing, 2005.

Soderquist-Togami, Wendy. "LGYC: Our History." Unpublished paper, 2000.

"Summary of Historical Data of College Camp 1884–1955." Unpublished paper.

Tardily, M. Elizabeth and Robert L. Carter. "Evaluation Report on Holiday Home Camp Services." Unpublished paper, October 1992.

West, Dennis. "The Eleanor Camp." *Beacon*, January 17, 2014.

Wittenstrom, Clarence and Edna. "A History of Camp Augustana." Unpublished paper.

wmsbayhistory.ipage.com

Visit us at
arcadiapublishing.com

www.ingramcontent.com/pod-product-compliance
Lightning Source LLC
Chambersburg PA
CBHW080606110426
42813CB00006B/1418